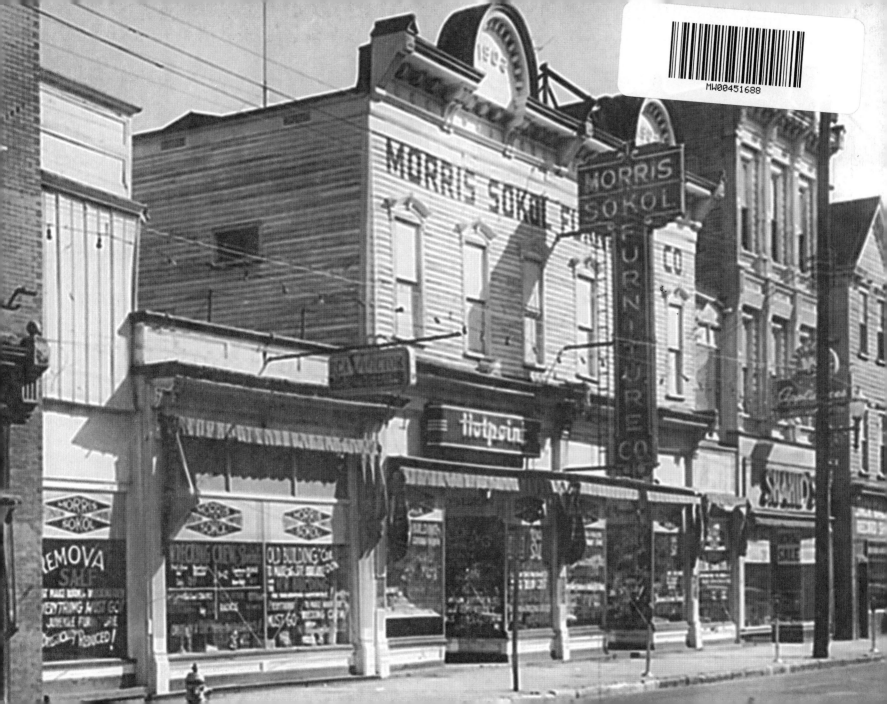

Our Charleston

Lowcountry Photos, People and Places

Published by

The Post and Courier

a division of The Evening Post Publishing Company
Larry Tarleton, Publisher

First Edition

ISBN 978-1-929647-10-1

Printed by
Inland Graphics
U.S.A.

697/5000

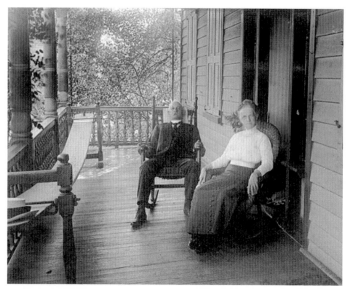

Joggling the Memory ◄

William Russel Welling and Dora Frances (Collins) Welling appear to prefer a rocking chair over the 16-foot joggling board featured prominently on the piazza of their home in 1913. The Wellings lived at 86 Bay St. (now East Bay St.), next door to Mr. Welling's lumber yard and mill. Their home, from all accounts in family photographs, was the epicenter of family life; photos of grandchildren in the yard and relatives in and around the house indicate that the Wellings were the hub of a very large family wheel, around which everything turned. The same may be said of many Charleston families pictured in this book.

This joggling board is much more than the children's plaything that was so commonplace in yards and on porches as far back as the early 1800s. This joggling board is a memory joggler, a reminder. It reminds that times change, and they also don't. It reminds that life can be beautiful, but it can also bounce a body around a bit from time to time. It reminds that children's playtime is eternal, but childhood is not. It reminds that remembering the past is the best way to honor those who lived it, and the best way to prepare a way for those who have not yet had their turn. The joggling board reminds that the Lowcountry is a special place, with special people whose memories and traditions deserve to be kept alive. If this child's toy joggles those memories, then it has served a higher purpose indeed.

Submitted by Frances Horres, Courtesy of the Charleston Museum

On the Cover

Swing Batter Batter ►

The only recorded name on the Logan-Robinson Sluggers' roster was Benjamin Thompson, who wrote reports to Edward W. Weekley about the team's season. In 1947 the team played 21 games: they won seven, lost 11, two games were called and one was tied.

Submitted by Eddie Weekley, Jr.

Girls Just Wanna Have Fun ►►

Admittedly, it is rare to see a group of prim and proper Charlestonian women captured on film being anything other than prim and proper. But even a century ago, people enjoyed a good time. These unidentified women certainly seem to be enjoying themselves on the beach at Sullivan's Island.

Submitted by Hal Coste

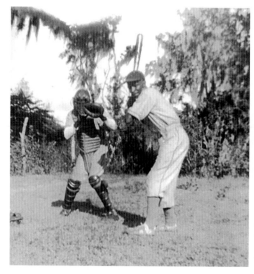

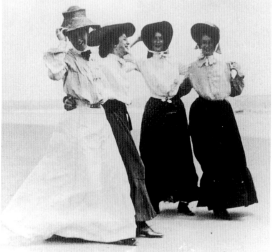

FOREWORD

Readers of The Post and Courier graciously responded to our request for remembrances of life in the Lowcountry by entrusting us with hundreds of treasured photographs. They cover a period of remarkable change, from the Civil War era when the nation was tragically divided to World War II when the nation was united against an enemy abroad and the Charleston Naval Shipyard played an important role.

Mostly this book captures, in events large and small, family life in the Lowcountry over a span of more than 100 years. Many of those events are mirrored in family albums across America — childhood portraits, school years, summer vacations, graduations, weddings, church socials, sporting events and family reunions. But this album also reflects this remarkable region, so replete with history and so irresistible in its natural beauty. Among the backgrounds that provide a sense of place are beach scenes, a joggling board, the Battery, The Citadel and the Avery Normal Institute as well as photographs of Azalea Festival floats, Cypress Gardens and historic houses lost to the wrecking ball.

Social change also is reflected throughout this photographic history which spans a time of substantial economic recovery. For the families who have spent generations in the Lowcountry, this album offers a source of reflection. For newcomers and visitors it is an invaluable source of information.

This is a book of irreplaceable memories. It also should serve as a reminder of the need to continue recording the events of today for generations to come. Our thanks to the contributors who kept their memories in a safe place for us to share.

Barbara S. Williams, *Editor*
The Post and Courier

Special effort was made to ensure accuracy of information accompanying these photographs. However, information written on the backs of photographs and dates recalled by contributors may not have been exact. For historical accuracy, we welcome corrected/additional information. It will be forwarded to the appropriate archives, museums and editors as well as noted in future editions.

Please write to:
Our Charleston
Robie Scott
134 Columbus St.
Charleston, S.C. 29403-4800

ACKNOWLEDGMENTS

Our Charleston, Lowcountry Photos, People and Places, Vol. I

The Project Staff

Robie Scott - Editor
Jamie Drolet - Retail Advertising Manager
Krissy Douglass - Assistant Editor
Zach Norris - Art Director
Lisa Foster - Writer
Shannon McCarty-Hardwick - Advertising Graphic Designer
Danny Enfinger, Dan Riddle, Lee Thomas, Jason Baxley, David Fields - Imaging/Scanning

Special Thanks

Barbara Williams
Christine Randall

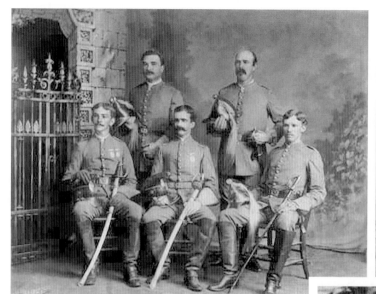

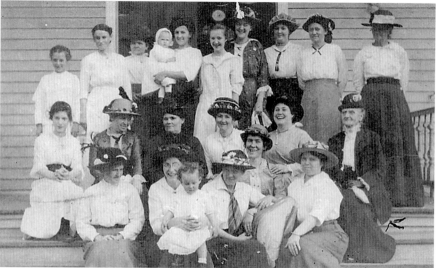

Triumphant Charleston Light Dragoons ▲

This fine-looking group of Southern gentlemen was proud to claim the title of Winning Rifle Team over the Savannah team in May, 1886. The "Drags," as they were fondly called, represented a tradition of "white-gloved cavalry" dating back as early as 1733. Originally known as "Charleston Horse Guards," the name was changed to "Charleston Light Dragoons" during the American Revolution. In 1792 they were formed into a city militia, drawing from the most prestigious families of planters, merchants and politicos. Pictured in the back row, left to right: Dr. John Allen Miles and Starling Hinson. Front row, left to right: Charles Gaillard, Sam Stoney and Tom Sinkler.

Submitted by Louisa M. Montgomery

Grand Gathering of Girls ▲

It is unclear what occasion evoked such a turnout in the late 1800s, or who most of these women were, but it is definitely a Charleston picture, and everyone seems to be having a good time. Martha (Petit) Brown, the mother of Charles Edward Brown and grandmother of Mattie Brown Sohl, is pictured on the second row, far right.

Submitted by Carl E. Sohl

Polish Immigrant ◄

Ida Posner was born in Poland but moved to Charleston. She and her husband Max lived downtown, their last home being on Montague St. off Lockwood. The couple had five children, all of whom grew up in Charleston. Those were times when extended family lived together until adulthood, and often beyond.

Submitted by Susan Ziman

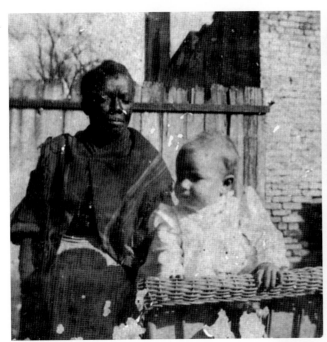

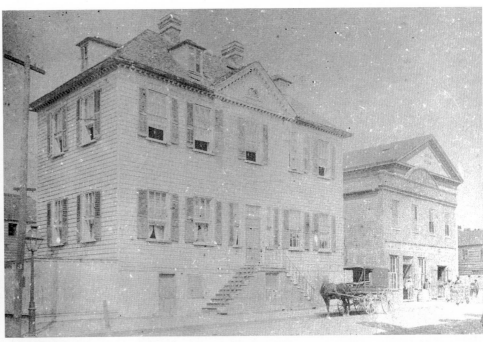

Taking Care ▲

Photographed in her wicker carriage in the back yard of the family's home at 56 Society St. is little Mary Sinkler de Saussure, born in 1899. The woman to the left is Mary's nurse; she more than likely lived near by. In those days the family retained one nurse for each child, and these women were either former slaves or related to slaves formerly owned by the family. During the post-Civil War era, almost all real estate was in a state of "preservation by neglect," which meant the families, often struggling, patched things up as best they could and made do. The house still exists; today it is known as the Dr. Joseph Johnson House in Ansonborough.
Submitted by Mary L. McQueen and Henry de S. Copeland

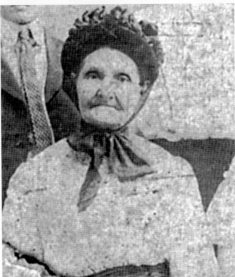

William Rieppe Hay, Grain, Grist and Mill Feed Store ▲

This photo, taken sometime around 1870, shows the Frederick William Rieppe home, 58 George St., and the Feed Store located next door at 56 George St. (right). The original structure was built in 1803 by Barnard Elliott. It featured Victorian elements, porches ("piazzas"), a bay above the front doorway, metal window caps and interior woodwork, which were added around 1870. The building, on the corner of George and St. Philip streets, is owned by the College of Charleston now.
Submitted by W. Rieppe Mehrtens

Mary (Mason) Priester, circa 1800s. ◄

Mary grew up on a farm in Hampton, S.C. and moved to Charleston when her daughter, Emma Rebecca, married. The family lived in Garco Village where Mary served as the Village midwife.
Submitted by Donna Hill

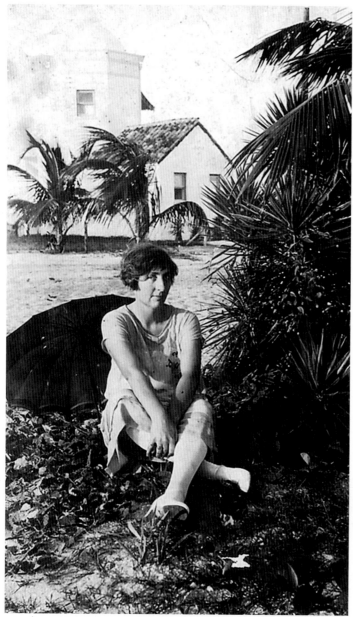

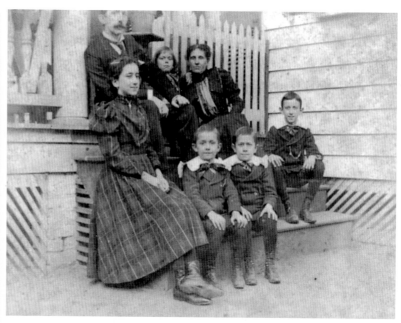

LaCoste Family Portrait ▲

In 1897 almost everyone lived on the peninsula, and the LaCoste family was no exception. Pictured outside their home on Queen St. is James Harvey LaCoste (top left) who was the business manager of The News and Courier for 30 years. He and his wife Henrietta (Robertson) LaCoste, pictured in the back on the right, had five children (bottom row, left to right): Bertie, Frank, Arthur and James Harvey. Five-year-old Edgar is seated between his parents on the top step. Frank grew up to be vice-president of the South Carolina National Bank, a member of the school board and friend of Mendel Rivers. Frank was known as a "party guy"—a lot of fun, his niece Jean (LaCoste) Edwins said—who prided himself on his seersucker suits and white bucks.
Submitted by Jean (LaCoste) Edwins

A Day Trip to the Island ◄

Emma Reeves Toomer grew up on the Edisto River near Jacksonboro, where the family owned Toomer's Motel and Restaurant. Although the business is no longer there, the restaurant was a local favorite for seafood and river fish, and the motel was the only one in the area at that time. In this photo, dated around 1918-1920, Emma was relaxing with her parasol behind her on a day trip to one of Charleston's islands. The umbrella would have kept the sun at bay on a hot day; sun tanning was definitely not in vogue in the 20s.
Submitted by Johnnie Lee (Reeves) Rowe

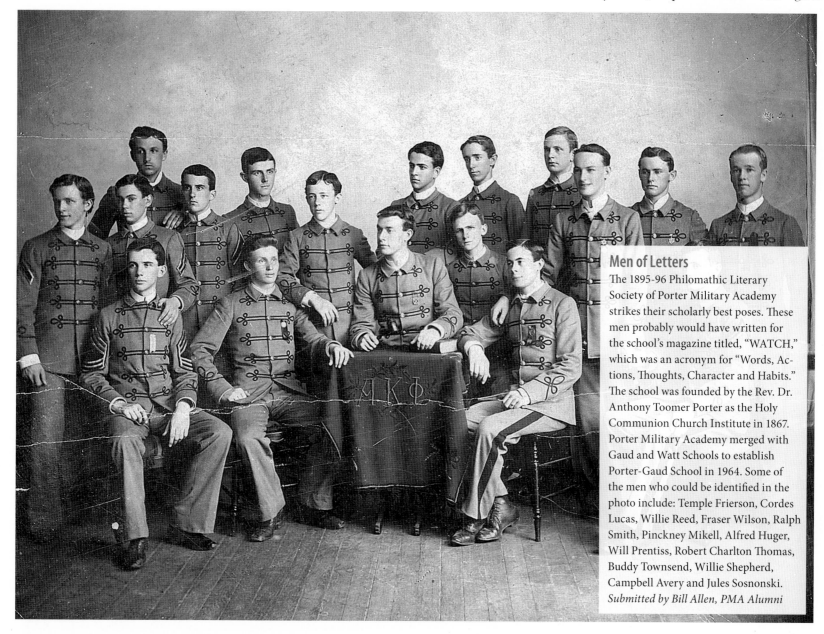

Men of Letters

The 1895-96 Philomathic Literary Society of Porter Military Academy strikes their scholarly best poses. These men probably would have written for the school's magazine titled, "WATCH," which was an acronym for "Words, Actions, Thoughts, Character and Habits." The school was founded by the Rev. Dr. Anthony Toomer Porter as the Holy Communion Church Institute in 1867. Porter Military Academy merged with Gaud and Watt Schools to establish Porter-Gaud School in 1964. Some of the men who could be identified in the photo include: Temple Frierson, Cordes Lucas, Willie Reed, Fraser Wilson, Ralph Smith, Pinckney Mikell, Alfred Huger, Will Prentiss, Robert Charlton Thomas, Buddy Townsend, Willie Shepherd, Campbell Avery and Jules Sosnonski. *Submitted by Bill Allen, PMA Alumni*

Confederate Maier Triest and His Wife Hannah ▼

This photograph taken around 1860 personifies the Jewish Charlestonian of the 19th century, according to great-great-grandson Larry Freudenberg. Maier Triest (right) was 30 years old when he enlisted in the 24th SC Volunteers to fight in the Civil War. Triest was promoted to Regimental Quartermaster Sergeant; his responsibilities included supplying the regiment. Toward the end of 1863 Triest was sent by Gen. Braxton Bragg to act as an agent for the collection of winter clothes, blankets and supplies. Triest used his own funds to crate and transport the supplies.

Triest married Hannah (Reichman) Triest (left) in 1869 and opened an import business in Charleston, Cohen & Triest, located at 259 King St. The business specialized in dry and fancy goods, carpets and upholstery. When his business failed in 1894, Triest lost everything but paid off his creditors in order to keep his good name from being tarnished.

Submitted by Larry Freudenberg

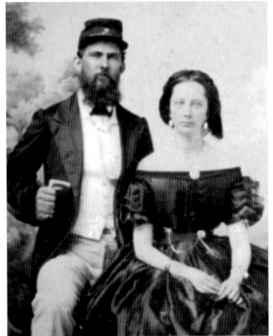

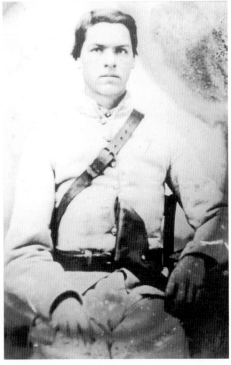

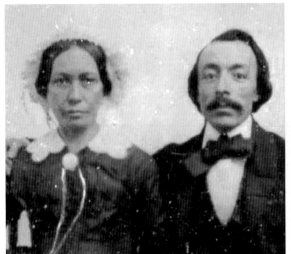

Quimby Portrait, circa 1860 ▲

This unidentified militia officer and his wife are dressed as if they belong to the affluent aristocracy of the antebellum South. The gentleman is wearing a dark military "kepi," or cap, with the letter "M" pinned on its front, indicating probably the first initial of his unit. The original case of the glass image photograph is embossed with "Quimby and Co., Artists, Charleston, S.C." and the background drop is a painted mural that appears often in his photos. Quimby established a gallery on King St. about the time of secession in 1860 and remained active in his studio until 1863. The man in the photograph is almost certainly an officer in a Charleston militia company about to be mustered into Confederate service, possibly the Marion Artillery, the Meagher Guards, the Montgomery Guards or the Moultrie Guards.

Submitted by Edward H. West

Confederate Mishoe ▲

Jeremiah W. Mishoe, pictured in his Confederate uniform during the War Between the States, enlisted in the Army at Georgetown, S.C. April 10, 1862 under Captain Tucker. He was 22 at the time of the photo in 1864. After his service he became a magistrate judge and was elected to the state legislature.

Submitted by Denise Pendley

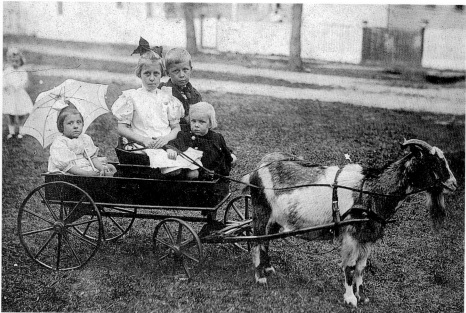

Seignious Drug Store ▲

John F. Seignious, Sr. (left) and his brother George W. Seignious owned two drug stores, one on Spring and President and this one on Spring and Ashley streets. George and his wife Rebecca lived above the store; John, who was the store's pharmacist, lived at 62 Bee St. In addition to the pharmacy, the store included a post office and soda fountain; one of the stools is visible at the left of the photo. The black man on the left of the photo was a paid, full-time employee who cleaned and made deliveries for the store. Both businesses were successful until they were sold in the 1950s.

Submitted by the John F. Seignious Family

A Different Sort of "Nanny" ▲

Many Charleston children had nurses or nannies in 1906, but not this sort of "Nanny." The goat, named Billy Ginger, is harnessed to the wagon of George and Claudia Walker's children. Pictured left to right are: Jo Walker (with the parasol) age 2, Julia, age 6, Henry, age 8 and Francis, just under a year old. The Walker family lived on Cannon St.

Submitted by Katie (Walker) Windmueller

All in the Family ▶

Cousins Inez Mouzon (left) and Edith Burnham have a little fun for the camera in 1903. Both girls lived in Charleston.

Submitted by the Sadler Estate

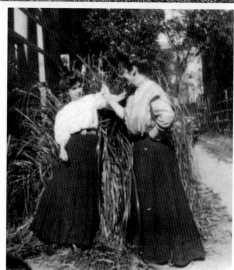

1770	1785	1794	1837	1970	1992
College of Charleston Founded	Chartered	Graduates First Class (Six Students)	Becomes First Municipal College in the U.S.	Incorporated into S.C. State College System	Establishes University of Charleston, S.C. (The Graduate School)

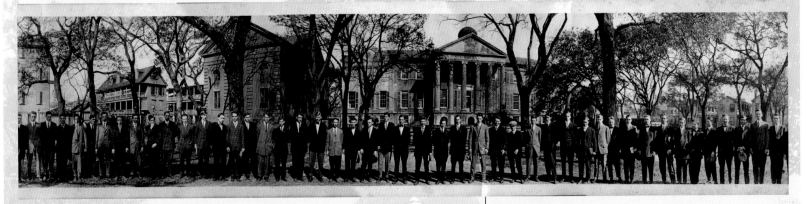

1913 Students line up for a class portrait in the Cistern Yard.

COLLEGE of CHARLESTON

2007 The College enrolls 9,989 undergraduates from across the nation and around the world.

The oldest institution of higher education in South Carolina and the thirteenth oldest in the United States, the College of Charleston's founders included three signers of the Declaration of Independence and three framers of the U.S. Constitution.

Today, the College of Charleston retains its traditions in the liberal arts and sciences while responding to the needs of its evolving student population and a changing world. With its distinctive combination of history, beauty, and cutting-edge programs and facilities, the College is among the nation's top universities for quality education, student life and affordability.

843.805.5507
www.cofc.edu

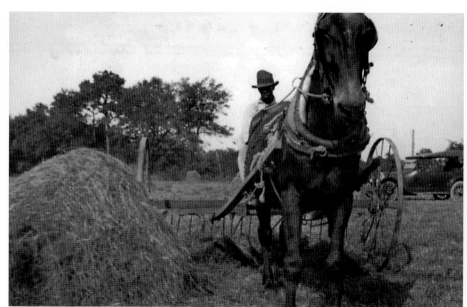

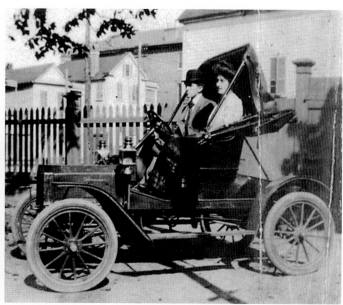

Ash Plantation ▲

In 1906 Joe Singleton was a hay reaper at Ash Plantation, a cotton plantation owned by Mr. and Mrs. E. W. King until 1958. Cotton is no longer planted there, and hay is no longer reaped by mule or horse.
Submitted by Mary K. Hatcher

Home of Dr. and Mrs. Reynolds ▷

Dr. Thomas Willard Reynolds and his wife, Katherine (Fogarty) Reynolds, made their first home at 316 Meeting St. They lived there until Dr. Reynolds died in 1916 and Mrs. Reynolds and her two sons moved in to her father's home.
Submitted by Katherine (Reynolds) Manning

The Horseless Carriage ▲

When this photograph was taken in 1907, Mr. Ford was busy making cars but it wasn't until the Model T rolled off the assembly line in 1908 that automobiles were priced to be affordable for the general population. The purchase price for the mass-produced Model T was significantly lower at $825; four years later the price had dropped to $575. The car in the photo may have been a Ford Model A, manufactured in 1903, or a Model N, which was in production in 1906. Regardless, the automobile owned by Dr. Tom Reynolds and his wife Katherine was still considered a luxury for most in 1907, but a necessity for a doctor.
Submitted by Katherine (Reynolds) Manning

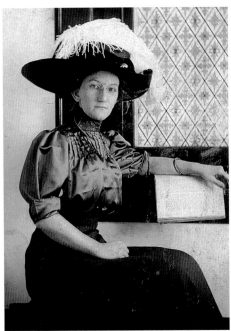

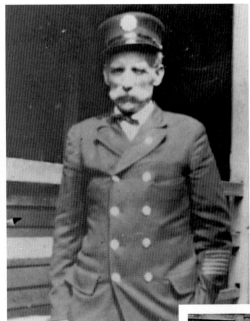

Fire Fighting Legacy ◄

Edward Able Lloyd was an engineer at Station 8 on Huger St., a station he helped to open in the early 1900s. Firemen worked five days and then had two days off; the station was truly a fireman's home in those days. Most of the equipment was horse-drawn in 1906; fires were fought by men who pulled a hose into the fire, fought it until they were exhausted, and then handed off the hose to another firefighter. Lloyd was the last firefighter to know how to use the Amoskeag Steam Pumper. He retired from the fire department in 1924 and died about a year later from black lung disease.
Submitted by Blanche Vaught Lloyd

A Proud and Proper Woman ▲

Carrie Lyerly would have been between 20 and 30 years old at the turn of the century. Although she never married, she helped to raise a niece, Evelyn Jordan, when the child's parents died. Evelyn's father was killed in World War I and her mother died at an early age due to complications with diabetes. Money was tight, especially during the Depression, but Miss Lyerly made sure manners were observed and things were in proper order. Her family affectionately knew her as "Ta."
Submitted by Page Dawsey Mann

Badham Schoolhouse at the Turn of the Century ►

A hand-drafted map created by the Sanford Insurance Map Company in 1931 shows the Dorchester Lumber Company off St. George Road in Badham, S.C., located in Dorchester County. This sawmill community had a one-room schoolhouse for all ages, shown in this 1907 photograph. Children are dressed in the best clothing for the privilege of education, even if they couldn't afford shoes. Marie Saulsbury Reeves, about 7 years old in the photo, is standing in the second row on the right, with ringlet curls. Her father worked at the sawmill.
Submitted by Louise R. McMillan

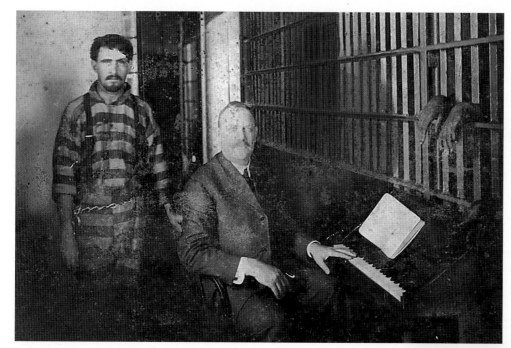

Ministering to Prisoners ◄

Charleston's Old Jail was a place most people avoided at the beginning of the 20th century, but Obadiah Dugan, the founder of Star Gospel Mission, made it a point to visit the men incarcerated there. It was a dark, dingy, foul-smelling place, with thick bars separating cells and men in chains and dirty prison uniforms, but Dugan endeavored to provide some hope by sharing the Gospel in word and song.

Submitted by William K. Christian, Star Gospel Mission

Feeding the Soul ►

The Star Gospel Mission's summer camp for girls and boys began in 1925 thanks to the generosity of John F. Ohlandt, owner of Ohlandt's Wholesale Grocery. A close friend of mission founder Obadiah Dugan, Ohlandt built the house on Sullivan's Island between Station 28 and 28 ½ on Middle St., and then donated it and the land to the mission. Faith Cottage, as it became known, ran week long camps for poor city children. Several Charleston businesses supported the camp with donations of food and milk for the children who attended. For many of these children, the opportunity made a tremendous difference in their lives.

Submitted by William K. Christian, Star Gospel Mission

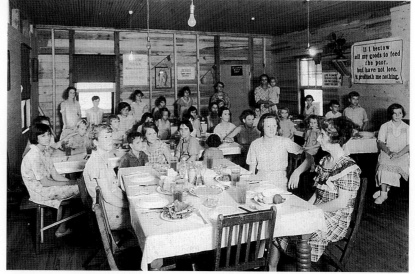

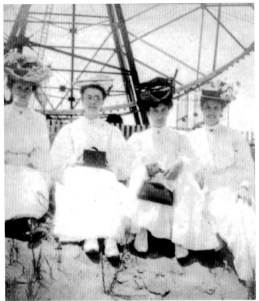

High School of Charleston Graduation ▽

The graduating class of 1909 proudly displays their diplomas, along with gifts and flowers they received for their accomplishments. The people who could be identified are: E. Weyman (left inset), most likely a teacher, Mr. Mixon in the center back row, Fred McDonald (back row, second from the right) Mr. Losse (seated on the left in the first row) and Harold A. Mouzon (seated second from the right next to a young man who is kneeling). The school is no longer in existence.
Submitted by the Sadler Estate

Isle of Palms Amusement ◁

The dress code for amusement parks at the turn of the 20th century certainly was a long cry from what it is today. It is unclear whether these ladies took a turn on the Isle of Palms Ferris wheel or not, but they seem to have brought their pocketbooks in case anyone fancied a candy apple.
Submitted by Carl E. Sohl

Prior to Remodeling ▽

The home, located at 112 Bull St., was owned by Capt. J.P. Johnson and Elizabeth (Davidson) Johnson. It is pictured here prior to remodeling when an upper porch was added. Captain Johnson, born in Oland, Sweden, was known for several remarkable feats during his career in the National Lighthouse Service, including the rescue of the master and 21 men who had been left aboard the sinking naval collier *Hector* in 1916. The house is no longer there.
Submitted by Pat Johnson

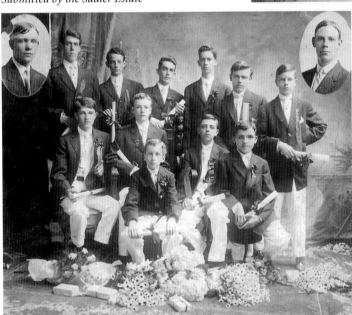

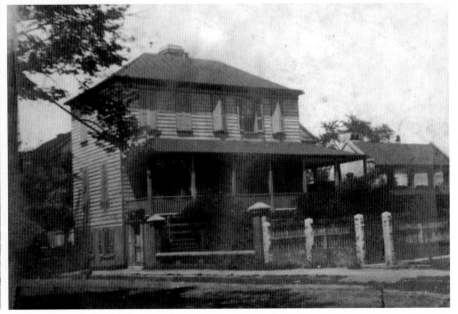

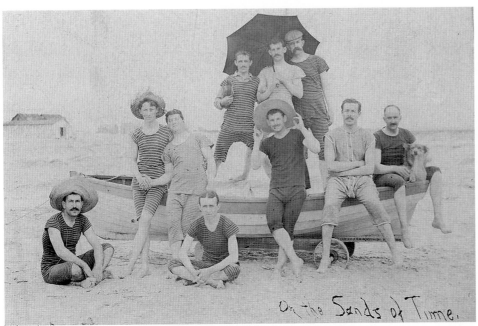

On the Sands of Time.

The Sands of Time ▲

This photo taken in 1896 by Charleston photographer William P. Dowling was featured in the book, <u>Charleston Come Hell or High Water</u>. The building in the background is the Atlantic Beach Hotel on Sullivan's Island, which was known as Atlanticville at that time. Second from the right is Montague Triest and next to him in the black "swimsuit" and hat is Melvin Israel, Montague's good friend, business partner and brother-in-law.

Submitted by Larry Freudenberg

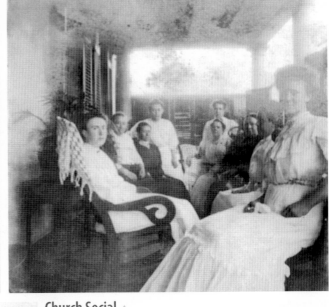

Church Social ▲

The ladies of St. Johannes Lutheran Church, 48 Hasell St., held a gathering on the upstairs porch of Meta and Louis Witt's home around 1910. The Witts lived at 504 Meeting St. on the southeast corner of Meeting and Shepherd streets. They bought the home a few years earlier in 1906; the house is still there. Meta (Mohring) Witt is pictured third from the left; the only other lady who could be identified is Mamie Anna Witt, on the far right of the photo.
Submitted by Carl E. Sohl

The Battery's Civil War Cannon ◄

Heningham Smith, on the left, stands beside an unidentified companion at one of the cannons that were placed around the Battery as fortification during the Civil War. The Battery officially opened as a public park in 1837. These women were photographed there in 1905.
Submitted by Pat Kennedy, Middleton Place Foundation

Sawmill Workers ▲

In this photo of Badham sawmill workers around 1908, the men are standing on a conveyor belt that carried cut trees into the sawmill. Workers inside prepared the raw timber to be cut into lumber.
Submitted by Mrs. Ruth (Reeves) Clark

Coming Out Photograph ▶

Forrester Rebecca (Warren) Leitch and her husband, William Wesley Leitch, are pictured after their wedding in 1900. Mrs. Leitch's mother passed away that year so, when she married, she could not wear white. The photograph commemorated her "coming out," or entrance back into society. The couple lived at 12 Sutherland Ave., outside of The Citadel in Hampton Park, an area known as "The Terrace." Other notable neighbors included the Hollings, the Condons and the Rileys.
Submitted by Gene Limehouse

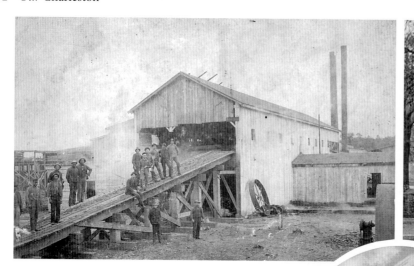

Spreading the Gospel ▲

Obadiah Dugan (right) ran a small furniture business on King prior to a religious conversion which would lead him down a different path. Often he teamed up with a traveling evangelist for revival meetings and public preaching. Dugan used horse-drawn carriages and later automobiles bearing banners such as those pictured here to conduct citywide evangelism efforts. One of the ladies is seated at a small organ, presumably as an accompanist for singing.
Submitted by William K. Christian, Star Gospel Mission

Graham Sisters' Home, Now Gibbes School of Art ▷

Thomas Graham, the only son in a family of nine children, gets a playful tousling of the hair from his sister Annie at the family's home at 76 Queen St. Their eldest sister Emma bought the vacant land for $1,200 in the late 1800s, where the family eventually built their home. Thomas worked as a pharmacist on King St. at Sweatman's Drug Store; all eight of his sisters became schoolteachers. The Graham Sisters' home is now the home of Gibbes School of Art.

Submitted by Ann (Graham) McGinnis

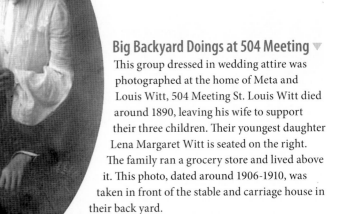

Boys on the Beach ▽

Every summer starting in June and ending when school began in the fall, Star Gospel Mission's Faith Cottage gave poor Charleston children the opportunity to spend a week at the beach swimming, exploring and playing games, and hearing the Gospel through stories and song. Camps were held for boys and girls separately, and by age groups. These boys and their counselors went swimming at Sullivan's Island one day while staying at Faith Cottage. The facility was located on what is now Middle St.; it was damaged badly by Hurricane Hugo in 1989, but not as badly as the mission's main location on Meeting St. Star Gospel Mission had no choice but to sell the Faith Cottage property for a fraction of what it would be worth today in order to keep the mission open.

Submitted by William K. Christian, Star Gospel Mission

Big Backyard Doings at 504 Meeting ▽

This group dressed in wedding attire was photographed at the home of Meta and Louis Witt, 504 Meeting St. Louis Witt died around 1890, leaving his wife to support their three children. Their youngest daughter Lena Margaret Witt is seated on the right. The family ran a grocery store and lived above it. This photo, dated around 1906-1910, was taken in front of the stable and carriage house in their back yard.

Submitted by Carl E. Sohl

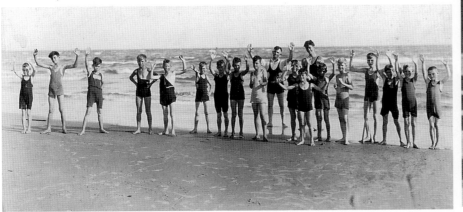

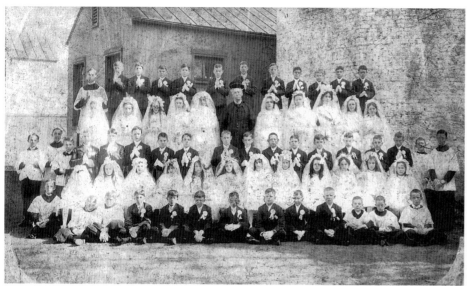

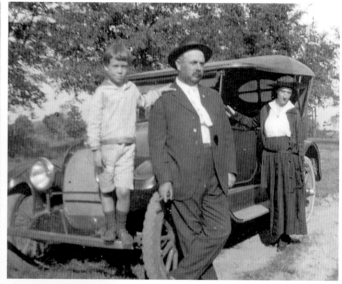

St. Joseph's Catholic Church ▲

This photo, taken April 18, 1909, commemorated the First Communion and Confirmation Class of the old St. Joseph's Catholic Church on Anson St. The building is still there, but the church moved to West Ashley in the 1960s. Katie Lighthart is pictured in the first row of girls, sixth from the left.
Submitted by Rose Mary Chapman Willson

Adams Run's First Automobile ▲

Mr. and Mrs. Ernest W. King and their son Ernest, Jr. were proud of the first car in Adams Run in 1906. The Kings owned Ash Plantation, on the Toogoodoo River. The family sold the plantation in 1958 and moved to Charleston.
Submitted by Mary K. Hatcher

Rhoda and Friends ▶

Rhoda Lyerly, or "Kay," as she was called, stands with two unidentified friends sometime around 1900. Rhoda, in the center, lived with her parents Robert and Julia (Welch) Lyerly on King St. She lived to be 92 years old.
Submitted by Page Dawsey Mann

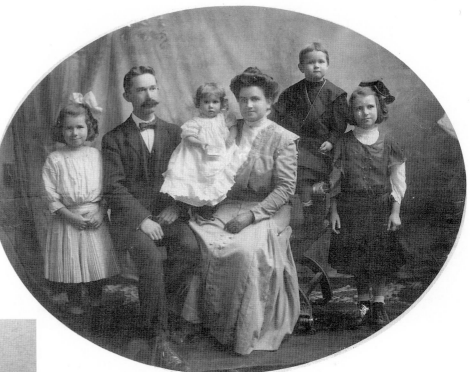

On Parade ▼

Charleston was famous for its parades, and decorated automobiles were center stage for turn-of-the-century extravaganzas. Nothing is known about this photo; the only clue seems to be the Quaker Oats man on the building to the left. Quaker Oats officially became a company after several oatmeal millers merged in 1901. Prior to that, however, Quaker Mill in Ravenna, Ohio had trademarked the jolly symbol of warm breakfasts around 1877. This photo could be as old as the late 1800s or sometime around the early 1900s.

Submitted by Mrs. John Witsell

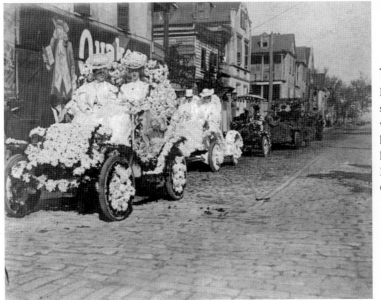

Turn-of-the-Century Family Portrait ▲

Photos were not as easy to come by in the beginning of the last century; when a family, such as that of Theodore A. and Alice (Mustard) Smith, sat down in front of a camera, it was for posterity. Their best clothing was worn on that day. Children wore bows in their hair. Women wore gloves. This was a visual record of their existence. The children, from left to right, are Lucille (Smith) Schirmer, Allie (Smith) Spencer, Milton A. Smith and Peirrine (Smith) Byrd, who grew up to become the first woman graduate of the College of Charleston. *Submitted by June S. Schirmer*

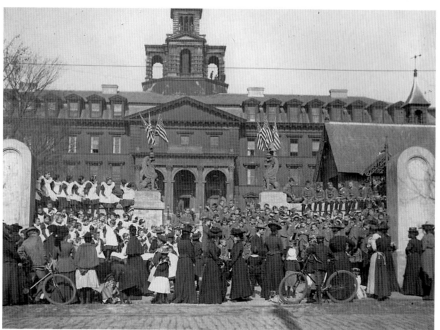

Charleston Orphan House ◄

Every year the city of Charleston celebrated the anniversary of the founding of the Charleston Orphan House with a glorious parade. Girls on the left, dressed in their Sunday best, and boys on the right, in suits and knickers, participated in the festivities along with local dignitaries and brass bands. The Charleston Orphan House, America's first publicly funded orphanage, took up an entire city block. The facility cared for orphans and children whose parents found themselves in desperate financial circumstances. The building was demolished in 1951 but one of the Orphan House residents, Tom King, captured the building on canvas. His work now hangs in the Carolina Youth Development Center in North Charleston.

Submitted by Kate Lloyd courtesy of CYDC

Canoeing at Otranto ▶

The lake behind Otranto Plantation was a favorite spot for the de Saussures to spend the day. Mary (Sinkler) de Saussure and her son, Henry William de Saussure, took the boat out for a spin around 1910. Mrs. de Saussure's husband, a doctor, died in 1898 of yellow fever, which he contracted tending to patients. Mrs. de Saussure wore black and widow's weeds for the next 25 years, the remainder of her life. Weddings were the only exception to black garments in public, when she would wear lavender. Widow's weeds were head-to-toe lace veils worn by widows at that time. When Mrs. de Saussure stumbled over her ankle-length veil and almost fell at church one day, her son informed her that "enough was enough." She cut back on the widow's weeds, at his insistence.

Submitted by Mary L. McQueen and Henry de S. Copeland

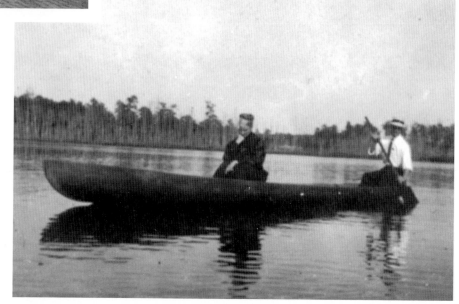

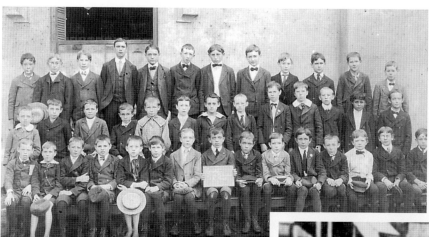

Courtenay Public School ▲

William Ashmead Courtenay, mayor of Charleston from 1879 until 1887, was a strong proponent of education. Built in 1888, the school which bears his name was originally located on upper Meeting St. This photo probably represents the entire school at that time, around 1905. Harold A. Mouzon, holding the sign on the front row, is pictured with schoolmates.
Submitted by the Sadler Estate

Life in Badham ▷

Lula (Reeves) Saulsbery would have been in her mid-30s at the time of this photo in 1908. She married John Jacob Saulsbery, who worked at the sawmill in town. Badham itself was nothing more than a collection of sawmill employees not far from Ridgeville in Dorchester County. Mrs. Reeves died just short of her 44th birthday.
Submitted by Mrs. Ruth (Reeves) Clark

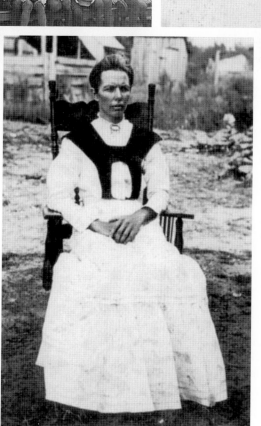

Backyard Picnic ▲

Katie Thuralt (left), Laura Clement, Kitty Unfug, Bessie Anthony, Marie Thomas, Lizzie Craig, Dora Unfug and little John Thomas in front picknicked in downtown Charleston in someone's back yard around 1908. Marie Thomas met her husband at a reunion of his Confederate unit in Hampton Park when she was 17…and he was 62. They married the next year and Marie was widowed at age 20. John Thomas was the couple's only child.
Submitted by Edith T. Dixon

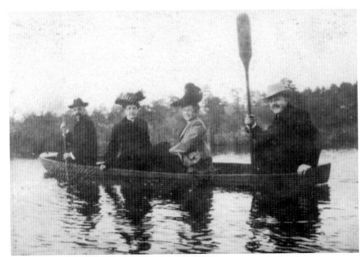

Paddling Around Goose Creek ◀

This photo, taken from the banks of Goose Creek, dates back to the late 1890s when the Simons family used to picnic at Otranto on Goose Creek. Their grandfather was one of the heirs of Otranto Plantation and the family gathered there regularly with friends.
Submitted by Carlton Simons

Confirmation Class ▲

This picture, taken by photographer D. M. Bahr on April 10, 1903, shows the confirmation class of St. Matthew's German Lutheran Church. The photo was taken on the side of the church, located at 405 King St. The children would have been around 15 years of age at the time. Fred C. Sohl is on the back row, far left. The Rev. William Mueller was pastor of the church.
Submitted by Carl E. Sohl

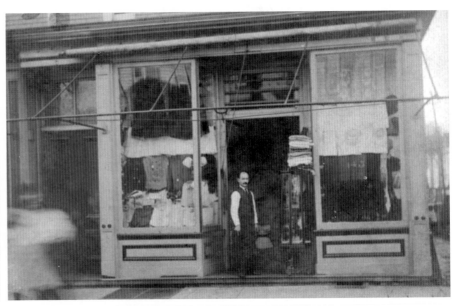

C.H. Nachman & Son ▲

Charles Nachman owned a dry goods store on the corner of King and Queen in the 1910s and '20s. Manning Bernstein lost his father at an early age; Charles Nachman was the only father he ever knew. Bernstein worked with Nachman in the store until around 1927. The family lived above the store at 143 ½-145 King.
Submitted by Charles S. Bernstein

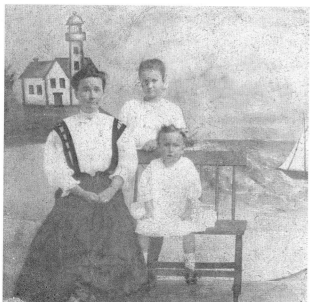

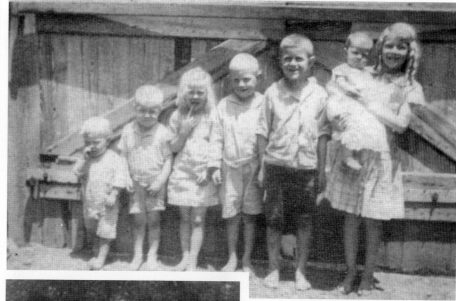

The Woodward Family ▲

Mrs. W. W. "Minnie" Woodward and her daughters, Willie Lee, age 8, and Mildred, age 2, frequently vacationed at Isle of Palms in the early 1900s. Mrs. Woodward's husband, William, was a contractor in Augusta, Ga.; the family took the train to Charleston and then the trolley to Isle of Palms.
Submitted by Candie Johnson

Picnic in The Park ▶

It appears the photographer caught Mary (Burnham) Andrews unprepared for the picture; she is adjusting her skirt while her brother Dr. Edward Burnham, a pharmacist, apparently was put in charge of her parasol. The photo was taken during a family picnic in Hampton Park, May 6, 1911. Hampton Park, just 10 years earlier, was the site of the South Carolina Interstate and West Indian Exposition from Dec. 1, 1901 until June 20, 1902.
Submitted by the Sadler Estate

Seven Sanders ▲

William August and Lina Sander were quite proud of their seven children. Mrs. Sander's half-brother, George Busch, shared their devotion; it was his camera that recorded much of the youngsters' childhood. From left to right, Adolph, Henry, Louise, Billy, Louis, Alvena and baby Dorothy line up at the wooden gate of their home on the corner of Line and Coming streets to have their photo taken around 1918. Mr. Sander, a German emigrant at age 16, purchased the house and store at 267 Coming St. in 1900. In the back of the L-shaped lot was a warehouse and space for a cow and chickens. The building is still there but the wooden gate is gone.
Submitted by Joan Seithel

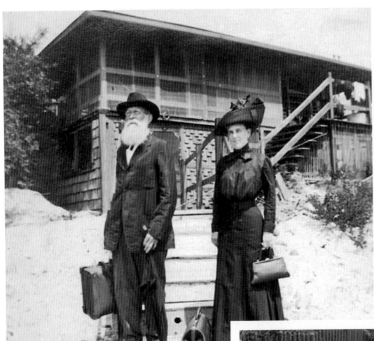

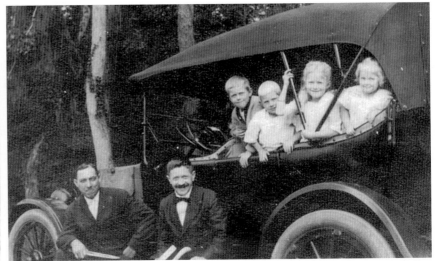

REO Speed wagon ▲

R.E. Oldsmobile Co., that is. A newly purchased automobile was a big event for any family in 1918. In those days there was no such thing as a driver's license. The person who sold the automobile took its purchaser for a ride and taught him how to drive. Mr. Ostendorff (seated at the far left), a car salesman at Palmetto Garage on Hayne and Pinckney streets, sold William Sander (seated next to him) the brand-new car and everyone went along for the test drive. Inside the car, from left to right, are Louis, Billy, Alvena and Louise Sander. The car, which came equipped with jumper seats, was used to take Mr. Sander's seven children, plus four or five more kids, to Sunday School at St. Matthew's Lutheran Church.
Submitted by Joan Seithel

Visiting the Beach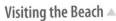

Although they do not appear to be dressed to visit the beach, Noah G. Osteen and his wife, Ester Ann, were wearing what would have been appropriate for 1911. They had been visiting family friends, the Wellings, at Sullivan's Island and were probably dressed and packed for the return trip to their home in Sumter.
Submitted by Betty McMichael

Special Delivery ◀

The family lived at 548 Meeting St. and it was Henry's job to hitch up the goat and deliver Mrs. Buckheister's fresh-baked bread to customers in the neighborhood, within a five- or six-block area. The photo was taken around 1912; Henry would have been about 12 in the picture. The age of the goat is unknown.
Submitted by H. E. "Dutch" Buckheister

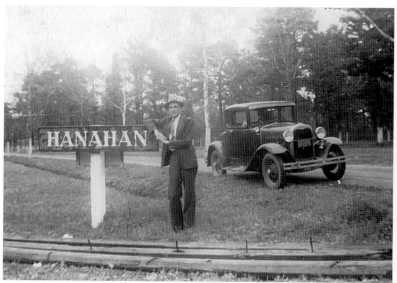

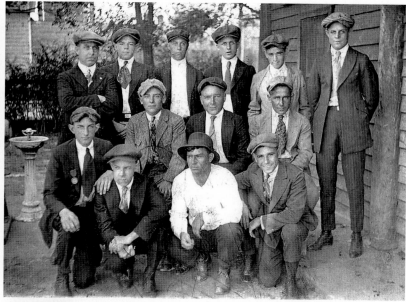

Welcome to Hanahan ▲

Jesse Tolbert, Sr. stood beside the first Hanahan sign in 1919. Since its beginnings, Hanahan has grown to a town with a population of roughly 13,000.
Submitted by Donna Hill

The Snow of 1912 ▶

What a treat for Southern children, whose experience is primarily sand and not snow. These children (and adults!) were taking advantage of the rarity on King St., near Huger. Everyone had to be properly attired, of course, which included hats, coats, scarves, mittens and/or muffs.
Submitted by Betty McMichael

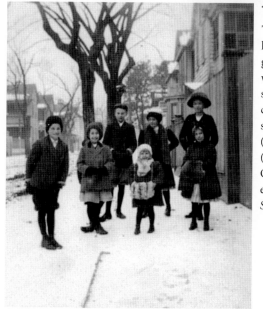

Team Photo ▲

The baseball team posed for a photo in coat and tie, and apparently hats were required as well. The photo was taken on Mitchell playground around 1915-17; Sheppard St. is visible in the background, as well as one side of the playground Field House. Although most of the structures in the background were eventually torn down when the crosstown was built, there is a corner of a house pictured that still stands today. Those who could be identified in the photo include: (front row, left to right): Leroy Axson, Fritz Strobel, Leroy Kanapaux (second row, left to right): Stanley Sigwald, Archie O'Connor, Mack O'Conner (top row, left to right): George Kilpatrick, Johnny Stehmeyer, George Weeks, Willie Kanapaux, Teddy Weeks.
Submitted by William J. Kanapaux, Jr.

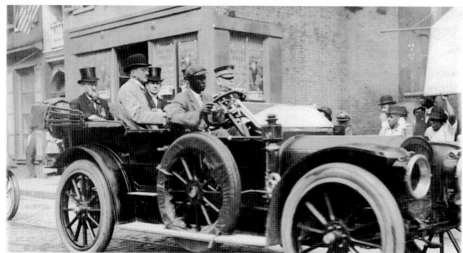

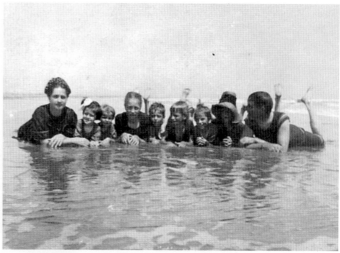

Dignitaries In Charleston ▲

Invited dignitaries such as Connecticut Governor Baldwin and Mayor Smith of Hartford, Conn., took part in a parade Oct. 11, 1911 with Mayor Rhett of Charleston. It is uncertain where the parade took place, although every parade went down King St. at that time. The window signs on the building in the background advertise matinee prices; perhaps it was one of Charleston's many theatres at the beginning of the 20th century.
Submitted by Roulain J. DeVeaux

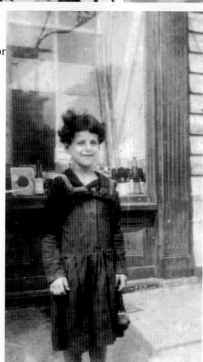

Wellings in the Water ▲

Pictured here on Sullivan's Island, August, 1911 are Mr. and Mrs. E. M. Tiller and family and some of the Welling children. The two families were relatives.
Submitted by Betty McMichael

Hyman Lipman's Grocery Store ◄

Ann Lipman, 7 years old, stood in front of the grocery store her father owned on America St. near Amherst around 1919. Ann attended Memminger School and grew up to marry Frank Seigel. The two lived their entire married lives in Charleston, attending Temple K. K. Beth Elohim where Ann was an active member of the Sisterhood and Frank was president of the Brotherhood. Their son, Robert, was the first South Carolina native to become a rabbi.
Submitted by Robert A. Seigel

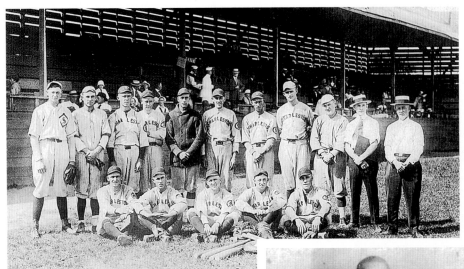

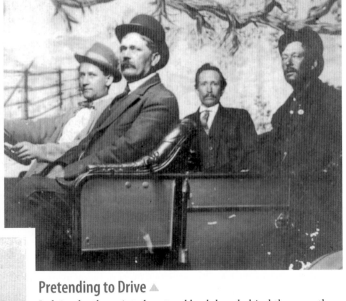

Charleston City Leaguers ▲

Pitcher James D. Reeves, at the far left of the photo, was known as "Bullet" because of his fastball. Still in the family are Bullet's glove and two of his trophies: one for the team league championship in 1919, and an individual trophy for "Leading Base Stealer" in 1927. College Park, located at the intersection of Rutledge Ave. and Moultrie St., was the scene for many baseball games at that time. City baseball leagues, some minor league professional baseball teams and The Citadel baseball team used College Park. Although the ballpark still exists, it is no longer used. Riley Park, adjacent to Brittlebank Park, replaced College Park as the city's premier baseball field and stadium.
Submitted by Brian Connor

Pretending to Drive ▲

Judging by the painted pastoral backdrop behind these gentlemen, this appears to be a staged photo in a studio. Unless Henry Fred Witt is driving a British automobile, the placement of the steering wheel would indicate the photo was printed in reverse. The photo is dated around 1910.
Submitted by Carl E. Sohl

In the Army Now ◀

Christopher A. Turner, or "Uncle Mike" as the family called him, was about 24 when he enlisted in the army. He had his photo made at a professional studio to commemorate the event.
Submitted by Cynthia (McCottry) Smith

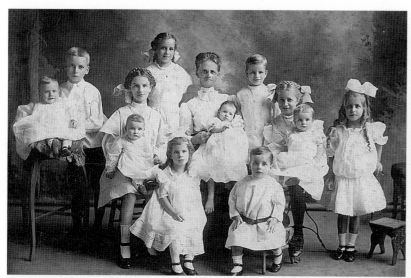

Grandmother's Pride and Joy ▲

Mrs. W. R. Welling, known to her grandchildren as Grandmother Middy, must have been honored to have her photo taken with her grandchildren in 1911. From left to right: Elizabeth Gayer, Welling Gayer, Dorothy Melchers, holding Virginia Melchers on her lap, Ida Welling, left front row, Will Ellerby on Grandma Middy's lap, Margarete Welling behind Mrs. Welling, Eugene Welling to the right of his grandmother, Emma Welling holding Marie Welling, Edwin Welling on the front row, right side, wearing a belt, and Marion Gayer, far right.
Submitted by Betty McMichael

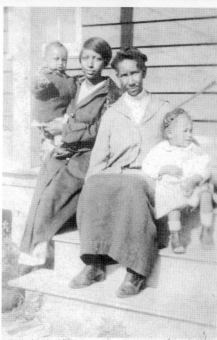

Summerville Graded School, circa 1910 ▲

Because many grade levels (Grades 1 through 11) were housed in the building, Summerville Graded School differed from a school in which several grades were taught in one room. A photo session was a special event in those days, but appropriate attire would have been observed any day of the week: dresses for female teachers and coats and ties for male teachers. Six chimneys are visible in the photo; rooms would have been heated with either coal or wood-burning stoves in each classroom. The building was torn down in the 1950s and the site on Laurel St. is now the Saul Alexander Playground.
Submitted by Mr. and Mrs. Harold E. Robling

Turner Home on Mary St. ◄

When Mary Heyward Turner's husband died around 1912, Mary (second from right) raised the family on her own, with the other children's help. Turner (left), Lucille, who finished Avery Normal Institute in the early 1900s and taught school, and Ruth (on the right) are pictured here in 1919.
Submitted by Cynthia (McCottry) Smith

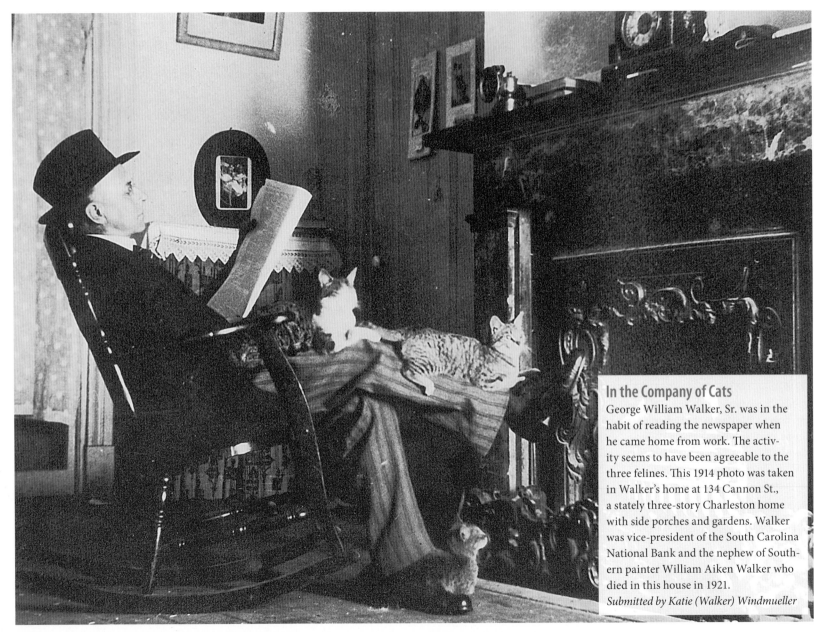

In the Company of Cats

George William Walker, Sr. was in the habit of reading the newspaper when he came home from work. The activity seems to have been agreeable to the three felines. This 1914 photo was taken in Walker's home at 134 Cannon St., a stately three-story Charleston home with side porches and gardens. Walker was vice-president of the South Carolina National Bank and the nephew of Southern painter William Aiken Walker who died in this house in 1921.
Submitted by Katie (Walker) Windmueller

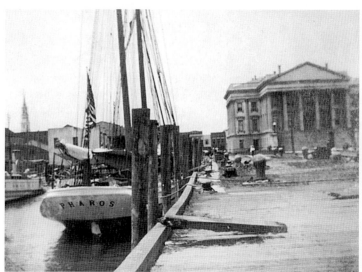

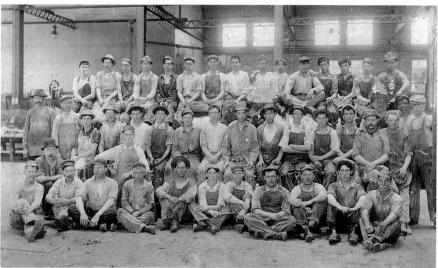

Water Lapping at the Foot of Market ▲

In 1906 the Custom House, a tribute to Roman Corinthian style in white marble, was located nearer the water than it is today. Today's Market St. was a canal at one time; it was a busy place where boats such as the Pharos came and went. St. Philip's Church steeple is visible in the background.
Submitted by Katherine (Reynolds) Manning

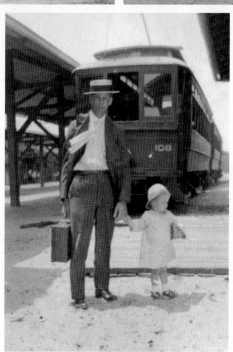

Hot Work, If You Can Get It ▲

This photo, taken around 1918, commemorated Robert Flagg Ilderton's promotion to Master of the Boiler Shop at the Charleston Naval Shipyard. Ilderton is pictured in the center of the second row, wearing long sleeves and a badge. In those days Navy ships used boilers, not electrical motors, as a means of propulsion. Ships burned fuel to feed the boiler, producing steam that turned the turbines, which then turned the ships' propellers. Boiler Shop work was hot and exhausting, a combination of labor in the open-air shop fabricating the materials required for the boilers aboard Navy ships, as well as shipboard welding. These civil servants were literally the driving force behind the fleet at the beginning of the 20th century. To celebrate Ilderton's promotion, the crew presented him with a gold Masonic ring.
Submitted by Robert W. Bullwinkel

Taking the Trolley at Isle of Palms ▶

John R. Johnson and his son George spent the day at Isle of Palms in 1918. Trolley cars met the ferries that operated during that time and took people over to Sullivan's Island and on to Isle of Palms until 1927.
Submitted by Roulain J. DeVeaux

The American Restaurant ▶

Minnie Green, a teenager at the time, stands in front of her father's restaurant at 229 Meeting St. The American Restaurant, one of several businesses owned by her father, was one of only three restaurants in Charleston at that time. The World War I poster displayed prominently in the window of the family restaurant reads, "See Him Through. Help Us To Help The Boys. National Catholic War Council, Knights of Columbus, United War Work Campaign—Week of November 11, 1918."
Submitted by Marjorie Shook

Burnham Family Gathering ▼

It's unclear what was on the menu for the buffet-style lunch in 1911, but it apparently met with everyone's approval. The family outing was held May 6 at Hampton Park. Before the Civil War, a jockey club used the property as a racetrack; the road around the park is exactly one mile long.
Submitted by the Sadler Estate

Marle's Bakery ▼

Gustave Marle (second from left) was trained as a baker in Germany. When he settled in Charleston he opened a bakery at 14 Queen St., near the corner of State St. Marle's Bakery was well-known in town in 1916; his customers, many of them German as well, loved his pumpernickel and rye breads. During the holidays it was Marle who made everyone's fruit cakes. The children especially enjoyed his sweet horse cakes, so named because they were in the shape of a horse. The boys helped him bake and deliver his bread. The business closed in 1957 when Marle retired; the address is now a residence. Pictured far left is Clemens Marle; next to Gustave is Carl Marle and on the right is Gus Marle.
Submitted by Mary Ann (Marle) Camp

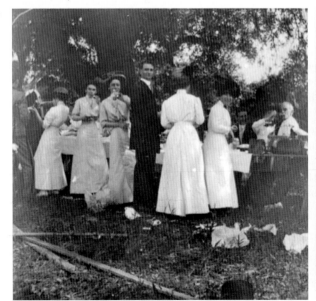

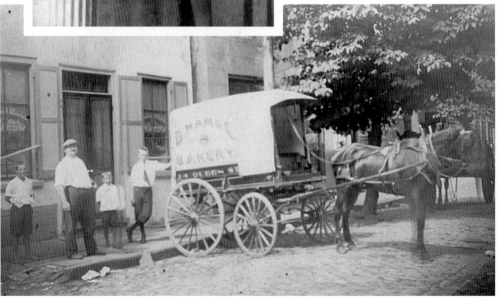

Harold's Cabin ▶

Named by Harold Jacobs' father, Samuel Jacobs, the small wooden framed building at Congress and President streets was 15-year-old Harold Jacobs' first business venture. Harold's mother, Mignonette, is pictured in the doorway. She ran the store while her son attended the High School of Charleston on Rutledge Ave.; Harold took over in the afternoons and on weekends. The store began as a snow-ball stand, selling three- and five-cent snowballs, shaved ice with flavored syrups of chocolate, vanilla and strawberry. Every morning the Southern Ice Company delivered a 50-lb. block of ice by horse-drawn wagon. The cost was 50 cents. The Nehi Company made the sign for the entrepreneurs; the business started with a loan of $25 from Hyman Karesh, who owned the Star Bargain House.
Submitted by Harold Jacobs

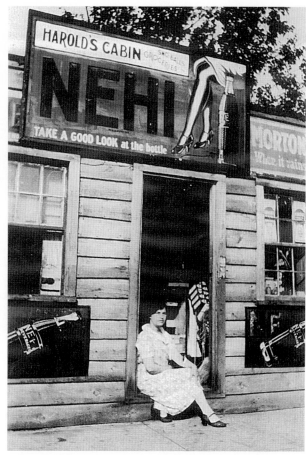

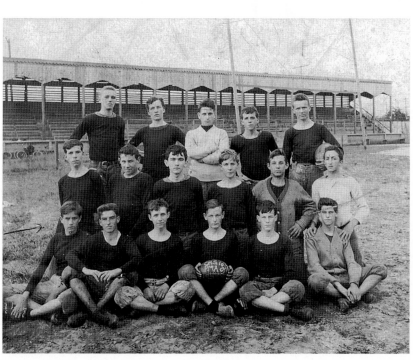

Charleston High's Football Team, 1911 ◀

Chesnee Cogswell (bottom row, left) was about 15 years old the year Charleston High skunked Porter Military Academy 16-to-1. After high school Cogswell attended The Citadel. He joined the Marines after graduation in 1917. Cogswell was awarded the U.S. Distinguished Service Cross award, the second highest award given by the Army for valor, and the U.S. Navy Cross, the second highest award given by the Navy.
Submitted by Edna Cogswell Staubes Roberds

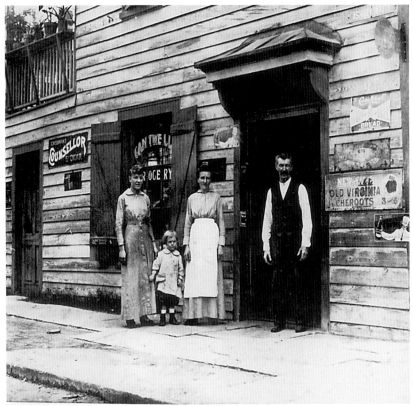

Cantwell's Grocery, 80 Ashley Ave. ◄

Cantwell's Grocery was located at 80 Ashley Ave. around 1915. The store's exterior was as much signage as siding, indicating an assortment of tobacco products for sale: Cressman's Counsellor Cigars, Stag Tobacco, Old Virginia Cheroots. A "cheroot" is a non-tapering, cylindrical cigar. The word is derived from the French word, "cheroute," which means "roll of tobacco." Soda pop and bread also were available inside. Hattie, Mildred, Meta and Diedrich Holling pose for a photo on the sidewalk in front of the store.
Submitted by Joy Bold

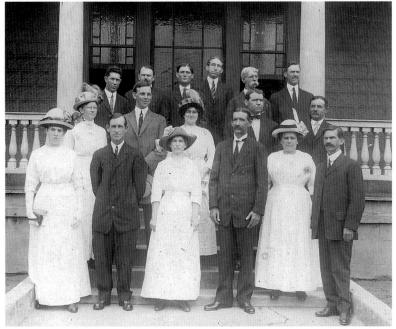

First Christian Church, 1911 ▶

The church, founded in 1897, was located at 172 Calhoun St. at the time of this photograph. Those who could be identified in the photo are, first row, left to right: Mrs. T. T. Bill, David M. Leitch, Mrs. W. J. Hilton, Joel Dermid, Mrs. Brunson and the Rev. William Brunson. Second row: Mrs. Hogg, (an unidentified man), Mrs. Welchel, (an unidentified man) and Capt. J.P. Johnson. Third row: (man on left is unidentified), Charles Svedberg, Phillip Brooks, Mr. Pine, David McDougall and J.E. Rourke. The church moved to Orange Grove Road in 1974.
Submitted by Pat Johnson

Established September 20, 1883, Berlin's was founded by Henry Berlinsky, who came to the United States from Eastern Europe with $1.38 in his pocket. In 1912, the business was turned over to Sam and Ben Berlin, sons of the founder. When Ben settled in New York in 1914, Sam Berlin took charge and the partnership was dissolved in 1932. In September, 1927, the store was enlarged by adding a two-story annex. In 1958, Sam Berlin retired and Henry Berlin joined his brother Alwyn in the firm. Alwyn died in 1978, and today Henry's son and daughter, Steve Berlin and Elaine Berlin, continue to operate the oldest establishment of its kind in South Carolina.

Steve Berlin Henry Berlin Henry Berlinsky Sam Berlin Alwyn Berlin

King at Broad Street, Charleston, SC

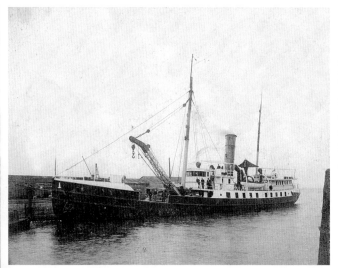

National Lighthouse Service ◄

The U.S.S. *Cypress* was in the National Lighthouse Service, which later became part of the Coast Guard. Her duties were to check navigational areas, buoys, lighthouses and aid boats in distress, rescuing people as necessary. *Submitted by Pat Johnson*

Captain of the U.S.S. Cypress ◄

John Peter Johnson, pictured here Aug. 13, 1938 in front of his home at 112 Bull St., was master of the lighthouse tender *Cypress* for 23 years of the 49 years he spent in the National Lighthouse Service. Captain Johnson's career was dotted with remarkable feats including the rescue of 96 Sullivan's Island residents during the hurricane of July 1916. On May 4, 1918 he took the unarmed *Cypress* in search of an enemy submarine with the words, "I am ready to go." *Submitted by Pat Johnson*

The Battery, circa 1911 ►

Sailing freighters were a common sight in the harbor in the early 1900s, ferrying goods in and out of Charleston. J. Clyde Leitch, age 5, and his brother Wesley, age 2, were visiting the Battery and the photographer happened to include a freighter passing by in the background. *Submitted by Gene Limehouse*

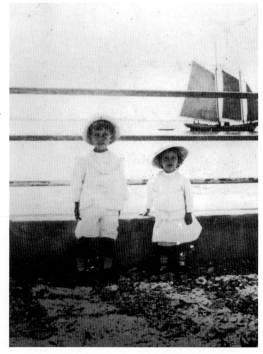

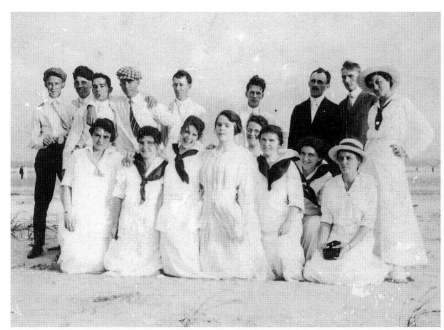

A Day at the Beach ◀

Loretta Leonard (front, third from the right) spent the day at Folly Beach with this group of young people sometime around 1915. Loretta was one of six girls in the family of John L. and Mary (Molony) Leonard. She would have been about 20 years old at the time.
Submitted by Joseph Lucas

Boys Will Be Boys ▼

The islands around Charleston were as much summer destinations 100 years ago as they are now; these boys, pictured in their swimsuits in August 1910, are having a bit of fun demonstrating their "gymnastic" ability.
Submitted by the Sadler Estate

Ocean Breezes ▶

Hats and scarves were at the mercy of the prevailing winds on the Isle of Palms in this photo of unknown date. The structure in the background was built to take advantage of the ocean breezes, however, with a wrap-around porch of significant size. Only two of the four people can be identified: Mande Jones and A. Jasch.
Submitted by Janet Creel

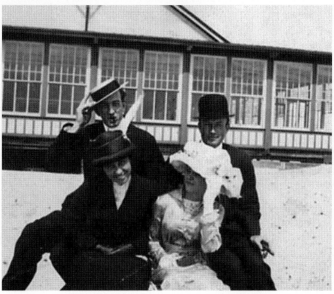

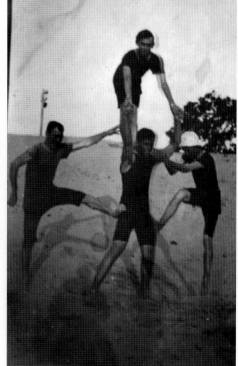

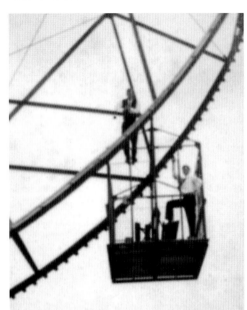

Isle of Palms "Thrill" Ride ▲

This photo, dated spring of 1911, must have been taken while the amusement park on Isle of Palms was under construction. The island became a destination for Charleston residents looking to escape summer temperatures in the late 1800s. As transportation became more accessible via a ferry to Mt. Pleasant and a trolley car to Sullivan's and Isle of Palms, interest in the island grew. James Sottile completed construction of a beach pavilion and an amusement park by 1912; the Ferris wheel was a part of that park, according to the city's website. One gentleman hangs from a beam on the ride while another man poses "safely" inside the open, plank-floored car.
Submitted by the Sadler Estate

Standard Oil Company ▲

The grounds of Standard Oil Company on upper Meeting St. Extension used to be a local hangout on Sunday afternoons. People were allowed to go onto the property and walk around. May Parker (left) and Marie Saulsbery (right) are pictured here with an unidentified gentleman in 1919.
Submitted by Mrs. Ruth (Reeves) Clark

Before the Storm ▶

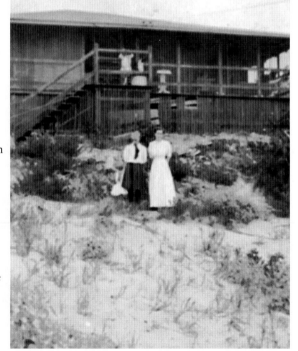

The Wellings lived at Station 28 on Sullivan's Island when this photograph was taken Aug. 15, 1911. The house was a typical island dwelling, according to Edwin Welling's journal: one story high, resting on pilings. There was a large room underneath the house in the center of the building. Edwin Welling was just 6 years old when one of the worst storms to hit Charleston came through two weeks later. The house was sheared off its foundation, leaving only the small room underneath the house where the family had sought shelter. The next day the Wellings were moved to Fort Moultrie, and then to safety in Charleston.
Submitted by Betty McMichael

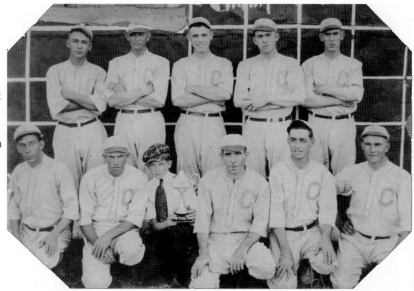

Baseball Champions ▷

These gentlemen earned the right to call themselves Charleston City Champions in 1919. Pictured on the back row, third from the right is John Joseph White.
Submitted by Joe and Ceanne White

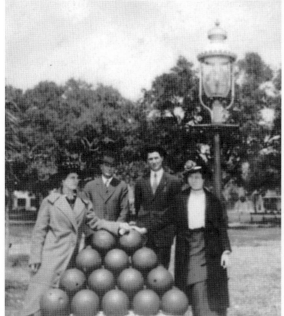

Making Sure the Ammo Doesn't Roll Away ◁

These folks, who could not be identified, took a turn holding down that stack of cannon balls at White Point Gardens on the Battery. The photo is dated 1918.
Submitted by Louise Sloan

Photo for a Navy Yard Badge ▷

The date on this badge photo indicates that Joseph Lucas began work at the Charleston Naval Shipyard on Nov. 17, 1917. Lucas moved from Florence, S.C., to work in Charleston as a ship fitter, building hulls and doing structural work on ships during World War I. He married Loretta Leonard in 1919 and the couple made their home on Reid St.: first at 33 Reid St., then 53 Reid St., then 60 Reid St. and later, 50 Reid St. They liked the neighborhood. Lucas worked in later years at Standard Oil Company on Meeting St. but wound up back at the shipyard around 1939 during World War II.
Submitted by Joseph Lucas

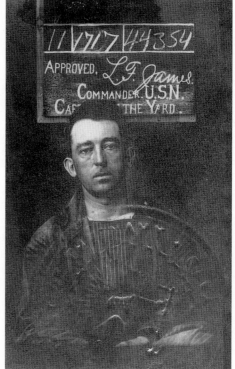

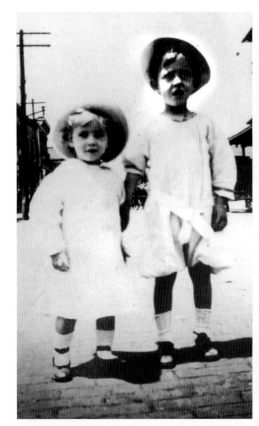

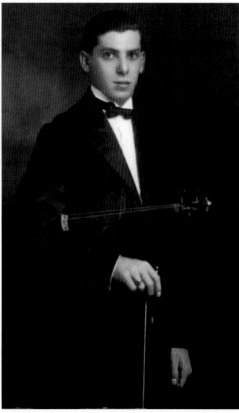

Violin Virtuoso ◄

Harry Berendt, pictured at age 19 in 1918, played violin for the Charleston Symphony. Harry used to perform for family gatherings; his daughter still has his violin and bow, hanging on her dining room wall.
Submitted by Susan Ziman

Welling Beach Photo ▼

Dorothy Melchers (left) Manita Osteen, Lily Melchers, Emma and Marie Welling enjoyed Sullivan's Island living in August, 1911.
Submitted by Betty McMichael

The Leitch Boys ▲

W. Wesley Leitch, age 2, and his 5-year-old brother J. Clyde Leitch (right) were ready to do a little shopping on King St. in 1911. The Leitch family lived in Hampton Terrace.
Submitted by Gene Limehouse

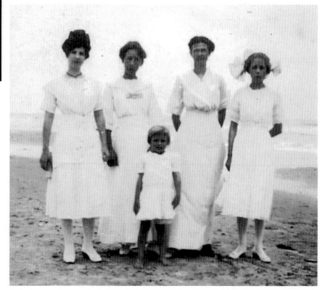

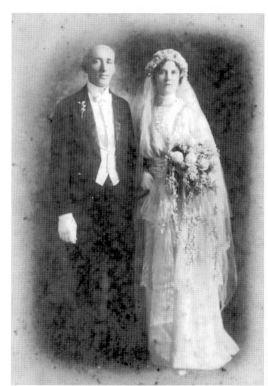

The Wedding of Sohl and Witt ▲

Fred Claus Sohl, 26, married Mamie Anna Witt, 29, on Oct. 14, 1914. The wedding ceremony, held at St. Johannes Lutheran Church on Hasell St., was officiated by Pastor H.J. Black.

Submitted by Carl E. Sohl

The Front Garden of Courthouse Square ▼

Katherine (Fogarty) Reynolds, pictured here with her sons T. Willard (left) and John Fogarty Reynolds, moved back into her father's home at 8 Court House Square with her brother when her husband died in 1916. The boys were 8 and 6 years old at the time. In the background the Courthouse Alley tenements are visible. Members of the Reynolds family continued to live in the house until 1955 when the property was sold. The house was moved to Broad St.; the site where the home once stood is now the court house complex.

Submitted by Katherine (Reynolds) Manning

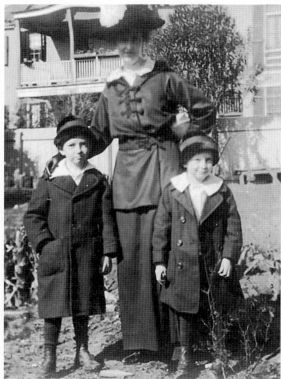

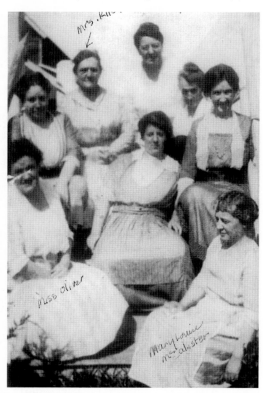

Jasmine Club ▲

Charleston is connected by bridges of one type or another, but these women were connected by a different sort of bridge: the card game. In the late 1800s this group of eight Charlestonians, including the great-grandmother of Mayor Joe Riley, got together on a regular basis to play bridge. Mrs. Riley is pictured third from the left, near the top of the steps. Miss Oliver is at the bottom left; Mary Louise McAlister is at the bottom right.

Submitted by Louise Bennett Doyle

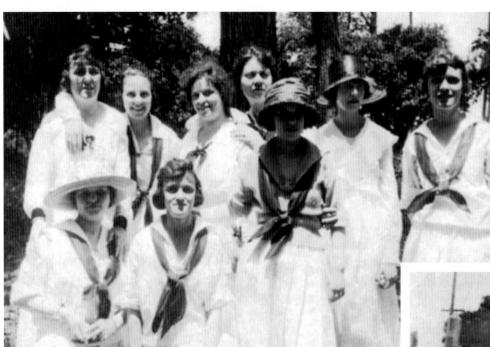

Island Outing with a Family Friend ▼

Both Elizabeth (left) and Mary de Saussure were fond of "Osborne," as he was known. "Osborne" was a student at the Medical College of South Carolina (now MUSC) who boarded with Henry William de Saussure and his wife Margarette Whitaker de Saussure at 89 Rutledge Ave. It was not uncommon for local doctors, and especially professors at the Medical College to offer rooms to out-of-town medical students.

Submitted by Mary L. McQueen and Henry de S. Copeland

Yeomenettes ▲

Because of the Navy's critical need to deploy enlisted men to sea during World War I, active duty women Yeomenettes were employed at the Navy Yard in Charleston. These women performed clerical duties for the most part; they were required to wear uniforms and were paid for their services. More than 11,000 women served in the capacity before the end of the war. Nora M. O'Conner (back row, far left) had just begun at the Navy Yard in 1918 as a phone operator; it was she who received the call announcing the end of World War I. Her sister Margaret is next to her on the back row; the fourth person from the left on the back row is Edith White, a neighbor on Anson St. at the time.

Submitted by Louise Sloan

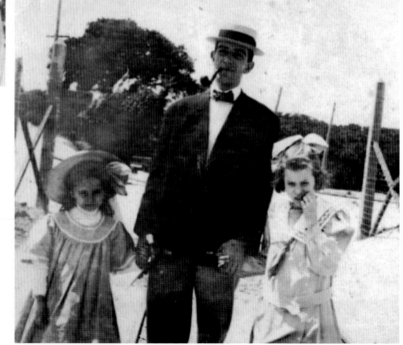

Supplying paint to Charleston for 93 years!

Charleston Paint Company, selling Benjamin Moore Paints since 1914, is owned and operated by father and son, Gerry and Andy Blanton. Recognized by Benjamin Moore for over 50 years of service, Gerry and Andy have over 60 years combined experience in the paint mixing industry. Bicycle delivery was offered to homeowners and contractors from the late 1940's until the mid 1960's. Charleston Paint Company still delivers custom paints to their valued customers today.

CHARLESTON PAINT COMPANY
522 King Street *Est. 1914* **577-6581**

Benjamin Moore®
Paints

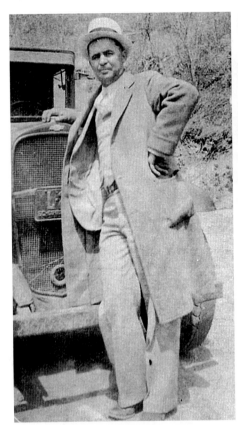

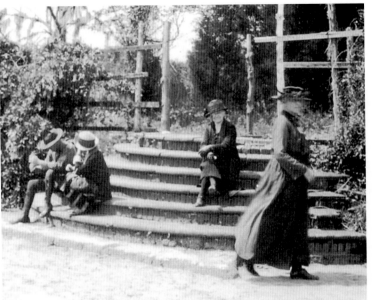

Middleton Place, 1923 ◄

The stone steps in front of the ruins of the old residence at Middleton Place were the subject of this photo in April, 1923. The main house and north flanker were referred to as the "ruins" since 1865 but the current house museum is the south flanker, which was restored in 1869-70. Middleton Place was last occupied by family in the early 1970s. The Middleton Place Foundation was established in 1974 and the house opened for tours in 1975.
Submitted by Pat Kennedy, Middleton Place Foundation

Just Two Buddies at the Beach ►

Charles Dawson (left) and his pal, Claude Landers, took a breather at Folly around 1925. Dawson worked for the Charleston Transfer Company on Pinckney St. for several years in the early 1900s and later operated his own ice cream shop on King St. Charles and his wife, Madeline Hoyt Spinney Dawson, had five children; they visited Folly Beach on a regular basis. Dozens of family members are still in the area today.
Submitted by Barry Bessinger

Unofficial Mayor of North Charleston ▲

Colie Morse owned a General Merchandise store in the 1920s and '30s in old North Charleston, selling a variety of soft drinks, crackers, cookies, canned goods, gun ammunition and tobacco products. But it was his political influence at Garco that garnered him his unofficial title.
Submitted by Donna Hill

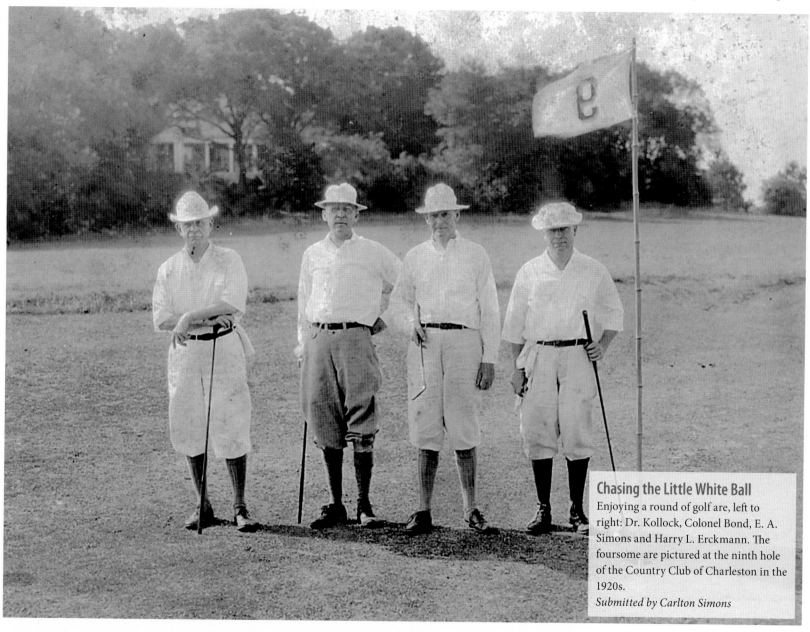

Chasing the Little White Ball
Enjoying a round of golf are, left to right: Dr. Kollock, Colonel Bond, E. A. Simons and Harry L. Erckmann. The foursome are pictured at the ninth hole of the Country Club of Charleston in the 1920s.
Submitted by Carlton Simons

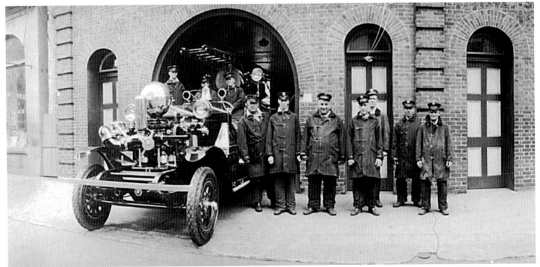

Construction of Grace ▼

Standing atop the John P. Grace Memorial Bridge in her shiny patent leather shoes, Alyce Mae Boyd was treated to a tour of the work site courtesy of the job's supervisor. The bridge, which was completed in 1929, was under construction at the time of this photo in 1928. Boyd ran a boarding house on Meeting St. in Ansonborough and several bridge workers and a supervisor stayed with her. She is standing next to the tracks that were used to haul steel up the bridge. The Grace and Silas N. Pearman bridges were demolished and replaced by the Arthur Ravenel Jr. Bridge in 2005.
Submitted by Chuck Boyd

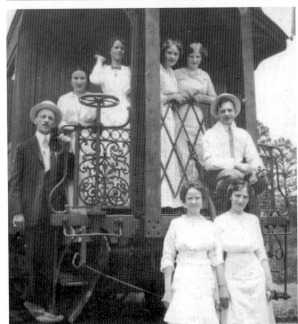

Fire Station #1 on Meeting ▲

This 1920s panoramic view of Charleston's Fire Station #1 shows the bay where the fire engine was parked, on the left, and the bay where the fire chief and administrative personnel parked, on the right. The firemen's dormitory was on the second floor. There is no #1 any longer and the building is now city administration offices. Seated behind the wheel is John Brantley Carroll, Sr., who became Battalion Chief in the 1930s.
Submitted by John Brantley Carroll, Jr.

Catching the Train ◄

Henry Gercken (left), and Lena Witt (standing below the train on the left) were photographed at the back of a train that ran into what is now the Visitor's Center downtown. Henry and Lena married in 1915; this photo is dated around 1912-13.
Submitted by Carl E. Sohl

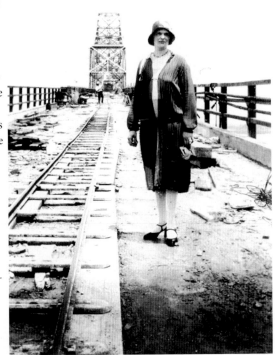

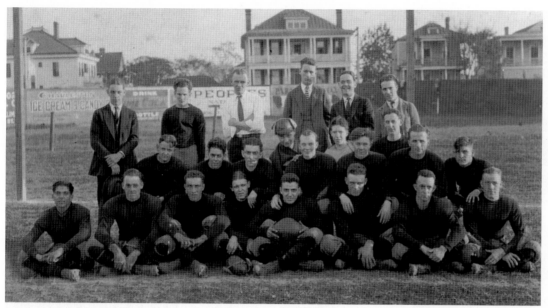

Knights of Columbus Football Team ◄

John Joseph White, Sr. (first row, third from the right) is shown here with the first Knights of Columbus football team in 1922. Knights of Columbus is a Catholic fraternal service organization; the men played other service organization teams.
Submitted by Joe and Ceanne White

First Christian Basketball Team, 1923-24 ►

This was the year the team of First Christian Church won against the likes of Bennett, St. Matthew's, Citadel Square and Jewish Juniors. David Hart was coach; Billy Buckley was the team mascot. The man behind Billy is believed to be his father. Players were: Luther Orvin, who played center and was nicknamed "Two Bits," Marion Patterson, standing guard or center, nicknamed "Shape," Romig Johnson, running guard, Leon Holst, captain and forward, Leonard Cameron, forward, nicknamed "Mutt," Warren Hilton, a substitute.
Submitted by Pat Johnson

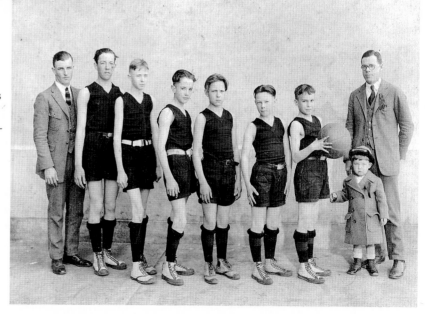

A Summer Cottage at Sullivan's ▷

The Metz's summer cottage was the place where relatives gathered in 1928. Notice the bathing suit on the clothes line, and the water pump on the right. Shown here are John Metz, Sallie Arnold, Sallie Metz, Walter Metz, John Arnold, Jane Metz and Rosalie Salvo. The trip to Sullivan's Island meant taking the ferry; from there they took the trolley which stopped at each station on the island. The station numbers still exist today.
Submitted by Mrs. Rosalie S. Orvin

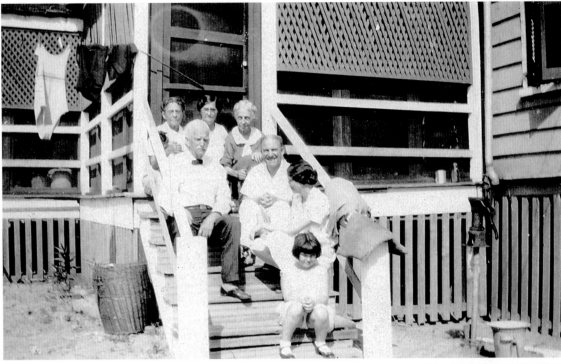

Turner and Ruth McCottry ▽

Turner loved his big sister, Ruth, who was about a year and a half older. When Ruth went to Shaw School (now the Robert Shaw Center) on Mary Street, the children's mother Lucille arranged for Turner to attend with her so they wouldn't be separated.
Submitted by Cynthia (McCottry) Smith

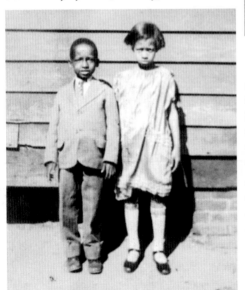

A Name Synonymous with Charleston ▷

Charleston Oil had a fairly large distribution operation back in the 1920s and until the company was sold in 1981. Their warehouse bordered the railroad tracks where product was unloaded; trucks made deliveries of kerosene, gasoline, motor oil and lubricants, fuel oils and industrial oils all around town and the Chasonoil Service Stations were a part of the landscape.
Submitted by Thomas E. Thornhill

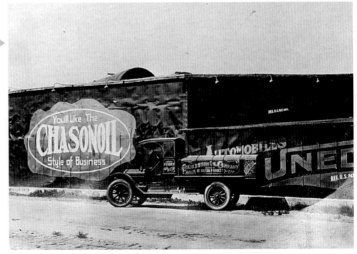

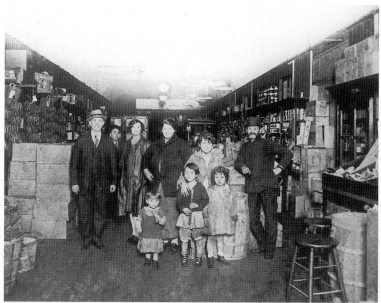

Mazo's Grocery and Delicatessen ◄

Elihu Mazo and his wife, Essie, immigrated to Charleston from Odessa, Russia in 1905 and opened a gourmet delicatessen at 478 King St. Mazo's sold delicacies such as kosher-style corned beef, pastrami , smoked salmon and white fish, much of which came from New York. People traveled from neighboring towns to shop at Mazo's. The Mazos also served sandwiches, and customers were invited to help themselves to one of the pickle barrels. The family of 12 lived above the store with one bathroom on the piazza. Pictured here around 1926, from left to right: A. J. Novitt, Mr. Feldstein, from Baltimore, Florence (Nirenblatt) Mazo, Essie Mazo, Nettie Solomon, and Elihu Mazo. The children in the front (from left to right) are: Donald Mazo, Norma Mazo and Miriam Solomon. The store is still there.
Submitted by Marilyn Hoffman

An Outdoorsy Sort of Girl ► ▼

Jaunita (Lemwigh) Baxley liked playing outside, a lot. In May of 1923 she would have been about 4 years old, and her pinafore and bare feet attest to the fact that outside was truly her playground. Juanita lived with her parents and five siblings at 88 Drake St.
Submitted by Jason Baxley

Wet Paint ►

Henry Able was a sign painter, but not just any sign painter. He was the Picasso of outdoor signage. Able, pictured here in his early 20s and splattered with paint from a job, traveled all over the state painting signs on the sides of buildings primarily for Esso Standard Oil and Coca-Cola. He was so good that, even in the early 1920s, he earned about $100 a week. He was a self-taught, self-made man in the truest sense; he used nothing but his own innate artistic talent, a book of scripts and his paints and brushes to earn his living. When signs morphed into something glued to paper, the art was gone for Able. When the Depression hit, he went out of business.
Submitted by Henry L. Able, Jr.

Achieving excellence in the education
of principled leaders since 1842.

THE CITADEL

THE MILITARY COLLEGE OF SOUTH CAROLINA

Photo Source: The Citadel Archives & Museum, Charleston, South Carolina

Labor Day, 1929 ▼

Freddie Heisenbuttle (left) and Ernest Fosberry grew up together and went to Crafts School back in the 1910s and '20s. The two friends took advantage of some time off Sept. 2, 1929 by spending it at Folly Beach.

Submitted by Mary Ann (Marle) Camp

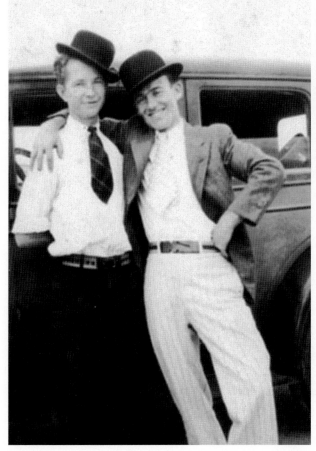

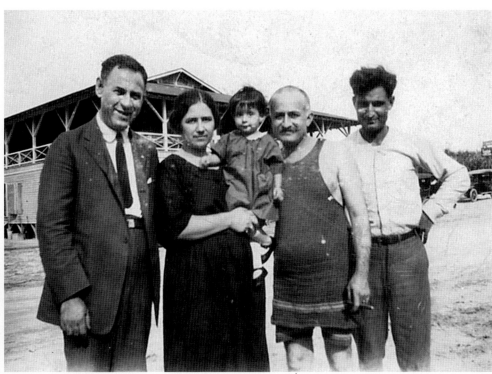

Folly Beach Pavilion ▲

John and Caliope Carris, holding Mary in her arms, Constantine Cockinos and John Latto were photographed in front of the Pavilion around 1922.

Submitted by Mary C. Catsimatides

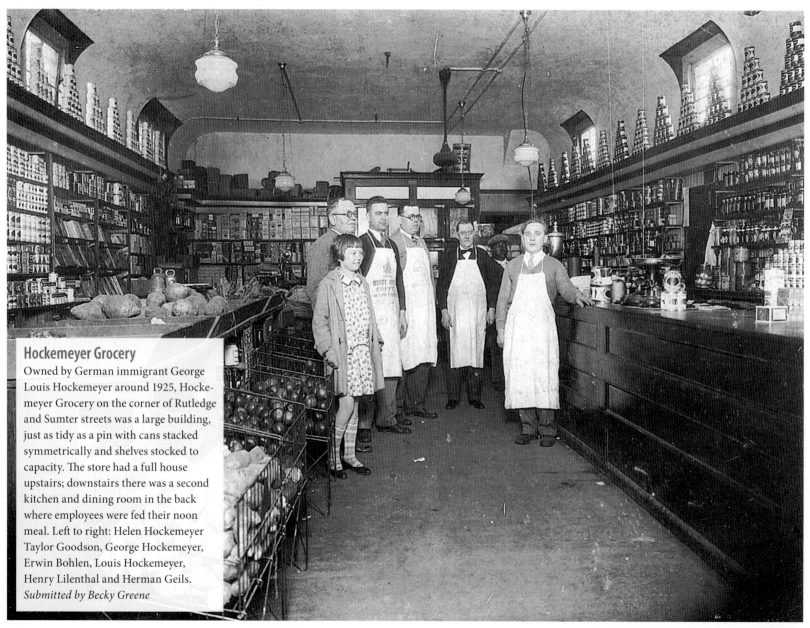

Hockemeyer Grocery

Owned by German immigrant George Louis Hockemeyer around 1925, Hocke-meyer Grocery on the corner of Rutledge and Sumter streets was a large building, just as tidy as a pin with cans stacked symmetrically and shelves stocked to capacity. The store had a full house upstairs; downstairs there was a second kitchen and dining room in the back where employees were fed their noon meal. Left to right: Helen Hockemeyer Taylor Goodson, George Hockemeyer, Erwin Bohlen, Louis Hockemeyer, Henry Lilenthal and Herman Geils.
Submitted by Becky Greene

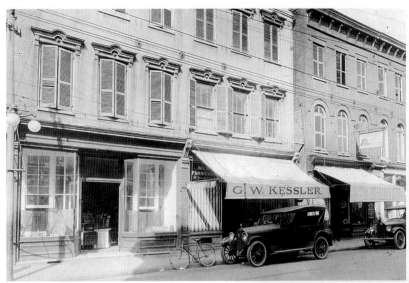

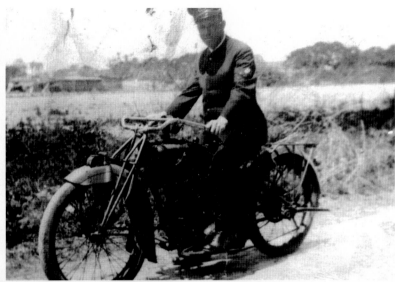

Some Things Change, and Some Things Don't ▲

Cars have changed and retailers move in and out, but some things have changed very little in the almost 90 years since this photo was taken. G. W. Kessler, a popular men's store, and the Gloria Hat Shop are no longer on King St., but the arches and cornices of some of Charleston's old buildings still remain. King St. was, and still is, a popular destination for shopping and entertainment, with the Majestic and Gloria theaters just down the street, and the Garden and Riviera and American theaters also within walking distance. Charleston was also home to other theaters including the Victoria, which became Victory Theatre after the war, the Arcade, and the Princess theaters. In their prime they showed silent movies and presented Vaudeville shows.
Submitted by The Pastime Amusement Co.

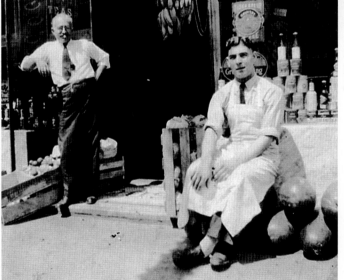

Charleston Motorcycle Policeman ▲

Edward North Millar was a Charleston City motorcycle policeman back in the 1920s. He injured his leg when the motorcycle fell on him in the line of duty.
Submitted by James L. Millar

Cockinos' Brothers Delicatessen ◄

Constantine Michael Cockinos and Michael John Cockinos ran a delicatessen at 209 King St. back in the early '20s. The store sold produce such as bananas, potatoes and watermelons, as well as sausages and Tetley's teas.
Submitted by Mary C. Catsimatides

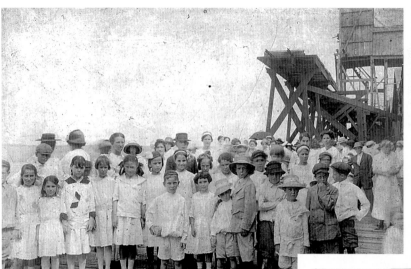

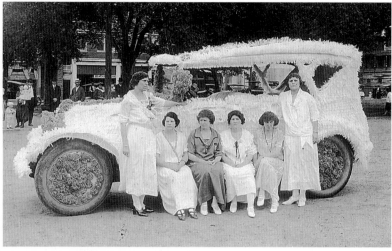

Waiting for the Boat ▲

These children were waiting to take a harbor excursion, probably aboard *The Islander,* in the 1920s. Star Gospel Mission often arranged for Charleston's younger population to go on outings, which also included car rides and summer camp. The mission, founded by Obadiah Dugan, began in 1904 in the old Star Theater as a shelter for homeless people. Star Gospel Mission continues to be the oldest not-for-profit Christian welfare organization in Charleston, located today at 474 Meeting St.
Submitted by William K. Christian, Star Gospel Mission

German Rifle Club ▲

This car, decorated with real flowers for the Schuetzen-fest in the mid-1920s, was parked on the Meeting St. side of Marion Square. Annie Harken is standing on the left; her sister Annette Harken is third from the left. The girls were in their late teens or early 20s.
Submitted by Katie (Walker) Windmueller

Self-Propelled All-Terrain Vehicle ◄

Little Channing Reeves took a ride down Nassau St. in the ATV of the day with his sister Louise (Reeves) McMillan. Louise, who was no more than 4 years old in 1925, did the pushing in the little toy car probably made of tin. Channing, in his hand-knit jacket, appears to be giving his sister directions. Louise grew up to be a teacher at the privately owned Avondale Kindergarten, run by Mrs. Till. The kindergarten kept a waiting list, and taught such Charleston notables as Thomas Gibson, who appeared in the movies "Far and Away" and "Eyes Wide Shut" as well as television series such as "Criminal Minds" and "Dharma & Greg."
Submitted by Louise R. McMillan

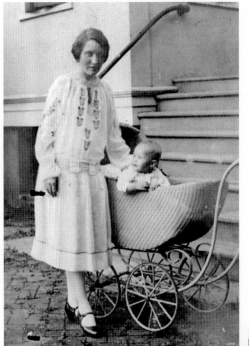

Carriage Ride ◄

Mary Iona Willis took baby Mary Jerusha Willis out for a stroll in 1926. The Willis family lived at 17 East Battery; the home is still in the family today. It is occupied by Roy E. Mebers, a nephew of Mary Iona Willis.
Submitted by Louise Bennett Doyle

Ashley River Memorial Bridge Opens For Traffic ▼

On May 6, 1926, the bridge was dedicated to the memory of South Carolinians who died in World War I. It was considered to be one of the most beautiful structures in the United States at that time, and an important link in the highway system between North Atlantic states and Florida. Pictured here from left to right are Matt Hanley, Rose Keeler, Frank Doogan, Ida Keeler and Mr. Hanley, Matt's father. The two younger men were cousins from Charleston and the women were Mathilda Keeler's sisters from Blackville, S.C. Ida and Frank were married in 1925 and Rose and Matt Hanley were married in 1927.
Submitted by Carmel Croghan Toland

Talk to the Hand ▼

Or at least walk in the direction the hand is pointing, from King St. east down Society. Perhaps the electrified hand pointed to The Hupp, which was a luncheonette that sold cigars and sodas, according to the store sign. Or maybe it was pointing to the YWCA, or the Greyhound Bus Station which were also in that direction. The building at 292 King is now occupied by Stella Nova.
Submitted by The Pastime Amusement Co.

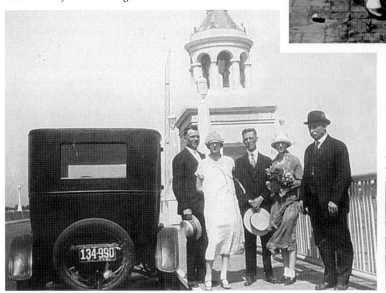

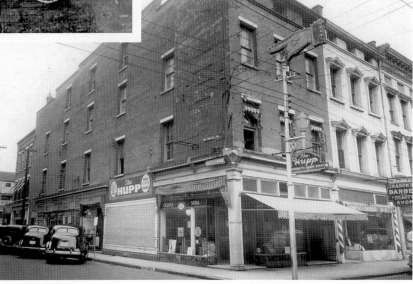

Wearing Her Brother's Uniform ▷

Alice Spell Champion had her picture made in her brother's Navy overshirt sometime around 1922, following World War I. The overshirt was made of dark-blue navy flannel, which was cut loosely. A neckerchief or cravat, depending on the sailor's rank, was worn around the neck and under the collar. Alice was born in Cottageville but grew up in downtown Charleston.
Submitted by Ruth Glover and Ranne (Glover) Hammes

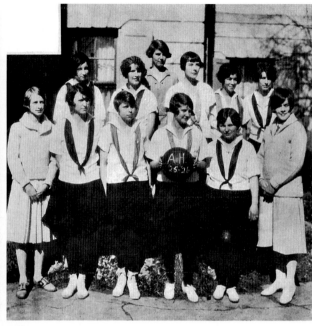

A Game of Croquet ▽

This group enjoyed a rousing game of croquet in the late 1920s at Middleton Place Gardens. Croquet was a popular form of entertainment in those days. Those who could be identified were John Julius Pringle Smith (far left) and Heningham (Ellett) Smith (fourth from the left).
Submitted by Pat Kennedy, Middleton Place Foundation

Ashley Hall's Basketball Team ▲

The girls and their coach were photographed for the newspaper during the 1925-26 basketball season. Lower row, left to right: Betty Poulnot, Julia Gourdin, Marjorie Thompson, St. Clair Buist (captain), Margaret Cleverius and Jacquelin Ambler. Top row, left to right: Nell Harris, Betty Mallock, Miss Rita Surrall (physical director and coach), Maybelle Hethington, Virginia Robertson and Margaret Bennett. Ashley Hall, a girls' college prep school, was founded by Mary Vardrine McBee. The school, located at 172 Rutledge Ave., will celebrate its centennial in 2009.
Submitted by Ambler Simons

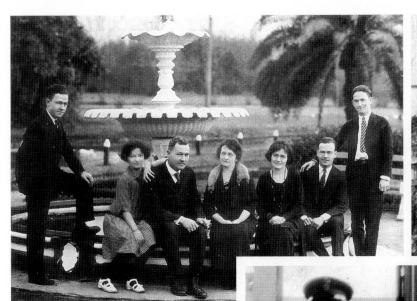

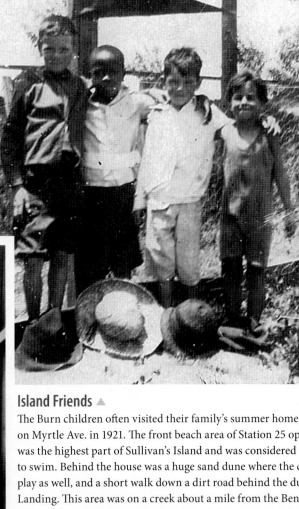

The Livingston Family, circa 1927 ▲

Pictured here in Hampton Park are (left to right) Walter F. Livingston, Jr. (Toots), Margaret Livingston, Walter F. Livingston, Margaret Broughton Livingston, Pauline Livingston Tecklenburg, Williams DeWees Livingston, Joseph A. (Fud) Livingston. "Fud" Livingston was a locally celebrated jazz musician.
Submitted by Elizabeth Long

Freshman at The Citadel ▶

Joseph O'Hear Sanders, Jr. was a freshman at The Citadel in 1927. He is proudly pictured in his uniform on the porch of a Charleston single house.
Submitted by Jo Gowdy

Island Friends ▲

The Burn children often visited their family's summer home, "The Merv Inn," on Myrtle Ave. in 1921. The front beach area of Station 25 opposite their home was the highest part of Sullivan's Island and was considered to be the safest area to swim. Behind the house was a huge sand dune where the children loved to play as well, and a short walk down a dirt road behind the dune led to the Back Landing. This area was on a creek about a mile from the Ben Sawyer Bridge and is a great place for catching crabs and shrimp even today. Pictured left to right are: Charles Gordon Burn, Sr., nicknamed "Jeff," Elmore Brown, William M. Pozaro, nicknamed "Pell," and Hazel Estelle Burn. Hazel had no difficulty keeping up with the fellows; she could do anything the boys could do, including helping construct a club house in a tree on the family property.
Submitted by "Cookie" Hutchinson

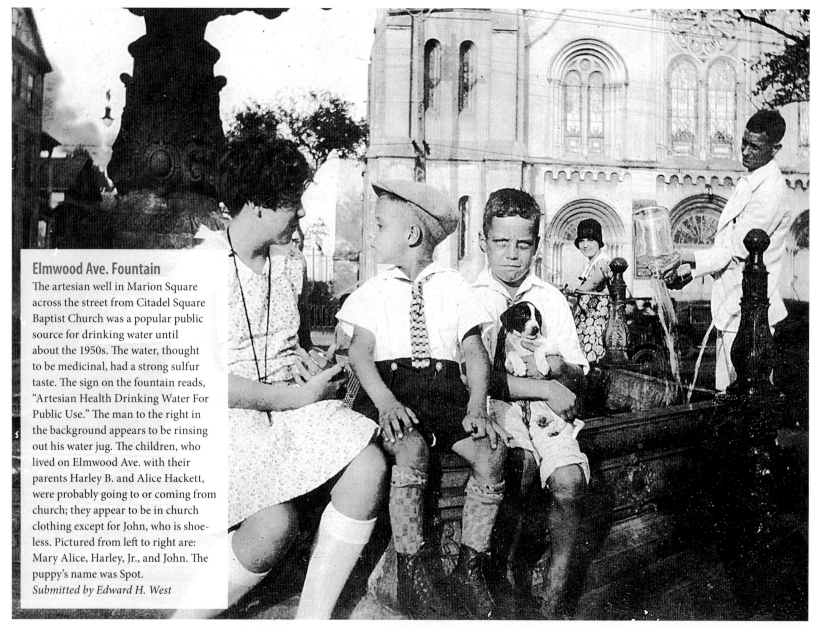

Elmwood Ave. Fountain

The artesian well in Marion Square across the street from Citadel Square Baptist Church was a popular public source for drinking water until about the 1950s. The water, thought to be medicinal, had a strong sulfur taste. The sign on the fountain reads, "Artesian Health Drinking Water For Public Use." The man to the right in the background appears to be rinsing out his water jug. The children, who lived on Elmwood Ave. with their parents Harley B. and Alice Hackett, were probably going to or coming from church; they appear to be in church clothing except for John, who is shoeless. Pictured from left to right are: Mary Alice, Harley, Jr., and John. The puppy's name was Spot.
Submitted by Edward H. West

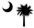

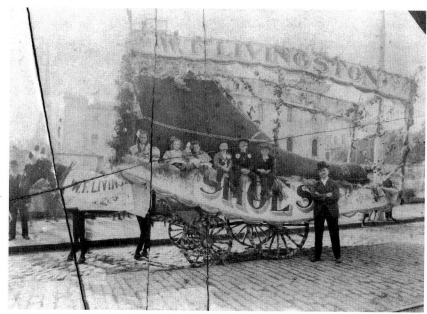

Do You Have It In a Smaller Size? ◀

Walter F. Livingston (standing on the right) went all out for this parade which was held downtown somewhere around 1920. It's unclear whether this is the actual shoe inhabited by the Old Woman, or if these are the many children that kept her at wit's end, but the shoe on the float certain looks big enough to live in. The girl in the center is Margaret Livingston. The shoe store, at 366 King St., was located in the first block after Calhoun St., across from the Garden Theatre. It is now a parking lot.
Submitted by Elizabeth Long

Election Night, 1927 ▶

The campaign for the mayoralty between Thomas P. Stoney and Daniel L. Sinkler was over on Election Night Nov. 15, 1927; this photo was taken at the German Artillery Hall on Wentworth, between King and Meeting streets. The building no longer exists. Stoney was declared the winner in his bid for a second term as mayor. Stoney served the city of Charleston from 1924-1931. He is pictured in the middle of the three men standing in the aisle.
Submitted by Thomas P. Stoney, II

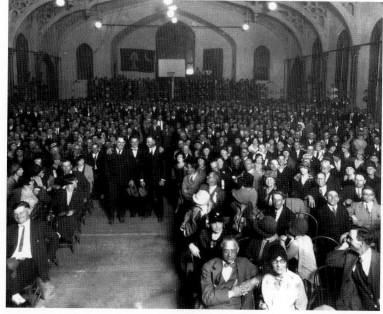

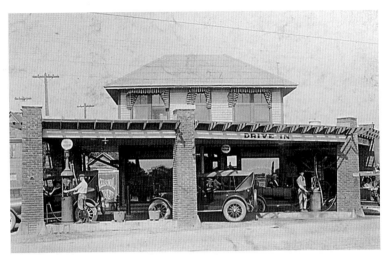

The Beginnings of Charleston Oil Co. ◄

"Chasonoil" started business in 1909 as a hut with one pump on Meeting St. at Mt. Pleasant St. The Drive In and Drive Out featured "visible pumps." The building was torn down when Meeting was widened to four lanes. In the late 1950s the entire plant was moved to upper King St., which was nothing but cornfields at that time. Gasoline in 1922 was somewhere around 10-12 cents per gallon.

Submitted by Thomas E. Thornhill

The End of the Trolley Line ▼

Back in the 1920s, according to an account by Quincy P. Brooks, Jr., the streetcar line ran from Charleston to Montague Ave. in North Charleston. The streetcar was much like a ferry in that, when it reached the end of the line, the front became the rear and the rear became the front. The motorman shifted the operating controls end to end and reversed the seatbacks to accommodate the new travel direction. When everything was in place, the motorman would ring the bell a couple of times and they would rumble down the tracks. The fare to the Navy Yard was five cents; to the city limits cost another nickel and on to the Battery, five cents more. Bus service replaced streetcars in the 1930s; after that, the tracks were removed.

Submitted by Donna Hill

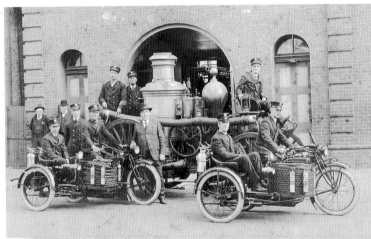

Firemen and Their Engine ▲

B. Lafayette "Fate" Muckenfuss was a fireman with the Charleston City Fire Department for about 20 years back in the 1920s and '30s. He is seated in the sidecar on the left of the photo, outside of the Fire House on Meeting and Wentworth streets. After World War II Muckenfuss went to work at the naval base as a fireman, eventually retiring as Battalion Chief.

Submitted by Blanche M. Szczepanski

Making the Rounds ▷

Dr. Henry William deSaussure was a well-established physician by June of 1920. City and rural home visits were part of medicine in those days, and Dr. deSaussure believed that doctors had a responsibility to serve all people. To that end, a car was a necessity for his line of work, not a luxury. The family lived a block away from his office on Rutledge Ave. and from Roper Hospital and the Medical College, but he often treated patients who weren't "just around the corner."
Submitted by Mary L. McQueen and Henry deS. Copeland

Thanksgiving Day Feast ▷

A mixture of mallards and teal along with a good-sized alligator made for a wonderful holiday meal at Lavington Plantation in 1926. The plantation, owned by John F. Maybank, was planted with a little rice and cotton but mainly the land was farmed for timber and produce. South Carolina had a few cotton mills at that time but the state raised more cotton than it could spin, so most of the cotton grown here was shipped to Europe for production. Those who could be identified in the photo are pictured front row (left to right) David Maybank, Tom Stoney, who was mayor at the time, and Reese Fraser, a cotton broker. John F. Maybank is in the center of the photo; behind him smoking a pipe is Burnet R. Maybank. In 1926 Maybank was alderman, but later succeeded Stoney as mayor in 1934. On the front row, second from the right is "Cotton Ed" Ellison D. Smith, a U.S. Senator. Because of his favorable stand on cotton, Burnet R. Maybank said that every time "Cotton Ed" made a speech about cotton the price would go up 3 or 4 cents a pound. The man pictured second from the right (in the back) is Francis "Danky" Pinckney.
Submitted by Burnet R. Maybank

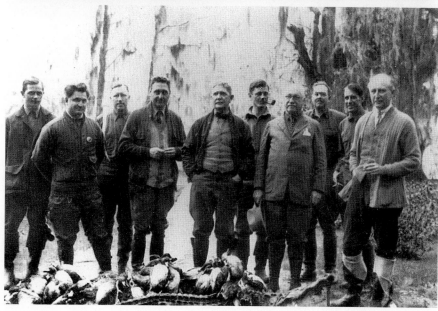

Dockside Family Outing ◀

Bertha and Willard Murphy are pictured holding a young relative, Ernest Prince, in 1929. The Murphys lived in Charleston and took many outings to the docks on the Cooper River side. The docks are long since gone, but Castle Pinckney, in the background, still remains.
Submitted by W. Dean Murphy

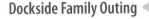

Petal to the Metal ▼

Pictured here in a parade for the Schuetzenfest, a shooting festival held by the German Rifle Club around 1920, are: Elsie Schwartz Dixon, Adele Doscher, Mrs. A. H. Gorse, Rosalie Stramm Martens, Addie Puckhaber, Riecka Mohlenhoff, and August H. Gorse, the driver. The Old Citadel (now Embassy Suites) is in the background.
Submitted by Rose (Martens) Bolchoz

Wedding Portrait ▼

The bride, Ellen Johnson, was a daughter of Capt. J.P. Johnson. She married Jack Buchanan around 1920. Her maids of honor were her sisters Teckla and Elizabeth. The flower girls were Ruth Johnson, a cousin, and Nola Mae Stephenson.
Submitted by Pat Johnson

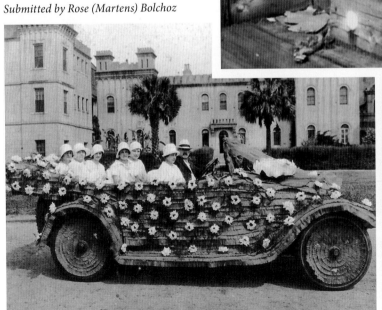

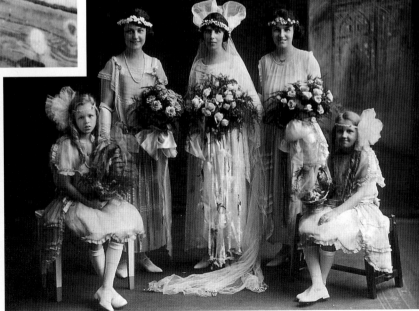

The Heisenbuttel Girls ▶

Memie (Heisenbuttel) Bolchoz (left) and Loretta Heisenbuttel, right, posed by the Marion Square fountain in the 1920s. The girls were decked out in pearls and pumps, probably for Easter, according to Memie's daughter-in-law. Truth is, in those days people dressed just to walk down the street.
Submitted by Rose (Martens) Bolchoz

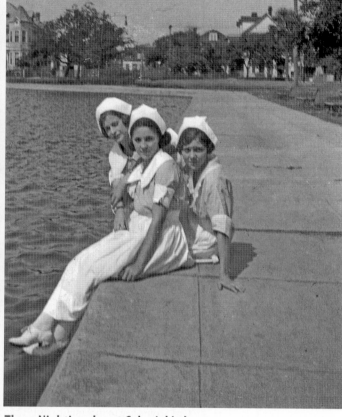

Three Nightingales at Colonial Lake ▲

Three Baker-Craig Sanitorium nursing students relaxed by the edge of Colonial Lake in 1921. The Sanitorium, established in 1912 by Drs. Archibald Baker, Sr. and Lawrence Craig, was a 60-bed hospital and nursing school in the northwestern edge of Colonial Lake, on the corner of Beaufain St. and Ashley Ave. The nurse in the middle is Nell Welsh Mays at age 18. Baker Hospital relocated in 1981; in 1983 the building was renovated and is now condominiums.
Submitted by Anna Nell (Welsh) O'Quinn

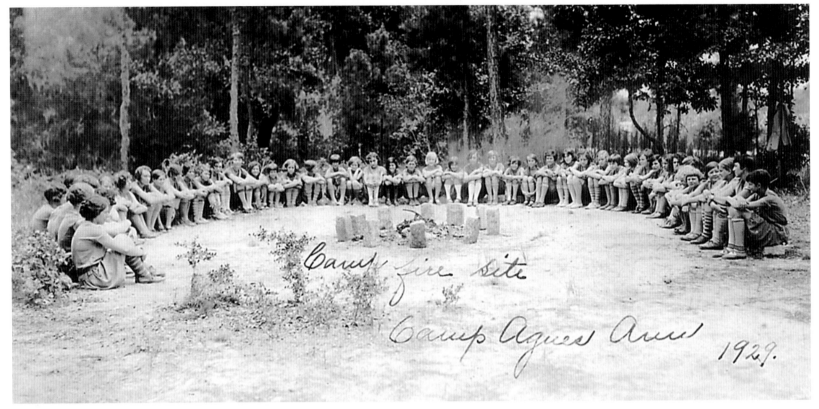

Camp fire site
Camp Agnes Ann
1929.

Girl Scouts at Camp Agnes Ann ▲

Girl Scouts began in America in 1912 so by 1929 scouting itself was about as old as some of the Viking Scouts pictured here. Vikings were the original Senior Scout Troop in Charleston, and it is likely that many of the Vikings were junior counselors at Camp Agnes Ann outside of the Hollywood-Meggett area. The camp was very primitive, with six wooden cabins that had shutters for ventilation, a stone chapel with a big fireplace where campers would sleep on the floor in the wintertime, and an outhouse. The camp was kept until the mid '60s, when the area around it became disreputable and the Girl Scouts bought land in Cordesville for their facilities. Camp Agnes Ann was out in the middle of nowhere during the first half of the century: the girls went on hikes and jumped off an old dock into a "mud hole" when the tide came in. At the back of the camp there was a special tree whose limbs, when cut and stripped, would safely cook raw dough over a campfire. The girls knew the camp's sandy area as "Little Sahara." Those who could be identified in the photo are: Ethel Hockmeyer, Margaret Bayly and Erna Till.
Submitted by Edith T. Dixon

Leitch Family Residence ▶

In the 1920s families lived together—generations of them. This 1920s vintage photo, was taken in front of the Leitch family residence, 12 Sutherland Ave. The home still exists today. At one time three generations of Leitches lived together in the home that featured a porch across the back, four bedrooms and one bathroom with a big claw-footed tub. Pictured here from left to right are: Wesley Leitch, Clyde Leitch, Dorothy (Leitch) Warren, Cecil (Leitch) Eiserhardt, and Tommy Leitch.
Submitted by Gene Limehouse

Aerial View of North Charleston ▼

This photo taken in the 1920s shows Montague Ave. and the Park Circle area toward the river. It is thought that Dr. Califf, North Charleston's druggist, may have taken the picture. He was a pilot, according to one account, and took aerial pictures of old North Charleston while flying with Bevo Howard. The landscape has certainly changed since then; in the '20s there were just a few small businesses that mainly served Garco Village.
Submitted by Donna A. Hill

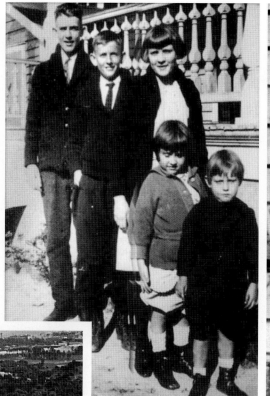
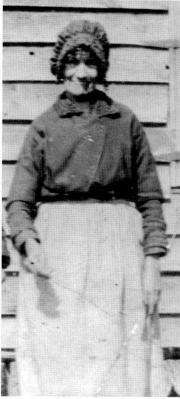

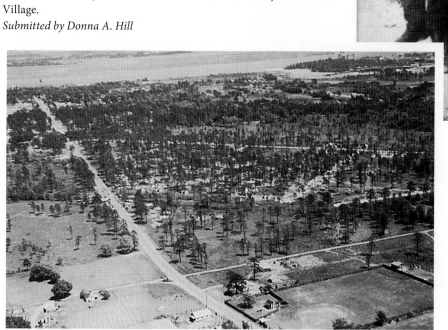

Life on the Edisto River in the Early 1920s ▲

Annie Flood Reeves was photographed in front of their home in the Sand Hill area on the Edisto River in the early '20s. The Reeves were fishermen and farmers, growing crops such as corn, cotton and peas and tending livestock for their livelihood.
Submitted by Johnnie Lee (Reeves) Rowe

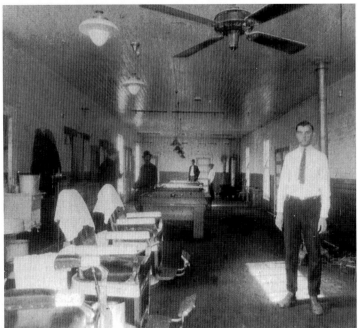

North Charleston's First Barber Shop-Slash-Pool Hall ◄

H. Harrison Attaway (right) opened his shop in 1921 at 1054 E. Montague in North Charleston's old village. Today it is the oldest barbershop in North Charleston, operating as East Village Barber Shop in the same location. Two of the four men pictured playing pool are Casper Padgett and Paul Harris. In subsequent years Attaway built a separate poolroom down the street.
Submitted by Eleanor (Attaway) Fuller

"The Moonlight Serenaders" ▼

Carl Marle (left) Ernest Fosberry, Gene Fosberry and Freddie Heisenbuttle (far right) drew big crowds in the Roarin '20s and '30s when they played receptions and nightclubs around town. All four men sang but they each also played an instrument or two: Carl played the saxophone and clarinet, Ernest played the trumpet and coronet, Gene played drums and Freddie played banjo.
Submitted by Mary Ann (Marle) Camp

Fenwick Hall ▼

By this time Fenwick Hall on Johns Island was almost 200 years old. Built for John Fenwick, a South Carolina planter, the property is considered to be the finest surviving example of an early Georgian two-story brick plantation house built on the Huguenot floor plan, according to the National Register Properties on South Carolina.
Submitted by Roulain J. DeVeaux

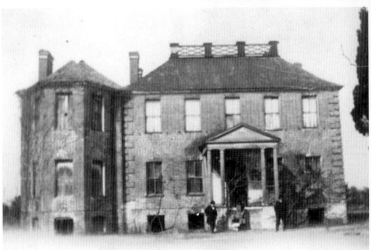

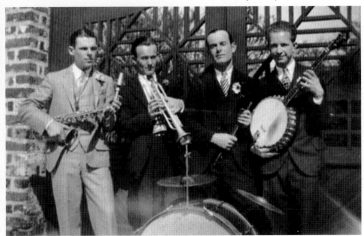

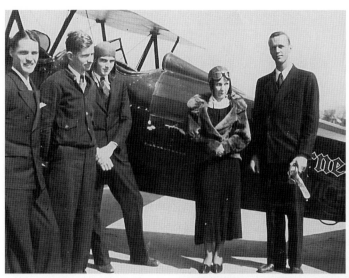

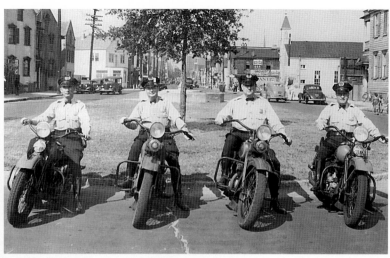

Women Take to the Air ▲

Nell W. Ashby (second from the right) became one of only 100 women in the United States to earn a flying license at that time. This photo, taken around 1930, shows Nell with Beverly "Bevo" Howard in front of his bi-wing plane after a flying lesson at the Charleston Airport. Miss Ashby heard so many flying stories from Mr. Howard, who was a friend of the family, that she decided she would like to learn. Howard bought Hawthorne Flying Services and trained pilots during World War II. He died in 1971 while performing at an air show as an aerobatic pilot.
Submitted by Robert W. Ashby

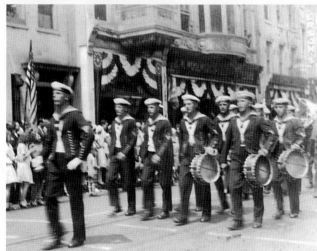

Motorcycle Squad ▲

In the days before cruisers some policemen like Herman Stehmeier (second from left) were assigned to the motorcycle squad in addition to walking a beat. After making an arrest the officer would walk the perpetrator to a call box and then wait for the paddy wagon to show up. Pictured next to Stehmeier, lining up to lead the Azalea Parade, are Mr. Chassereau and William "Billy" Jantzen (far right). The fishpond in the background occupied the middle of Calhoun St. at the corner of East Bay for several decades before it was filled in with dirt and then later removed for construction of the aquarium and parking garage.
Submitted by Shirley (Stehmeier) Winter

Charleston's 250th Anniversary Parade ◄

This band, composed of German sailors from the training cruiser, *Emden,* marched in Charleston's birthday celebration while crowds watched in 1930. Germans later destroyed the *Emden* to make sure the ship was not captured. F. W. Woolworth is in the background, on King St. between Wentworth and Hasell streets.
Submitted by Edith T. Dixon

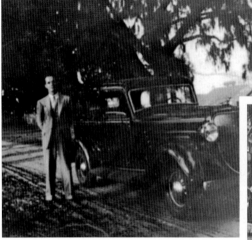

Boone Hall Plantation ▲

John Romig Johnson, son of Capt. J.P. Johnson, visited Boone Hall in March of 1935. Johnson was a 1930 graduate of The Citadel and was working for Durham Life Insurance Company at the time.
Submitted by Pat Johnson

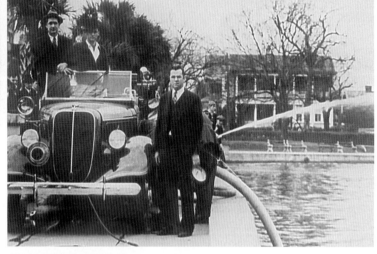

North Charleston Gets Fire Protection ◄

When H. Harrison Attaway's barbershop on O'Hear St. burned down, there were nothing but buckets of water to douse the flames. Attaway decided fire protection was needed for North Charleston, so he began working toward that goal. Attaway is pictured in 1935, standing beside the city's first fire truck; L.P. Baker is in the truck, on the left, and E.W. Maxwell is beside him. The men were at Colonial Lake to pump water and test the truck.
Submitted by Eleanor (Attaway) Fuller

Condon's Parkway ◄

On the corner of King and Warren streets, Condon's sold almost anything: furniture, clothing, shoes and gasoline. The gas station was located at the rear of the store in the parking lot. Gasoline was manually pumped from an in-ground tank into a 10-gallon glass bulb, marked off in gallon increments. An employee attached one end of a hose to the glass bulb, put the other end in the customer's tank and opened the valve. Gravity would drain the gas into the tank. This photo was taken at the service station's grand opening in 1935; it was closed in the early '50s and the building was demolished in the late '50s. Mattie Oliver is pictured third from the right.
Submitted by Bernie Oliver

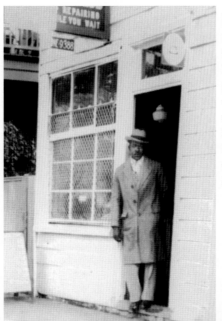

Center of Ladson Community ▼

Back in 1938 the Limehouse General Merchandise, which adjoined the family's residence, was the place where elections were held and gatherings of all types were known to happen. Owner Loyless Limehouse (pictured far right behind the candy counter) was the self-appointed mayor of Ladson, as well as postmaster, businessman and master of the barbecue. Fauftina (Cummings) Mahaffey and her father, James Gordon Cummings (far left) drove from Summerville to get gasoline the day this photo was taken. Next to them are Mr. Heise, Dick Limehouse, Junior Limehouse, Hal Limehouse (standing behind Junior on the counter), Vinnie Limehouse and Harold "Cool" Brooks.
Submitted by Lynn Limehouse-Priester

Bruington Pressing Club ◄

Samuel W. Bruington owned one of the first pressing clubs in downtown Charleston in the late '30s to middle '40s. The business, located at 41 ½ Cannon St., offered cleaning services, pressing and alterations. Bruington had a thriving business with two employees: a secretary who handled clerical affairs and a boy who delivered clean clothes to customers on his bicycle. Bruington was a member of the Order of Knights of Pythias, a national organization originally formed as one of the first civil rights movements after World War I.
Submitted by Freddena K. Hayes

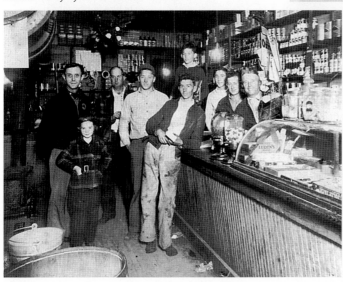

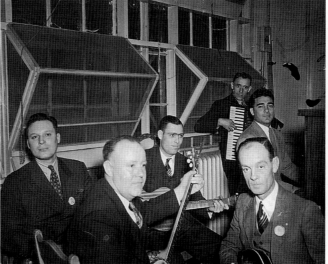

Big Band ◄

Walter A. Blois (second from the left) had his own band in the early '30s, and the group played all over Charleston. The men are wearing what appear to be political buttons; it is possible that, on this particular occasion, they were playing for a political fundraiser.
Submitted by Irene Suit

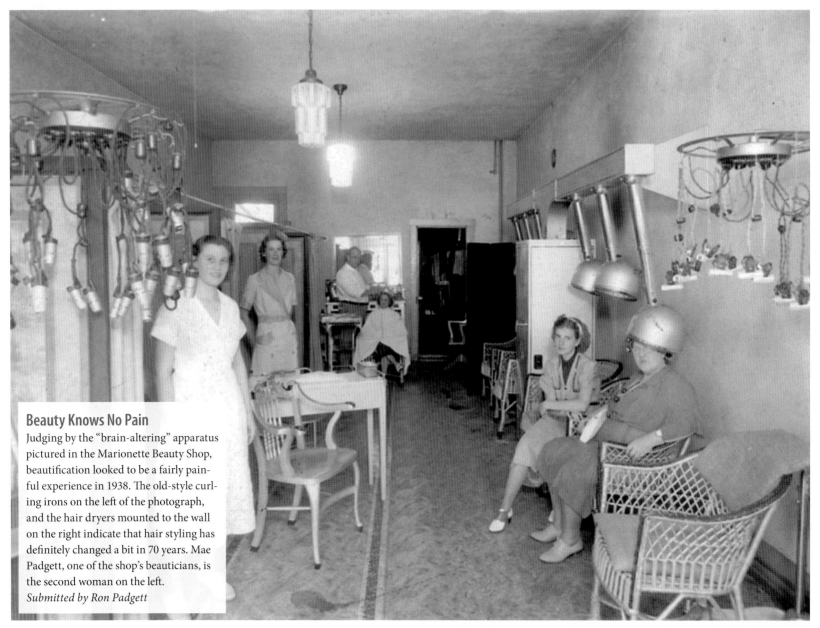

Beauty Knows No Pain
Judging by the "brain-altering" apparatus pictured in the Marionette Beauty Shop, beautification looked to be a fairly painful experience in 1938. The old-style curling irons on the left of the photograph, and the hair dryers mounted to the wall on the right indicate that hair styling has definitely changed a bit in 70 years. Mae Padgett, one of the shop's beauticians, is the second woman on the left.
Submitted by Ron Padgett

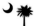

Six-Foot-Tall Hen Stood in Front of the Hen House ▲

The business was called Mappus Grocery in January of 1930 when it was located at 46 Spring St. on the corner of Spring and St. Philip. T. T. Mappus, Sr., pictured behind the counter, owned the business. Elsie (Buck) Mappus and their son, Ted, pictured to the left of the counter, helped out as well. Henry Buck, Mrs. Mappus' brother, was employed as a clerk in the store. They sold everything from bananas and apples and other fresh produce, to lots of tobacco and candy, including Baby Ruths shown in the case. Customized paper shopping bags with the store information printed on them hung conveniently at the store's entrance. The business moved to King in the early '30s and became more of a poultry business. Little Ted was old enough at that point to pitch in at the Hen House, as it was known. He was in charge of killing the squab, chickens and geese sold in his father's store. The business moved several times before it was sold in 1943; the six-foot chicken sign went to Rivers Ave. with the new owner.
Submitted by Ted Mappus

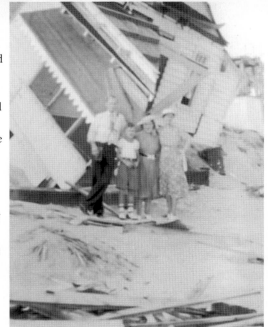

WCSC Radio Amateur Hour ▲

Chuck Simpson (behind the microphone) was a sportscaster at WCSC. His wife Velma (playing the organ) teamed up with him every Saturday morning in the '30s and '40s for amateur hour on the radio. This was a time when people would come and sing songs across the airwaves while Velma accompanied. The couple lived on Folly Beach.
Submitted by Charles H. Reed

Hurricane of 1938 ◄

Henry, Fred and Gussie Schmidt from Long Island went "sightseeing" at the Isle of Palms in 1938 after the hurricane blew through. Their friend Lena Gercken went with them. The Gerckens lived on Meeting St. at the time; the tin roof of their home rolled off due to the storm. Hurricanes were not named prior to 1950.
Submitted by Carl E. Sohl

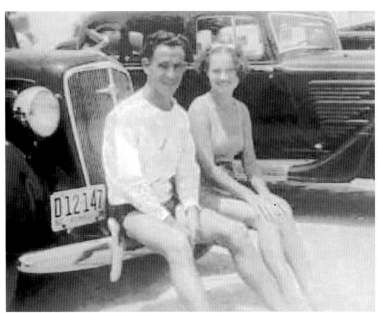

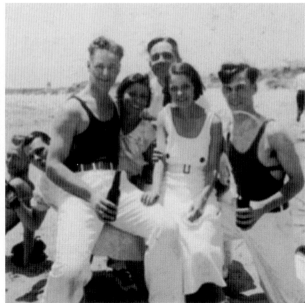

A Day at the Beach ▲

Back in 1935 automobiles were allowed to drive on Folly Beach, so Theodore Anthony Rowland, Sr. and Martine (Woods) Rowland took advantage of a nice day. Ted Rowland was a fourth generation Charlestonian; he was a supervisor in the newspaper's mail room, working until 4 a.m. at that job and then heading over to the waterfront to start his other job as a cargo checker. Rowland had six little mouths to feed and that kept him fairly busy during the Depression years.
Submitted by David Rowland

Swim Fashions in the 1930s ▶

As if sand in your swimsuit wasn't itchy enough, women wore wool into the water in the 1930s. Margaret Saulsbery Ashhurst is pictured on Folly's Front Beach in the swim fashion of the day. It is believed they wore tennis shoes into the water, which is why she was wearing socks. Margaret married James H. Ashhurst, Jr. in 1928 and lived with his parents until they had saved enough money to buy their own home. By the late '30s they had moved to 84 St. Margaret St.
Submitted by Ann and Joe Wolfe

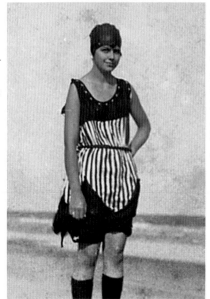

Atlantic National Bank Picnic ▲

It was June 4, 1933 and the Atlantic National Bank held a picnic on the Isle of Palms. There was plenty to drink and it was a nice day at the beach; it doesn't get much better than that. Atlantic National became C & S Bank, which is now Bank of America. Pictured are Rubert Khune, Carl Marle, Walter Weiters, Caroline Marle, Julius Schroeder, Katie Trescott and Howard Lathrop.
Submitted by Mary Anne (Marle) Camp

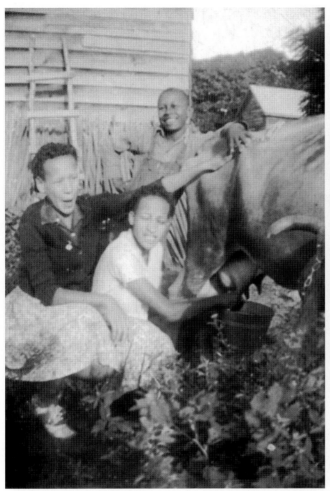

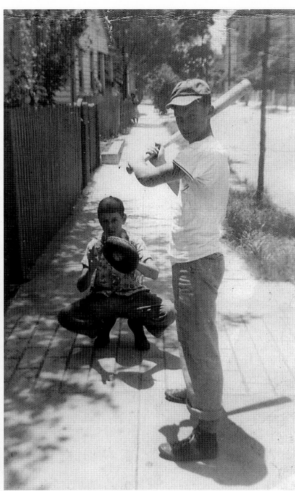

Cows Can Be Cantankerous ▲

Cynthia McCottry admits she was afraid of that cow at her relatives' house on Edisto Island in 1930. Her cousins seemed to be getting a "kick" out of it, though; on the left is Gloria McCottry and behind the cow is Laverne McCottry.
Submitted by Cynthia (McCottry) Smith

Street Baseball ▲

When they weren't in school at James Simons Public School on Moultrie and King, Thomas "Buddy" Brown and Henry Buckheister (batting) would get up a baseball game on Maverick St. in the Hampton Park area. The boys lived on this street in the late '30s; they later joined the Navy in 1944.
Submitted by H. E. "Dutch" Buckheister

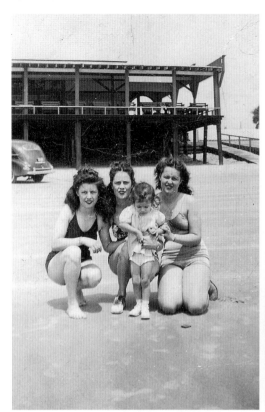

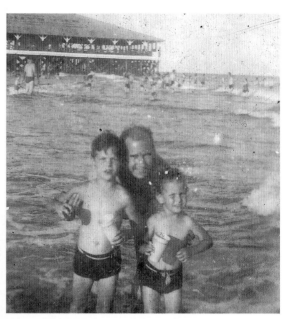

Califf's Drug Store ▼

Dr. Califf's business on Montague Ave. was the most popular meeting place in old North Charleston in the 1920s and '30s. His marble soda fountain was his pride and joy; the drinks, shakes, and banana splits he and his clerks were trained to make were a cornerstone of the drug store. But if a customer preferred not to enjoy a cold drink at the counter, curbside service was available too.
Submitted by Donna Hill

A Day at Folly Meant A Day of Fun ▲

The Folly Beach Atlantic Pavilion shown in the background was the place to be in the late 1930s. Folly's eclectic way of life seemed to successfully blend just enough sea and sand to feed the soul. Pictured above in 1938 are Frederick Earl (left) and Robert Bullwinkel with their dad, Frederick, behind the two boys.
Submitted by Robert W. Bullwinkel

Have Car, Will Travel to the Beach ▲

Delores Weaver (left), Ella Nora (Bolchoz) Welcker, Artes Welcker (18 months old) and Bessie Smith enjoyed a day at Folly Beach in 1939. In the background is the old Folly Beach pier which was located off Center St. approximately where the new pier now stands. It was the usual practice for cars to drive and park on the beach. Access for automobiles was off of Center St., pictured on the right side of the photo beside the pier. All the girls lived in Charleston, but having access to a car called for a special trip, and going to Folly Beach was always a treat.
Submitted by Martha Fox

W. M. Means Heads Realty Firm

William M. Means was born in Charleston, a son of Robert Martin Means and Mary Pinckney Means. He first attended the schools in Charleston; later the Military Academy and the University of the South, both at Sewanee, Tenn.

Mr. Means attended the first officers' training camp at Fort Oglethorpe, Ga. He served with the ...hteenth machine gun battalion, ...ision, during the World ...ed as a first lieu-...he division re-...go into

WILLIAM M. MEANS
INSURANCE – REAL ESTATE
66 BROAD STREET
CHARLESTON, S. C.

October 10, 1933

...ank Norris,
...elphia, Pa.

... Norris:

...ting to some of my friends and acquaintances ...hat I am entering the Real Estate and General ...business at the above address.
...dle all forms of insurance including Fire, ...tomobile, Casualty, etc., and all form...
...transactions.
...ore than a pleasure ...
...and if you ...

William Means Real Estate is the preeminent broker of luxury property in the Lowcountry and is one of the oldest firms in the area. Founded in 1933 by William Means, the firm initially offered both real estate and insurance services and specialized in the sale of plantations. The real estate division of the company was acquired by Mr. Mean's son-in-law – W. Elliott Hutson – in 1957 and was later purchased by Helen Lyles Geer, who remains as the owner and Broker-in-Charge.

Today, the company specializes in the buying and selling of the finest residential real estate on the historic peninsula, surrounding communities and islands. With more than 25 seasoned real estate agents and multiple offices, the firm continues to grow and is committed to their long-standing reputation of integrity, professionalism, and knowledge. As a further testament to their success, William Means is Charleston's exclusive affiliate of Christie's Great Estates, the largest international network of real estate companies committed to the marketing and sales of premier property. Only firms who have a leading market share and who meet Christie's strict standards of service excellence and consistent achievement are invited to become affiliates.

For more information on William Means Real Estate, visit www.charlestonrealestate.com or call 843.577.6651.

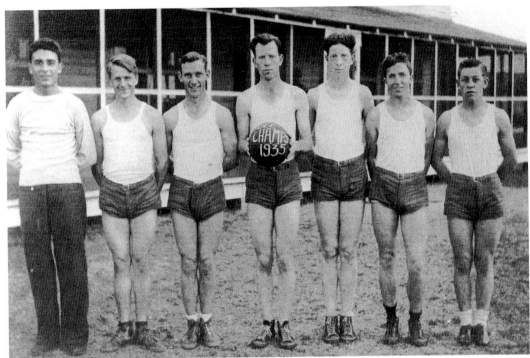

Civilian Conservation Corps Basketball Team ▲

These gentlemen were part of a program under FDR's administration to provide income to men in the 1930s and into the early '40s. The Emergency Conservation Work Act linked thousands of unemployed young men with gainful employment protecting the country's natural resources. They earned $30 per month; $25 went to their families back home and the remainder was kept for spending money. Left to right are: Marion Salerni, Eric Sucdberg, Jake Dawkins, Sam (Red) Blanton, Max Kimbrell, George Olney and Mr. Pratt. The CCC building in the background was torn down; a restaurant occupies the site today.
Submitted by Judy (Blanton) Meyer

A Visit to Grandma's House ▼

Virginia (Petit) Buero and Dorothy (Petit) Lahmeyer took the children to visit their mother and father at the Petits' home, 13 Spring St. Virginia, on the left, is holding Frank who is about a year old. Wallace, standing in front of his mother, is about 2 years old. Both boys grew up and joined the United States Coast Guard, eventually retiring from that service. Dorothy (right) is holding her daughter Sonya. Sonya and her husband Don Baxley live on James Island.
Submitted by LaVerne (Buero) Kennedy

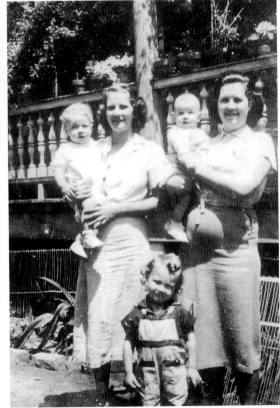

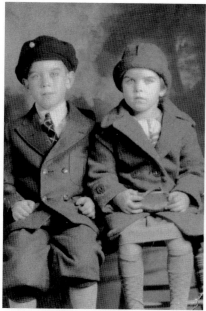

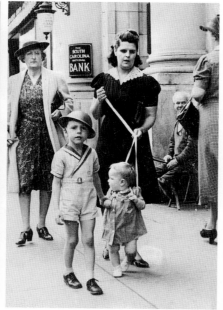

Shopping Meant King St. in the 1930s and '40s ◄

Shopping options may have changed since then but apparently shopping with children has not changed at all; little ones were just as difficult to keep hold of back then. Dianne Rowland, about 18 months old in this photograph was clearly distracted by something to the left, but her mother Veronica Rowland has a tight grip on the baby leash. Four-year-old brother Philip Rowland holds his sister's hand for good measure while smiling for the camera. It was customary at that time to get your photo taken by a street photographer on King St. He took pictures of almost everyone and then offered to sell the photograph to his subjects. Dianne (Rowland) Smith grew up to have six sons; she still lives in Charleston.

Submitted by Martha Fox

All Dressed Up For Pictures ▲

Claude and Dorothy Barrs were willing enough to have their photo made in 1936, as long as no one took Dorothy's purse. She seems to have quite a hold on that. The siblings lived in the city and attended Mitchell Elementary School.

Submitted by Dorothy Luhrs

A Presidential Visit ▶

President Franklin D. Roosevelt visited Charleston before boarding a cruise to Brazil in 1939. Although he could have sailed to Brazil from the northeast, Roosevelt chose to take a train to Charleston and leave from the Charleston Naval Base in order to save time. The war was already underway in Europe; the trip to Brazil was intended to demonstrate that America would stand with our South American friends. While in Charleston Roosevelt toured the city with Mayor Maybank, riding around town in the mayor's convertible Packard with one secret service man. Security was much different in 1939. Pictured next to FDR are Charleston Mayor Burnet R. Maybank and Charleston Mayor-Elect "Tunker" Henry W. Lockwood. Lockwood became mayor when Maybank was elected governor.

Submitted by Burnet R. Maybank

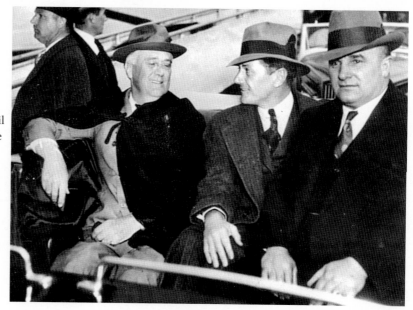

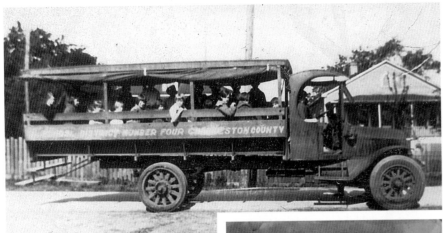

North Charleston's First School Bus ▲

These motorized wagons were owned and operated by H. Harrison Attaway. The school buses ran in School District No. 4 and St. Paul's District. Canvas flaps, shown rolled up near the roof of the bus, were lowered in the wintertime to provide some protection from the cold. Bus transportation has improved somewhat since that time.
Submitted by Eleanor (Attaway) Fuller

Play Date ▲

It was common to meet neighborhood friends at White Point Gardens in 1931; often nurses would take the children under their charge to the park for an afternoon outing. The Lucases employed Sarah Grant, whom the children affectionately called "Dah." "Dah" is pictured holding Virginia (Lucas) Drake on her lap. Jane (Lucas) Thornhill is on the second row, left, next to her brother Tootsie Lucas. On the bottom row (left to right) are childhood friends Harry Hutson, Henry Ravenel, James Ravenel, a child who could not be identified, and Elizabeth Williams.
Submitted by Jane L. Thornhill

Memminger Graduate ◄

Mable Cooper lived on Sullivan's Island in the early 1930s and caught the ferry to attend school at Memminger. Memminger was 11 grades at that time. Mable was approximately 16 years old when she graduated; she later married Edward W. Weekley.
Submitted by Eddie Weekley, Jr.

City Champions ▼

The Lemoco team took the championship in the early '30s, against other City League teams sponsored by companies such as Copleston's Dry Cleaning, American Tobacco Company and West Virginia Pulp and Paper Company. Leland Moore Paint and Oil Company sponsored the Lemoco players. Bottom row, left to right: Billy Sander, Allison Seigling, Freddy Huneken. Top row, left to right : Henry Fisher, Allen Ducker, "Bagger" Schroeder, and George Huneken (Freddy's twin brother).

Submitted by Joan Seithel

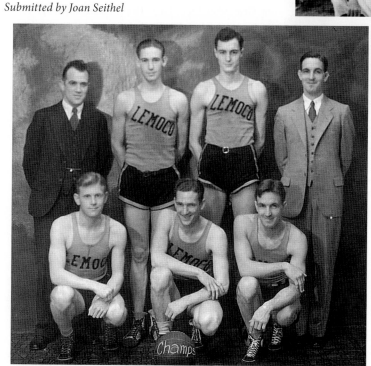

The Cambar Team ▲

Dayton W. Crawford (back row, center) was a salesman for Cameron & Barkley in the 1930s. He and several other employees played for the company's baseball team in a recreational league.

Submitted by Mary (Crawford) Finley

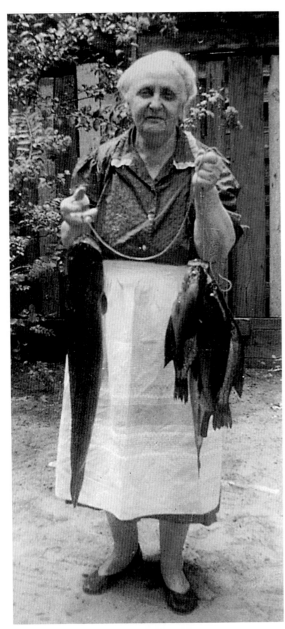

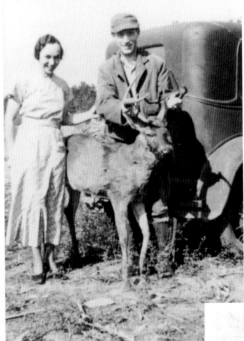

Deer Hunt ◄

Clarence Vaught is proud of the buck he brought home, which he displayed for photos. Clarence and his wife Anna are pictured somewhere in the Lowcountry around the time they were married in 1936.
Submitted by Blanche (Vaught) Lloyd

Shrimping with the Grandkids ▼

Emma Gardner Hackett took her two grandchildren shrimping at White Point Gardens about 1928. At that time there was a floating dock at the Charleston Harbor. Granddaughter Mary Alice Hackett, about age 13, displays the catch while her brother Harley Hackett, Jr. about age 9, hauls in more shrimp.
Submitted by Edward H. West

Looks Like Fish Is on the Menu ◄

Mary M. Hilton, Earl Hilton's mother, displayed her fine catch of redbreast caught in Goose Creek in 1939. Mrs. Hilton is pictured in her "fishing attire" before cleaning and cooking dinner. The photo was taken at 83 East Bay St., which is now 667 East Bay.
Submitted by Diane Zielinski

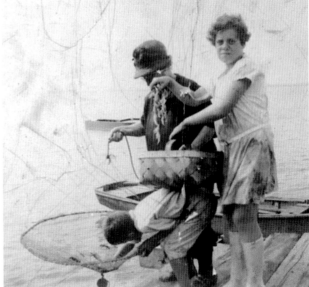

Saturday Afternoon at the Oakland Hunt Club ▽

Dressed for an afternoon of leisure, (left to right) Lawell Martin, Tom Martin, Harley Coachman and Frank Coachman enjoyed a buggy ride at Pineville's Oakland Hunt Club in the early '30s. The Martin brothers lived at the club where their father, Jimmy Martin, worked. Frank and Harley, also brothers, were visiting for the summer. The Hunt Club, formed in 1905, was a private club for deer hunting, dove shooting (in season), horseback riding, carriage and buggy rides, fishing, and picnicking with friends. Several families lived at the club. Belle Isle Plantation, now a part of the Oakland Club, was the home of Gen. Francis Marion. The "Swamp Fox" and his wife are buried on the property.
Submitted by Wilma R. Martin

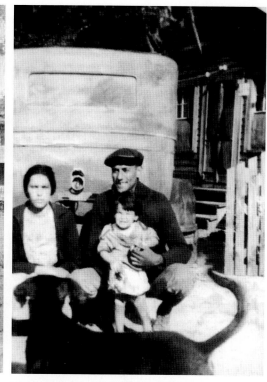

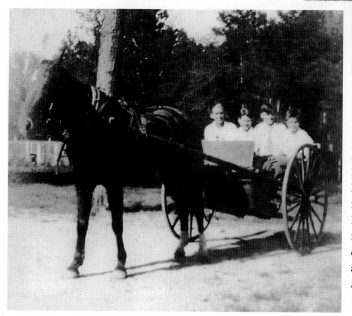

The Boylston Home at Rutledge Ave. ▲

Walter Presley Boylston, Sr. had his picture made in the yard of his home at 235 Rutledge Ave. around 1930. Boylston and his family lived in the home pictured on the left. He was a farmer on the Ashley River where the Rifle Club stands now. He also had farms in Barnwell County. Of his nine children, the youngest daughter is still alive at age 94.
Submitted by Anne (Boylston) Tokarczyk

On the Banks of the Edisto River ▲

The Reeves family and an unidentified canine were photographed in front of their home in 1935. Bessie Reeves (left) John Reeves and Gloria are sitting on the back of Reeves' Ford.
Submitted by Johnnie Lee (Reeves) Rowe

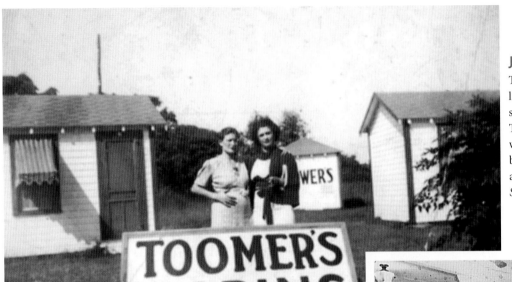

Jacksonboro's Finest Motel ◀

Toomer's Cabins was the place to stay in Jacksonboro in the late 1930s. Henrietta Winkle (left) and Lottie Reeves are standing in front of the quaint little cabins rented by the Toomers. The family also ran a restaurant across the street, which served cabin guests and locals. The building in the background is the "SHOWERS" facility for travelers staying at the motel.
Submitted by Johnnie Lee (Reeves) Rowe

North Charleston Recreation ▶

The recreation facility built by T.P. Gibson included a bowling alley in the late 1930s. Located on the corner of Montague, the facility was managed by Pop Davis. Although it was a very popular place during the war and the late '40s, especially with North Charleston High School students, its popularity waned and the bowling alley eventually closed.
Submitted by Donna Hill

"We'd Rather Be Chasing the Ducks" ▼

Little Frances (left) and William Edwin Bullwinkel, fraternal twins born in 1941 at Baker Hospital, paused long enough to have their photo taken at Colonial Lake with their mother. The twins, about 2 years old in this photo, lived around the corner on Smith St. and used to walk with their mother to the lake. Although they appear to have duck-chasing on their minds, their mother, Frances Elizabeth Bullwinkel, made sure they didn't budge, at least long enough for one picture.
Submitted by Robert W. Bullwinkel

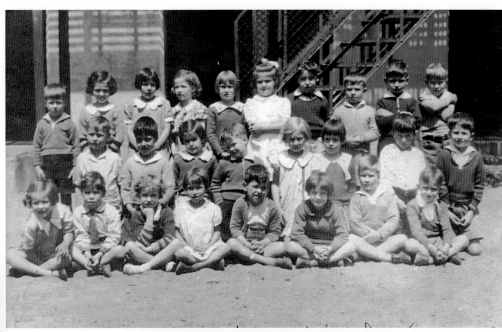

Crafts Elementary ▲

In 1934 Alvin Steinberg was 6 years old and in the first grade at Crafts, on the corner of Queen and Legare streets. His teacher, Miss Laura Brown, taught first, second and third grades. Those who could be identified in the photo include: Douglas Appleby, Ann Fitzsimons, Dorothy Ann Walker, Caroline Kennedy, Lucia Jenkins, Harold Holmes, Alvin Steinberg, Jenkins Crayton, Herman Balzano, Ann Jones, Gene Woodberry, Robert Figg, Frank Holmes, Phyllis Epps, Billy Matthews, Deloris Newman, Goldie Baker, Babs Roberts and Jackie Dempsey.
Submitted by Dr. Alvin H. Steinberg

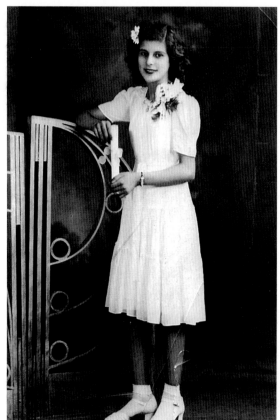

Sixth Grade Graduating Beauty ▲

Kyriakoula Nicholas Bazakas graduated from North Charleston Elementary School on Durant Ave. off Park Circle in 1938. Koula was 11 years old in the photograph, the child of a Greek father and a German mother who immigrated to America. The Greek custom was for boys, and girls, to take their father's first name as their middle name, so Koula's middle name became Nicholas. It was also the custom in those days for the father to select his daughter's husband, so Koula married the man of her father's choosing.
Submitted by Koula B. Malanos

The Queen of Sheba ▼

While working at Silver's Department Store on King St., 19-year-old Harriette Ackerman Huggins (pictured) was approached by a Hollywood representative to appear in the play, "The Queen of Sheba." This photo was taken at the Dock St. Theater in 1939, after its refurbishment by Works Progress Administration funds secured by then Mayor Burnet R. Maybank. The dress went back to Hollywood after the performance; Harriette went to Hemingway, S.C.
Submitted by Anne Lane

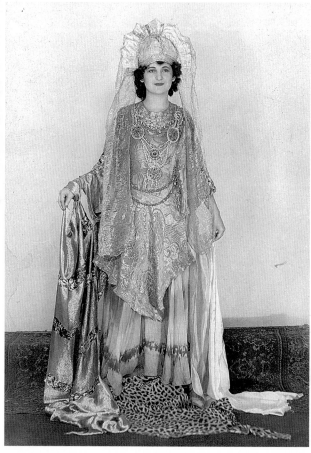

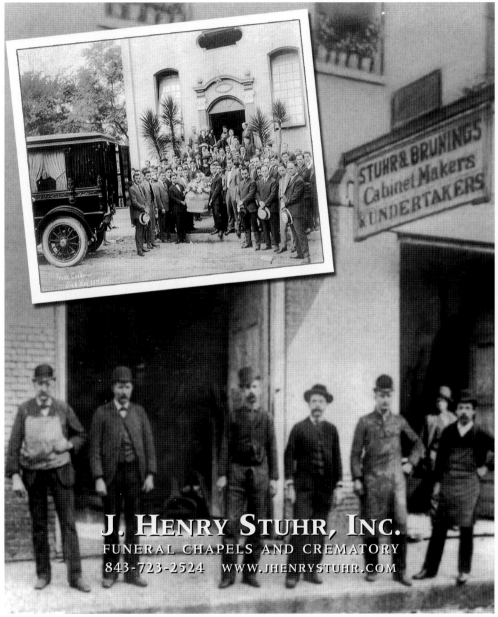

J. Henry Stuhr, Inc. represents the 5th generation of the Stuhr family as Funeral Directors in Charleston with more than 142 years of service to the community. Stuhr Funeral Home is the largest volume Funeral Service Operator and one of the oldest family owned businesses in the State of South Carolina.

In 1865, Henry D. Stuhr came to this country from Germany, settling in Charleston. That same year, he and John H. Bruning opened Stuhr and Bruning, Cabinet Makers and Undertakers. After purchasing 56 Wentworth Street from Samuel Meeker in 1881, Mr. Bruning sold his interest to Mr. Stuhr in 1894. Mr. Stuhr operated the business until his death in 1899 when leadership was handed on to his sons, J. Henry Stuhr and John Albert Stuhr.

The death of J. Henry Stuhr in 1922 prompted the business to become a corporation: J. Henry Stuhr, Inc., in 1923. The firm relocated to its present location at 232 Calhoun Street in 1941. J. Harry Stuhr and J. Albert Stuhr took over the family business upon the death of John Albert in 1936. And in 1982, J. Harry and J. Albert died within weeks of one another, leaving responsibilities to John Albert Stuhr, Jr., William Sanderson Stuhr, and J. Harry Stuhr, Jr.

J. Henry Stuhr's has flourished over the years. In addition to the Downtown Chapel, Stuhr's has funeral homes in West Ashley, Mount Pleasant, Goose Creek and North Charleston with two on-site crematories, also located in North Charleston. They also have a cemetery, Mount Pleasant Memorial Gardens located in Mount Pleasant. Stuhr's remains a trusted leader in the funeral industry, not only because of their longevity, but because of their ability to evolve with the needs of the community. Their active pre-need program educates families on the importance of planning ahead and offers them the opportunity to save on funeral costs. Their Aftercare Facilitator coordinates support groups, makes home visits and offers a comforting presence to those who are grieving. The Stuhr tradition and commitment of serving families extends far beyond the death of a loved one.

(pictured from left to right) W. Sandy Stuhr, W. Sandy Stuhr, Jr., Catherine L. Stuhr, Tim Stuhr, Frances Stuhr, and John Stuhr

J. HENRY STUHR, INC.
FUNERAL CHAPELS AND CREMATORY
843-723-2524 WWW.JHENRYSTUHR.COM

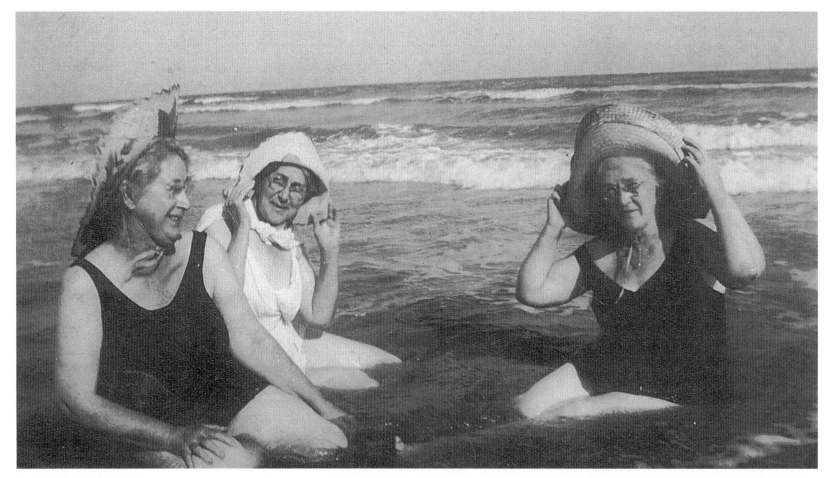

Sand, Surf and Sisters ▲

These ladies demonstrate that beach fun isn't just for the young, but also for the young
at heart. The tide rushing in and around your toes feels good at any age. Alice "Honey"
Rustin (left) enjoyed a visit with her sisters, Sally and Roxie, who were from Georgia. Alice
Rustin had a summer house at Isle of Palms where family used to enjoy getting together.
Submitted by Amy Rustin

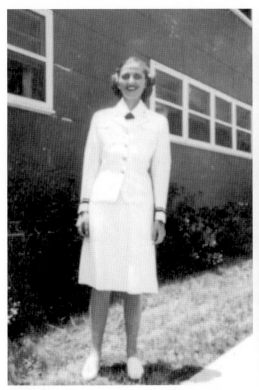

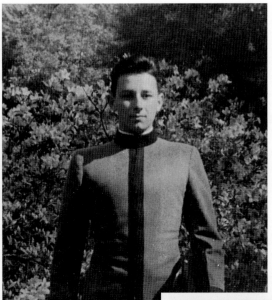

Citadel Cadet, Class of 1948 ◄

Peter Ziman, shown here in Hampton Park, was a senior at the time of this photo. After graduation he entered the Air Force as a second lieutenant and became an aerial photographer. He served in the military three years; when he left the Air Force he had made first lieutenant.
Submitted by Susan Ziman

A Royal Visit ▼

While recovering from a fractured spine in 1952, Fireman J.R. Bankston was treated to a visit by, not one, but three queens. During the Azalea Festival the ladies visited patients in the hospital. Left to right are: Miss Washington, D.C., Lynn Henderson, Miss Azalea Queen XII, Jean Neal and Miss Greenville, Dana Coleman.
Submitted by Naval Health Clinic Charleston

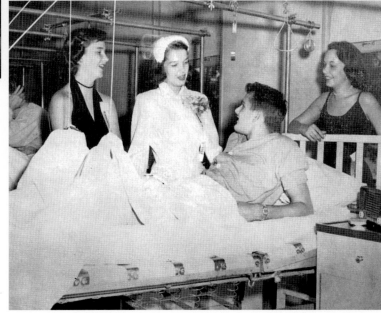

A W.A.V.E. in Charleston ▲

Doris Aileene Thomas was stationed in Charleston between 1942 and 1945 as a lieutenant in the W.A.V.E.S—a Navy acronym for Women Accepted for Volunteer Emergency Service. Similar in some aspects to Yeomenettes of World War I, the Navy accepted large groups of enlisted women in World War II and also female commissioned officers to supervise them. Miss Thomas' position required her to keep a schedule for the coming and going of vessels.
Submitted by Grace Bomar

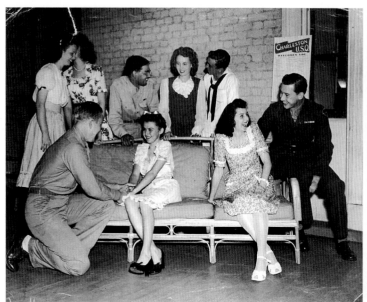

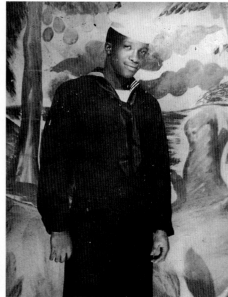

Anxious to Join the Fight ◄

Charles B. Washington, Jr. was about 16 when he joined the service. World War II was going on and he joined up early. He spent more than 25 years in the military as a cook in the Navy. He lived at 63 Lee St.; the family home is no longer there.

Submitted by Tara Reynolds

Charleston U.S.O. Welcomes You to the Joseph Manigault House ▲

In 1945 the Joseph Manigault House was used by the United Service Organization as a place where all branches of the military were welcome to dance, relax and enjoy light refreshments. Pictured left, standing on the front porch of this historic home at 350 Meeting St. are Margaret Thompson and Marie Readen and guests. The Charleston Museum's Joseph Manigault House, a National Historic Landmark, was built in 1803 by brothers Gabriel and Joseph. It stands today as a three-story testament to a Charleston's architectural heritage.

Submitted by Margaret (Thompson) Towles

Moultrieville, 1943 ▶

Shown just before they were married, Virginia (Tilson) Evans and Tod Evans stood on a street in "Moultrieville," now known as Sullivan's Island, in April of 1943. Evans was a Master Sergeant in the Army specializing in radar during World War II and was stationed there. At that time the island supported military personnel and just a few local residents.

Submitted by Sally Fisher

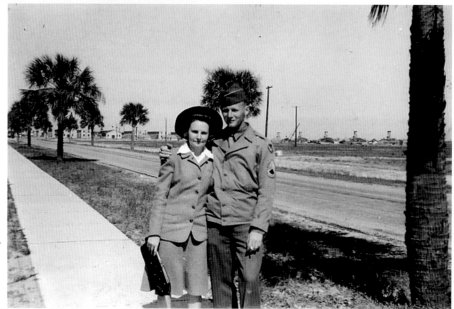

A Busy Day ▶

Margaret and Florence, two sisters, and their mother Margaret Driggers (also known as "Little Mama") had work to do in 1948. Margaret was tatting with the spool of thread at her side. Florence has a hoe in her hand, perhaps on her way to or from the family garden.
Submitted by Amy Freeman

Summerall Chapel ▽

In 1944 it was Summerall Chapel and very little else. George Reves (left) taught in The Citadel's Math Department in the late '40s and '50s. He is holding Jerry Reves; on the right is Bud Masterson.
Submitted by Jerry Reves

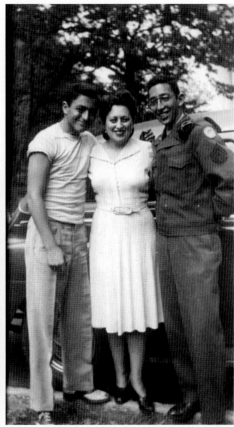

The Bernstein Boys ▶ ▲

Mildred Bernstein stood with her sons, Charles (left) and Maurice in front of their home at 97 Church St. Maurice was home on leave from the Army, where he served as a Tech Corporal. Maurice was 18 at the time; Charles was 15. Both boys attended the High School of Charleston.
Submitted by Charles S. Bernstein

Daddy's Home ▼

Arthur W. Allison, III got just what he wanted for his first birthday: a visit from his daddy. Arthur's father is Capt. Arthur W. Allison, Jr., United States Air Force.
Submitted by Arthur W. Allison

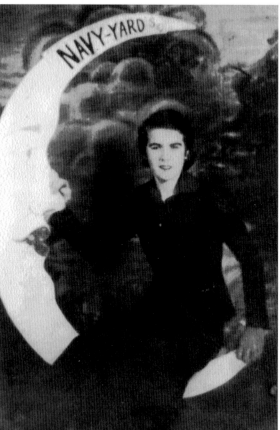

Fort Moultrie, 1942 ▼

Yes, the date is accurate, although the helmet pictured is quite a bit older. Tod N. Evans was stationed on Sullivan's Island at Fort Moultrie in January of 1942; the war was only one month old but the soldiers were still using 1918 helmets.
Submitted by Sally Fisher

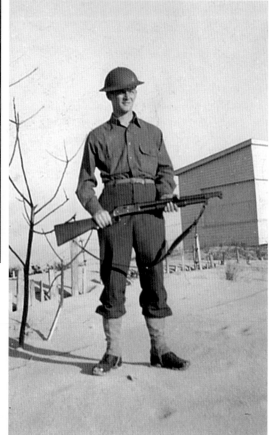

Swingin' on the Moon ▲

Catherine Oliver Poole was about 20 at the time of her moon ride at the Navy Yard in 1940. She is the daughter of David and Catherine Oliver, who owned Oliver's Grocery on Reynolds Ave. between the 1930s and '50s.
Submitted by Mrs. Joe E. Still, Sr.

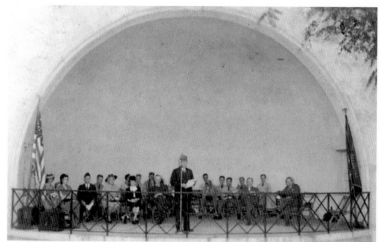

Marion Square Event at the Old Bandstand ◄

April 20, 1946 was the beginning day of Child Welfare Week and the event was commemorated in Marion Square Park. Pictured on the far right is Chet Nowak, Sr. who was with the Palmetto Post 112 American Legion.
Submitted by Chet Nowak

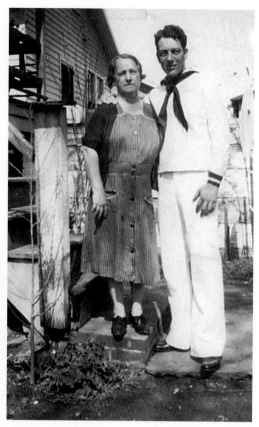

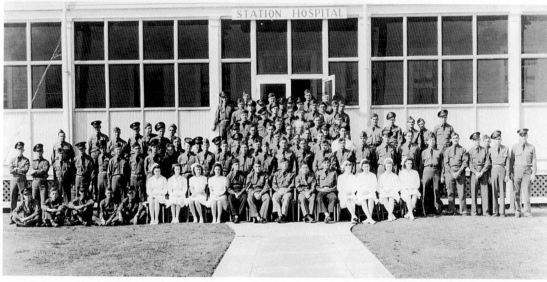

Station Hospital, Fort Moultrie ▲

This picture, taken between 1941 and 1943, shows the old Station Hospital at Fort Moultrie, Sullivan's Island. The town at that time was known as Moultrieville. Shown in the photo are Lt. David E. Hawkins, Jr. and Lt. Grady P. Darnell.
Submitted by Martha Ohlinger

My Son, the Sailor ▲

Orrin Patrick Ryan (right), home on leave from World War II in 1942, enjoyed some time with his mother, Rosalie Ryan. Orrin, or Uncle O.P. as the kids called him, was serving aboard the heavy cruiser U.S.S. Tuscaloosa. Ryan served a total of 22 years in the military. The family lived at 138 North Tracy St., a one-block street that ran between Moultrie and Huger streets. North Tracy was a blue-collar neighborhood, made up of dock and shipyard workers and policemen.
Submitted by Michael Young

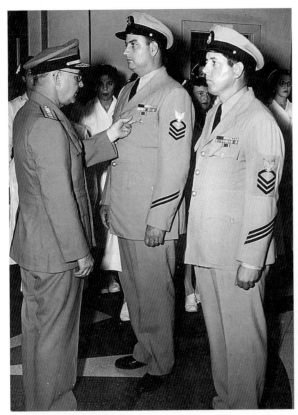

Awards Ceremony ▲

Rear Admiral R.W. Hayler, Commandant, Sixth Naval District, presented the Navy Unit Commendation Ribbon to John W. Faulkner, HMC USN, for service in the U.S.S. President Adams and to Harry S. Wilson, HMC USN, for service in the U.S.S. Brooks. The commendations were awarded in the foyer of the main hospital July 15, 1949.
Submitted by Naval Health Clinic Charleston

Shore Leave ▼

Edward R. Fennell, photographed with his mother Nina at White Point Gardens, was home on leave from the Navy. Fennell was about 20 years old in the picture, around the close of World War II. His military service continued during the Korean War as well.
Submitted by Edward C. Fennell

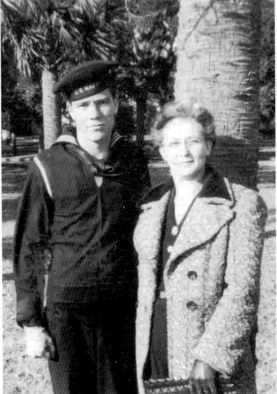

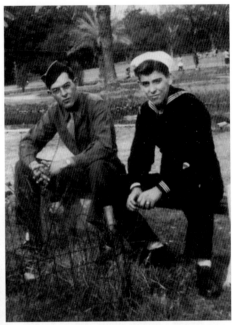

Two Brothers On Leave from the War ▲

Taso and Johnny Misoyianis were both on leave from World War II at the same time in 1943. They are pictured here in Hampton Park, watching the ducks. Taso (left) was about 22 at the time, a private in the Army infantry under Mark Clark. Johnny (right) was about 18, a third class parachute rigger in the Navy. Johnny recently designed a World War II specialty license plate; the tag is available to South Carolina veterans of the Greatest Generation.
Submitted by Johnny Misoyianis

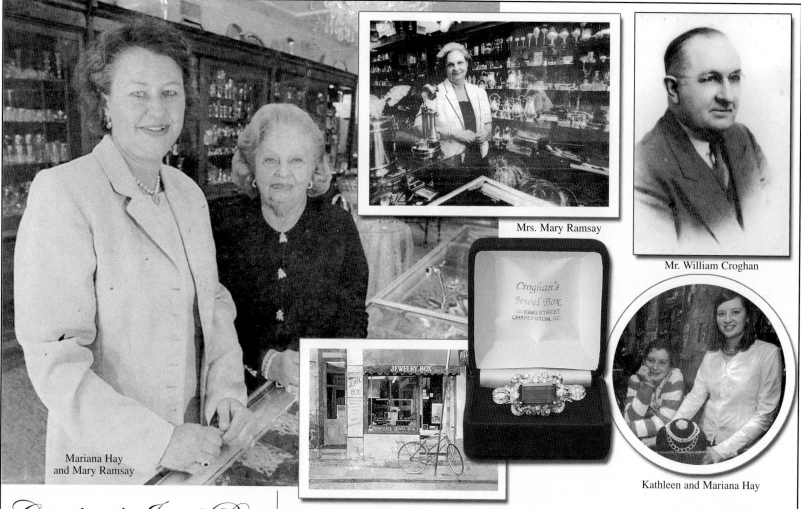

Mrs. Mary Ramsay

Mr. William Croghan

Mariana Hay
and Mary Ramsay

Kathleen and Mariana Hay

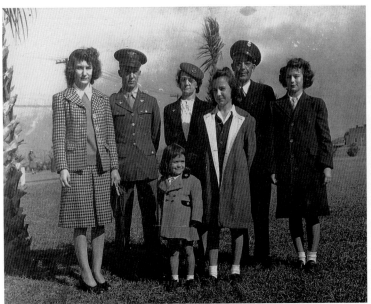

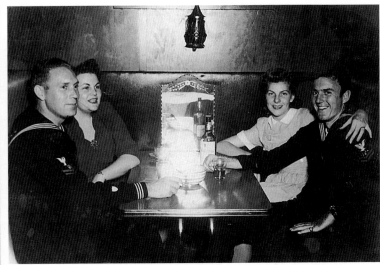

Getting Together at the Rathskeller ▲

Before there was Jimmy Dengate's, there was the Rathskeller, located at 14 Courthouse Square, below street level. It was 1945 and the two men pictured were in the U.S. Coast Guard stationed in Charleston. Floyd Napier (left) was dating Hilda Reeves and Chuck Wireman (right) was dating Hilda's sister June. Both couples married and remained in Charleston. The Rathskeller, run by Jimmy Dengate, later moved up to 714 Rutledge Ave. and was known as Jimmy Dengate's Restaurant and Bar for years.
Submitted by Anna (Wireman) McAllister

Thanksgiving at the Charleston Naval Base ▲

Navy Chief John P. Moore (second from the right) was assigned to the Charleston Naval Base in 1944 so most of his family gathered at the Naval Air Station for the holiday meal. At the time the Air Station was home to several blimps that patrolled the coast looking for enemy subs. Louelle (Burton) Moore is to the left of her husband. Five of their seven children, pictured left to right are: Marcia (Mrs. Fred Nolte), James, who was an Army Air Corp Cadet, Mary (Mrs. Tom Smith), June (Mrs. William Milligan) and Louelle (Mrs. Ted Bolchoz).
Submitted by Elizabeth Pate

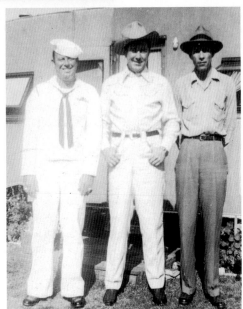

Surf Meets Turf ◄

In 1945 Johnny Mack Brown's Hollywood film career was bustling. That year Monogram released six Westerns and one drama starring the Dothan, Alabama cowboy film star. It was also the year that Brown (center) visited Charleston. When he asked someone where to go for a good shrimp dinner, Red Blanton (right) "directed" Brown to The Hanover on Meeting St. Apparently Blanton's recommendation was so good that the two became friends and visited each other for years to come.
Submitted by Camilla Blanton

Wash Day ▼

Pallie (Owen) Branham was barely a teenager in 1944 but it was her job to do the family laundry once a week at their Fairhaven Trailer Park home. The trailer park was in the North Area between Mixon and Helms avenues. Behind Pallie and her washtubs is her cousin's garage, where he kept his precious "A" model car. Residents of the trailer park were more like family than friends, with lots of children playing "War" and the grown-ups playing horseshoes in the evenings.
Submitted by Pallie Branham

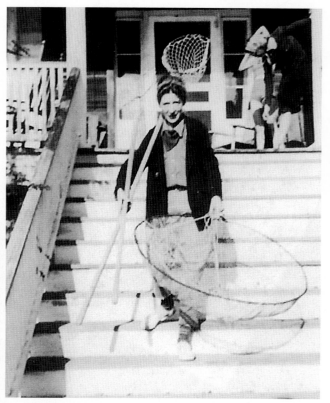

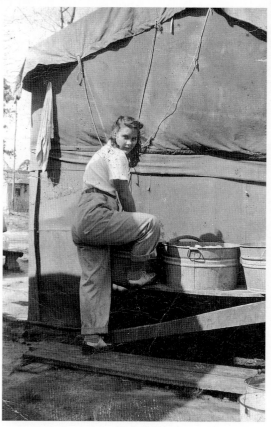

Going Crabbing ▲

Maybell Witham Walker loved to go crabbing in Charleston in the late 1940s, something she couldn't do in Washington, D.C. While she was single she split her time between Washington and her home at 118 Broad St., between King and Legare streets. The Cathedral of St. John the Baptist Church's parking lot occupies the location today. She is shown leaving the house on a crabbing trip with two nets: the bigger net would contain chicken necks tied in different areas around the net. As blue crabs crawled in, she would pull the net and dump the crabs into a wash bucket. Inevitably some crabs would get loose so she used the smaller net to scoop up the "ones that got away." Charlestonians would crab all day long and, after boiling them, they would "pick" crabs around a large dining table covered with newspaper, enjoying conversation and eating fresh crab meat right from the shell.
Submitted by Dottie W. George

Padgett's Drive-In ◄

Drive-ins used to be all the rage, at one time, but in 1946, they were a relatively new phenomenon. Padgett's Drive-In, on Rivers near Durant Ave. and the train station in the North Area, is believed to be the first drive-in to show outdoor movies. To the left of the photograph there is a small screen mounted in a tree. Mae Padgett, owner of the drive-in, spent much of her time in the kitchen preparing food for customers of the short-order restaurant. Casper Padgett, pictured on the left, serves queued-up customers. It appears the first man in line already has his hamburger, and the second man, Navy Warrant Officer Paul Burch, has his wallet out in preparation for payment.
Submitted by Ron Padgett

A Boy and His Dog ▶

Six-year-old Pete Rugheimer, Jr. and his bulldog-mix side-kick Butch spent many hours riding up and down neighborhood streets in the '40s. The family lived at 37 Montagu; the residence still exists but the garage pictured in the background was torn down years ago. Pete's father owned a custom tailoring firm at 202 King St. in the Rugheimer Building which is now the home of Fulton Inn. The tailoring firm, started by Pete, Jr.'s great grandfather John Rugheimer, made all of The Citadel cadet uniforms for a number of years.
Submitted by the Rugheimer family

Bouncing Baby Boy ◄

Little 6-month-old Bobby Anderson bounced on Janie Davis' knee in the back yard of 305 Broad St. in 1945. The house in the background was a Coast Guard house; it was moved there with an address of 8 Chisolm.

Submitted by Brenda Anderson

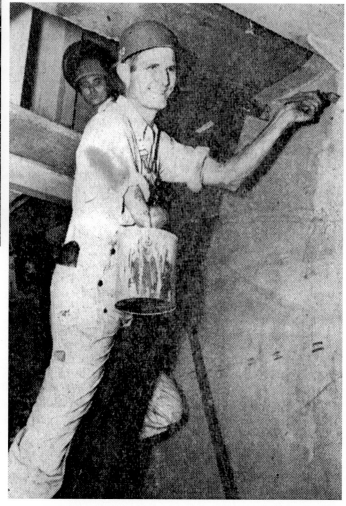

Man Refused to Let Handicap Slow Him Down ▷

Bennie D. Floyd was injured in a hunting accident on Christmas Day when he was 14 years old. A double-barreled shotgun fired one shot at the bird he was hunting; the other barrel misfired and shot him in his right arm. Floyd did not let the injury slow him down, however. He played basketball in his school years and worked as a painter at the shipyard. He insisted on wearing work boots with shoelaces and tying his own tie; nobody waited on him. The shipyard highlighted Floyd in its newspaper because of his handicap but he made it clear that wasn't how he viewed things: "I can slosh as much paint as any of them," the right-hander said. Floyd and his wife raised seven children; they lived in Liberty Homes in North Charleston. Floyd worked for the shipyard until he retired.

Submitted by Rose Martha F. Motte

Bears Love Honey ▼

And a honey sandwich is even better! At least this bear at Hampton Park Zoo back in the mid-'40s seemed to like the delicacy offered by Ray Owen. The zoo, which was situated on the side of the park closest to the ball field, is no longer there. At one time though, it was locally famous, housing such wonders as a crow that sang "South of the Border," and peacocks that ran loose on the property. Gold Bug Island was another big attraction in the park, an amusement that was representative of Edgar Allan Poe's short story set on Sullivan's Island titled, "The Gold Bug."
Submitted by Pallie Branham

Reeves Fish Camp on the Edisto River ◄

John and Bessie Reeves ran a fish camp, which included boat and cabin rentals, a restaurant and a total of eight cabins eventually. People came from Greenville, Spartanburg, Columbia and North Augusta to stay for a weekend or a week, do a little fishing or hunting and enjoy the pastoral surroundings. Bessie ran the restaurant; she is pictured here in the mid '40s with a mess of redbreasts, cat fish and trout she and her fishing party caught. The door on the left of the photo is the front entrance to the restaurant; that was the only place to eat unless guests cooked for themselves over a campfire. To the right of the photo a cabin is visible, nestled among the trees. The family home is still there today.
Submitted by Johnnie Lee (Reeves) Rowe

Pullling in the Anchor ►

Chet Nowak, Jr. and Mr. McCartney worked together on the *Marmac*, Oct. 10, 1948. The boat was docked at Wappoo Creek after a day of riding around on the water.
Submitted by Chet Nowak

Early Exposure to Estuaries ▼

Two-year-old John Carroll Doyle was always exposed to fish as he grew up. His father, Harry Doyle, Sr. and a fishing buddy caught these bass somewhere out towards Folly—possible Wappoo Creek or Bowens Island—in 1944. Doyle, an artist, grew up to paint cover illustrations for sport-fishing magazines. His artistic interpretations of Charleston's landscapes and wildlife decorate the walls of some of the city's favorite restaurants.

Submitted by John Carroll Doyle

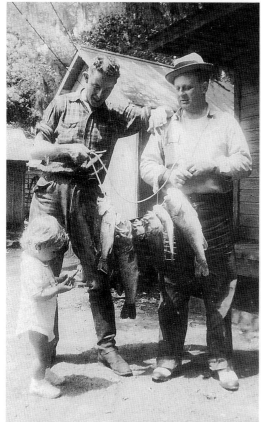

Carolinas Doubles Handball Champions ▼

Before professional sports, state and city events were huge. In 1942 Otis Skipper (left) and Howell Lemacks were the equivalent of sports celebrities when they won the two-state (North and South Carolina) tournament. This photo was taken at the YMCA on George St. (now the College of Charleston basketball building), after the two partners returned home. The men, both 24 at the time, are still the youngest men to hold the title of Carolina Doubles Champions.

Submitted by Joy (Skipper) Cornwell

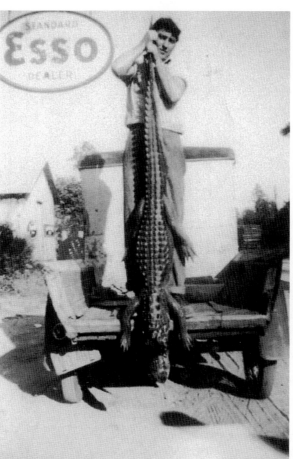

Quite a Handful ▲

Vinnie Limehouse proudly displayed his "catch" outside his father's general store in the 1940s. Vinnie's father, Loyless Limehouse, owned L. B. Limehouse General Merchandise Store in Ladson. The store was the center of the small community of mostly farm families and Charleston defense workers in those days. It stood on the corner of Highway 78 where a Kentucky Fried Chicken stands today.

Submitted by Lynn Limehouse-Priester

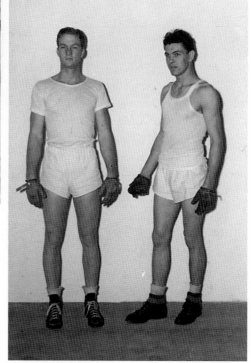

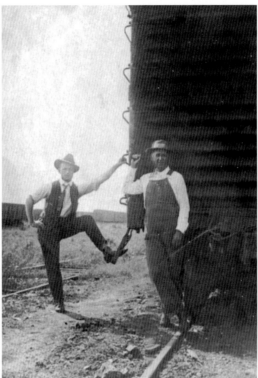

Toddling After the Toddler ▾

Baby Margaret seemed interested in something, while her mother Clementine Couch made sure she doesn't get into any trouble. Margaret's father worked at the Navy Yard; the family lived at 137 N. Tracy St. at the time of the photo, around 1937.
Submitted by Margaret Ripley

Welcome Home to Nafair ▴

Aileen Mercer (left), Ann Knox and Doris Lake stood in front of "The Ideal Home Site" in 1941 where Dorchester intersects with Rivers Ave. The homes, built by Long Construction Co., are still there. The Federal Housing Administration built the homes for Navy Yard employees.
Submitted by Aileen (Mercer) Long

Yardmaster at Atlantic Coast Line, Charleston ▴

Yardmaster Henry Hackett became a railroad man when he was 16 years old. He is pictured here at the Charleston yard near Columbus St. and the Cooper River about 1950. The yardmaster was responsible for overseeing all activities including assembling trains, scheduling, and coordinating trains coming and going out of the Charleston rail terminal.
Submitted by Edward H. West

Beach Creatures ▼

It looks as if Florence Read (right) is showing the children some sort of sea life on Folly Beach in 1946. Suzanne (Read) Thomson (left) Rosemary (Read) Cohen (center) and Jane Rubin, a cousin from Columbia, seem ready to look but not as eager to touch. The family rented a house on Folly every year for at least a month, and sometimes for the entire summer before purchasing a home later on East Arctic Ave.

Submitted by Rosemary Cohen

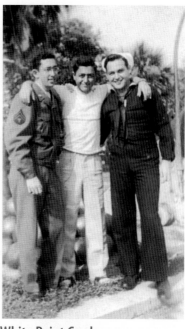

A Good Spot to Squat ▲

Pallie (Owen) Branham must have thought this tree would be the perfect spot to take a photo in the summer of 1947. The two women at the foot of the tree, identified as Pricilla and Aurilla, preferred terra firma.

Submitted by Pallie Branham

White Point Gardens ▲

Maurice "Tiny" Bernstein (left) stood with his brother Charles "Charlie" Bernstein (center) and Bernard Solomon on the Battery at White Point Gardens around 1947. At the time of the photo "Tiny" was about to finish his service in the Army. After being discharged, he attended The Citadel as a veteran student and graduated in 1953. All three men graduated from the High School of Charleston. They have remained close friends for more than 60 years.

Submitted by Marcia Bernstein Shealey

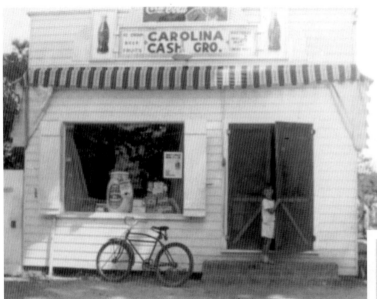

More Than Just A Neighborhood Grocery ▲

Back in 1942 the Carolina Cash Grocery sold ice cream, beer, fruits, vegetables, fresh meats and luncheon meats to Carolina Terrace neighborhood families such as the Hanckels and the Ravenels. The store was located across the street from where the Coburg cow is now; Firestone Complete Auto Care now occupies the spot. As one of the first retail stores west of the Ashley on Savannah Highway, they functioned as more than just a mercantile, however; W.T. and Mamie Ilderton's business was a part of the community. The boy in the photo, James W. Ilderton, Sr., worked in his parents' store. He remembers a civil center on Coburg land across the street where St. Andrews Shopping Center is now. Men going off to World War II would meet there to catch buses bound for Fort Jackson in Columbia. "My father would open up the store early so the men could get a bite to eat and drink before having to get on a bus," Ilderton said. His job, at 9 years old, was to let 12 men in at a time, then close the doors until they were finished. Then he would let 12 more in until they were all served. "My father felt sorry for them," Ilderton said. The sign in the window reads, "NAVY CALLS MEN 17-50."
Submitted by Jane Ilderton

"Faytsie" Read ▼

A family member brought a chair down to the beach for Fredericka Lief Read so she could enjoy the beach in the '40s. Mrs. Read was married to Frank Read, owner of Read Brothers on the corner of King and Spring streets. Frank Read built the three-story building at its current location in 1912, offering two floors of retail items such as bolt cloth, shoes, hats, men's work clothes, china and children's dolls. Nothing in the store cost more than one dollar at that time. The family lived on the third floor.
Submitted by Rosemary Cohen

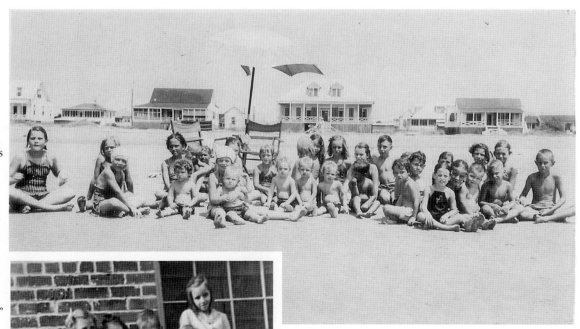

Birthday Party on the Beach ▶

Legare (Coker) Kane turned 9 years old in June of 1944; she and her friends were summer residents on Sullivan's Island. The party revelers had their photo taken in front of Station 22. The children who could be identified are: Deryl (Maybank) Hagood, Lavinia "Babe" (Maybank) Grimball, Betty Craig (Rivers) Levine (in bathing cap), Martha (Rivers) Ingram, Frances Hanahan, John Hope, Jaqueline (Walker) Dunbar (in bathing cap), Henry Walker, Harriet (Maybank) Hutson, the Maybank triplets—Tommy, Jackie and David, Anne Melton Ford, Betty Poulnot, Barney Baker, Mary Ross "Dede" Hanahan, Cynthia (Simmons) Corley, Betsy (Baker) Ford, Hinson Coker, Bill Robertson, Legare (Coker) Kane, Betsy (Whitaker) Tezza and Arthur Schirmer.

Submitted by Cynthia (Simmons) Corley

Robert Mills Manor ◀

These children are pictured in front of the Robert Mills Manor in the early 1940s. Those who could be identified are Mary Ellen Nolan (first row, third from the left) and June Jenkins (first row, second from the right).

Submitted by Mary Ellen Drolet

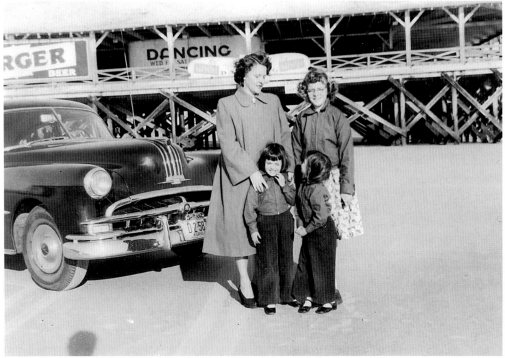

Sunday Afternoon Drives on the Beach ▲

The Crawford family lived at Folly during the summer but during the school year they lived in the city. In the off-season Dayton Crawford would take his family on Sunday afternoon drives to check on the house. Pictured is Frances Crawford with their children Eleanor (age 11), and twins Mary and Margaret, 5 years old. The original pier is in the background; the car is parked on the beach.
Submitted by Mary (Crawford) Finley

In Support of the Troops ▼

Ruth Elizabeth (Champion) Glover agreed to be photographed by a friend who worked for the Air Force magazine. Almost every base had its own publication, and Ruth's picture "to Joe" was published in 1945. At the time Ruth was engaged to Joe, an airman stationed in Charleston. She didn't marry him though; Buffalo, N.Y. was too cold for the Southern girl.
Submitted by Ruth Glover and Ranne (Glover) Hammes

Even the Car Seems to be Smiling ▼

Ben Polis, who was stationed at the Charleston Naval Base, and Gussie Toporek, a graduate of Memminger School, spent a day at Folly Beach in 1941. The "smiling" car belonged to Ben; the make and model is uncertain but Ben was partial to Packards.

Submitted by Robert A. Seigel

Old Folly Pier ▲

Maggie Smith (left), George Lempesis, Mary Scott and little Nick Lempesis enjoyed a day on the beach in 1947. The Lempesis family lived at Folly Beach and spent many summer days at the Pavilion on the rides. Nick's grandmother had a hot dog concession on the boardwalk; life was good for a youngster, growing up.

Submitted by Nicolas Lempesis

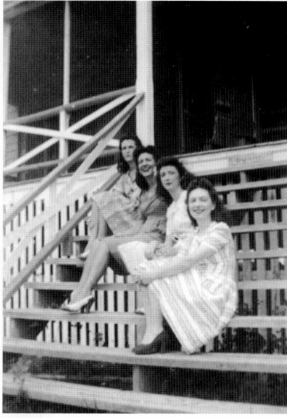

"Just Us" ▲

Mary, Mattie, Gertrude and Genevieve Duane are sitting pretty on the steps leading up to their family's "island house," as their mother called it. The Sullivan's Island property at Station 27 ½, 2714 Brooks St., was purchased in the 1930s; Hurricane Gracie destroyed the house in 1959. It was literally lifted up, intact, and dropped several feet away, like Dorothy's house in "The Wizard of Oz." The property is still owned by the Duane family and a small cottage stands on the site today.

Submitted by Mary Coy

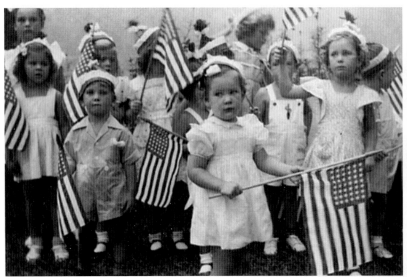

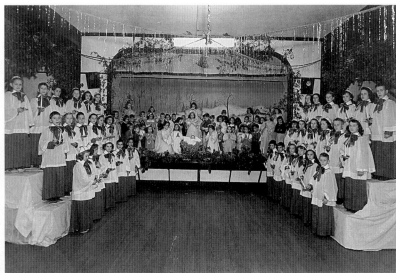

Happy "Fourth" ▲
It was Jerry Reves' fourth birthday Aug. 14, 1947 so they celebrated with a "4th-Themed" party, held at Jerry's parents' home on The Citadel campus. Jerry is now the Dean of the College of Medicine and Vice-President of Medical Affairs at MUSC.
Submitted by Jerry Reves

Angelic Student Body ▲
The students of Cathedral of St. John the Baptist Grammar School on Queen St. performed the Christmas story in the school hall, 1947. The tall angel, standing on a chair in the center back of the photo is Rose Mary (Chapman) Willson. Her sister, Carolyn, is standing on the left side of the stage dressed in a dark sweater with a white collar. The school in no longer there. It has been replaced by townhouses.
Submitted by Rose Mary (Chapman) Willson

Baker Hospital at Colonial Lake ◄
Patricia Felder remembers playing at Colonial Lake as a 3-year-old in 1947. Her mother, father and two brothers lived on Cromwell St. She has fond memories of her uncles coming by to get her for a stroll around the lake, spending many hours fishing and feeding ducks on Sunday afternoons. It was a clean, safe place for a child to run around. Baker Hospital is pictured in the background.
Submitted by Patricia (Felder) Overbaugh

A Mother and Daughters ▷

Jane Fry is pictured in front of her mother, Myrtice, in this family photo taken around 1943 or 1944. Myrtice Fry is holding baby Anne.
Submitted by Anne Fry

Little Red Riding Hood ▽

Barbara Ann (Brannon) Cass had the lead role in "Little Red Riding Hood," a children's production by Footlight Players under the direction of Emmett Robinson in 1945. The photo was taken with a "Brownie Box" camera, still owned by "Red," who was 11 years old at the time. The Brownie was developed by Eastman Kodak primarily for use by children and sold for $1. By this time there were numerous photography shops where the film could be developed.
Submitted by Barbara Ann (Brannon) Cass

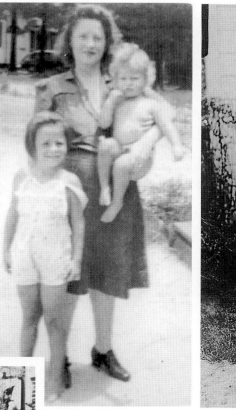

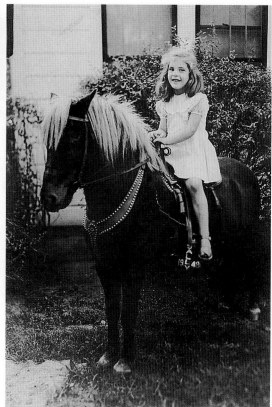

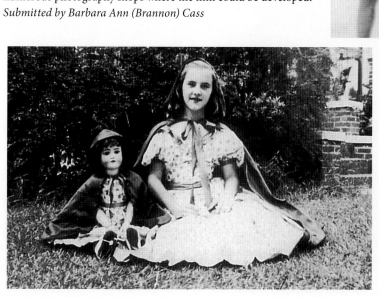

Ride, Sally, Ride ▷▲

Five-year-old Dottie Ashley took a turn on "Sally" the Pony in 1949 at a friend's home near Hampton Park. Sally the Pony, according to Mrs. Ashley, was trotted around Charleston neighborhoods by a man who went door-to-door taking pictures of children on the pony. The photos were then offered for sale to the parents. Mrs. Ashley taught at St. Andrews High School on Wappoo Road and at Rivers High School. She has worked as the arts writer for The Charleston Post and Courier since 1992.
Submitted by Dottie Ashley

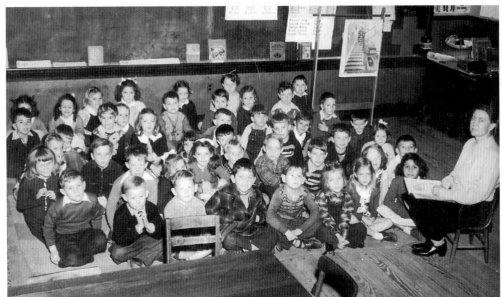

Mt. Pleasant Academy's 1st Grade Class ◄

Ms. Johnstone (seated at the right) managed a class of 45 students at the old two-story grammar school in 1946. The junior high and high schools were housed in a separate, one-story building. The school is gone now; Moultrie Middle School is taking its place.

Submitted by Carol Way

Kelly Kindergarteners in Costume ▶

The 1948 class of Kelly Kindergarteners put on a frightfully delightful display in their Halloween parade, with at least two skeletons and what appears to be one of Snow White's seven dwarves. Ms. Bell, their teacher, stands behind Veronica Wolfswinkel, who is wearing a horizontal striped polo shirt and vest for the occasion. Apparently the children crafted the headgear themselves, and many of them seem to be holding candy apples in honor of the occasion. The kindergarten was on Huger St. near Sacred Heart Church, which is pictured in the background.

Submitted by Veronica Wolfswinkel

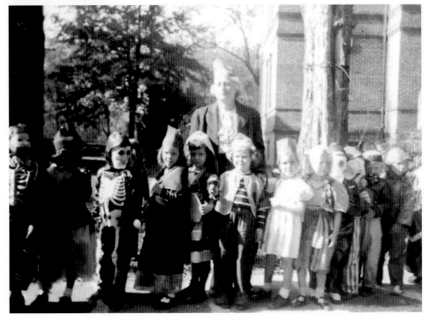

The Corner of St. Philip and Spring ▼

Joseph D. Read, of Read Brothers, is pictured on Spring St. in 1948, when traffic on Spring was still two-way. Buicks, like the one pictured in the foreground, weren't always the only means of transportation along this main peninsular artery, however: note the trolley car tracks shown on the left. The tracks had ceased to be used by 1948.

Submitted by Rosemary R. Cohen

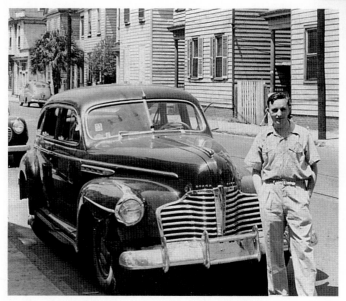

Grandfather Comes for a Visit ▲

Two-year-old twin girls Judi and Susan Blanton always enjoyed a visit from their grandfather, Moody Saunders. Saunders lived in Walterboro where he worked as a contractor. Although Grandmother couldn't come on this visit in 1944, it didn't stop the girls from an outing with Grandfather. During the war years the Blantons lived in town in a trailer.

Submitted by Camilla Blanton

Well-known Novelist and Poet ▲

Katherine Drayton Mayrant Simons (left) spent her life writing short stories, poetry and novels from her uncle's home. She is pictured here in 1949 with William R. Mayrant on the steps of his residence, 26 Gibbes St., and her nephew Ambler Simons (right). Writing under the pen name, Drayton Mayrant, Miss Simons wrote nine historical novels, two of which received national book club awards. She was preparing to go to a book signing party in this photo.

Submitted by Ambler Simons

Last Avery Normal Institute Faculty ▼

Avery Normal Institute trained black students to become teachers. Their graduates had the equivalent of two years of college. In 1947 the school continued as a public school and continued as Avery High School until integration in 1954 when students moved to Burke High School. Left to right, back row: Carutha Williams, Isabell Coaxum, Alphonso Hoursey, John Davidson, Hattie Green, John F. Potts. Second row: Geneva P. Singleton, Ann Duncan, Francis C. Thomas, D. Jack Moses, John Howie, Michael Graves, Luther Bligen. Front row: Margaret R. Poinsette, Lois Moses, Johnnie Johnson, Cynthia McCottry, Esther Manigault, Lucille Williams, Charlotte Tracy.
Submitted by Cynthia (McCottry) Smith

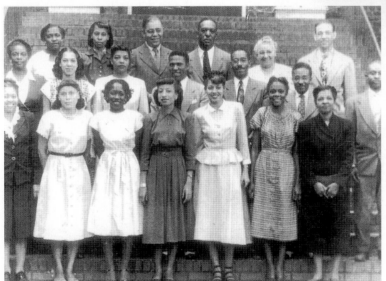

Let's Go Shopping ▲

Doris (Thames) Harmon (left) and Amy (Thames) Clayton shared boiled peanuts and an afternoon of shopping in 1948. The sisters, age 20 and 26 respectively, were born in Awendaw but moved to Charleston in the mid-40s. Both women and their families lived on State St. at the time.
Submitted by Wendy Keenan

A Night at the Armory ▲

Henny (King) Miles and Ralph Jenkins took to the dance floor at the Armory at The Citadel in 1948. Popular dances back then were the jitterbug and shag, and live music was de rigueur. Henny was 18 at the time; Ralph was 21 and a veteran student at The Citadel. At the end of World War II The Citadel allowed returning veterans to attend in a civilian capacity. This policy was kept through the class of 1950, after which time veterans could attend but could not live in the barracks.
Submitted by Ralph Jenkins

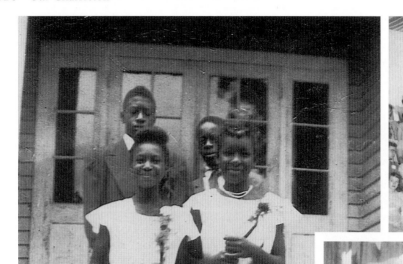

Graduation Day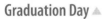

Standing in front of Lincolnville Elementary School in 1949 are graduates Mildred Muldrew (left) and Rosalee Williams. Behind them on the left is Freddie Hardee; Charles Deweese is on the right. The school no longer exists; the Charles Ross Municipal Complex stands on the site now.
Submitted by Christine W. Hampton

Activity Festival ▲

The North Charleston High School Activity Festival was a celebrated event in 1948. It was a chance to decorate the auditorium with crepe paper and dress up, recognize the king and queen and take part in a big dance that evening.
Submitted by Margaret Ripley

Wedding Day, 1941 ▷

When Joseph and Dorothy Preston married Dec. 18, 1941, he was in the Army. After World War II, Preston returned to work at the shipyard and the couple made their home on St. Philip St. He retired from the shipyard after nearly 40 years; Joseph and Dorothy raised six children and shared 55 years of marriage together.
Submitted by Roberta Richardson

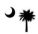

Old Memminger Wall ▶

It was the spring of 1948 and these Memminger 10th-graders took a break from studies by the old wall. At that time boys went to the High School of Charleston and the girls attended Memminger where they received diplomas in one of three areas: Classical, which involved four years of Latin; Sciences, which required four years of science; and General, which was a combination of disciplines. Pictured left to right are: Mary Goblet, Joyce (Steedly) Murphy, Nancy Harrison and Betty Jean (Parker) Guthrie. The school is an elementary school now, but that old wall is still standing, running along St. Philip St. and turning back on Beaufain.
Submitted by Joyce (Steedly) Murphy

Rivers Junior High School Students ▼

Although the school on upper King St. is now closed, these seventh grade students are preserved for posterity in a 1942 photo taken by their teacher. The students who could be identified are Doris Strickland (second from the left, front row), Pearl Rudick (center, front row) and Theresa Knight (far right, front row). The school was located near Hampton Park, next to Charleston County Hall where name bands, such as Dean Hudson among others, used to play.
Submitted by Theresa Covington

College of Charleston Commencement ▼

In the processional from the steps of the chapel behind the Cistern is the graduating class of 1946; the conspicuous absence of men is due in large part to the fact that most boys of college age were fighting in the war. Elizabeth Mouzon majored in English at the college; she is pictured in the second pair of women, on the right hand side. Other graduates included Frances Jenkins, Jonolyn Stehmeyer and Marjorie Stapleton.
Submitted by the Sadler Estate

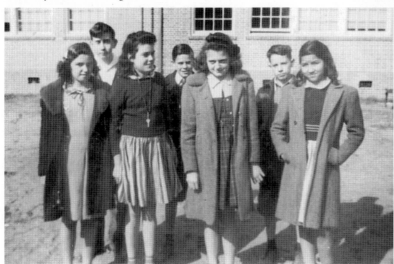

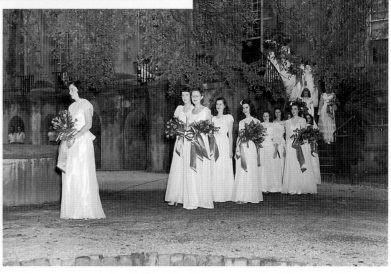

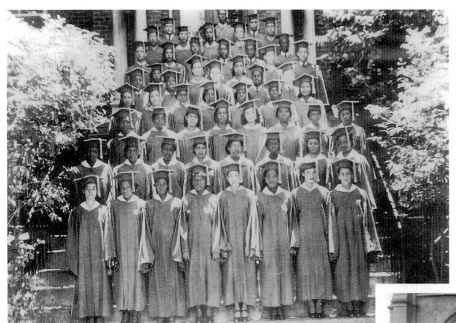

Avery Normal Institute Class of 1940 ▲

1st row: Mildred Thompson, Ercell Seabrook, Marjorie Singleton, Louella Kirk, Alice Nelson, Mildred Green, Marilyn Webb, Isabell Evans

2nd row: Emily Robinson, Hilda Hutchinson, Addie Dayson, Alcathia Holmes, Hattie Brown, Ruth Anderson, Jametta White, Catherine Pelzer

3rd row: Muzetta Taylor, Calarthia Reid, Bernice Noisette, Julia Magwood, Israella North, Genetta Wiggins, Marie Wragg, Blanche Frost

4th row: Willie Mae Matthews, Cynthia McCottry, Virgie Evans, Julia Fields, Leila Haynes, Mary White, Myrtle Brown

5th row: Thelma Howard, Margaret Allen, Alma Lumpkin, Archibald Lewis, Evelena Evans, Pierce Shecut, Harold Bennett, Harold Mazyck

6th row: Clayton Harleston, Helen Radcliff, Albert Allen, Albert Cooper, Ralph Broughton, Richard Fields

7th row: Herbert DeCosta, Susie Rouse, Martha Bianchi, Melvin Miller, Theodore Stent

8th row: Alvin Turner, James Brown, Vodrey Shokes

Submitted by Cynthia (McCottry) Smith

Preparing to Take the Next Step ▼

These Bishop England High School graduates were prepared to take the next step in their lives on the steps of the Cathedral of St. John the Baptist in 1948. The location hasn't changed much in 60 years, but the same cannot be said of these young people who grew up to attend college, enter the service, work and live and raise families in Charleston and elsewhere.

Submitted by James R. O'Neill

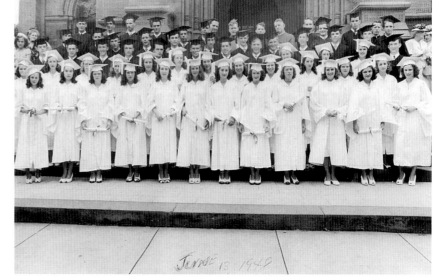

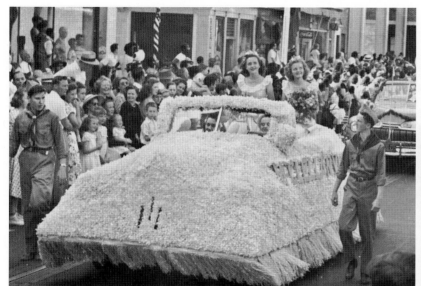

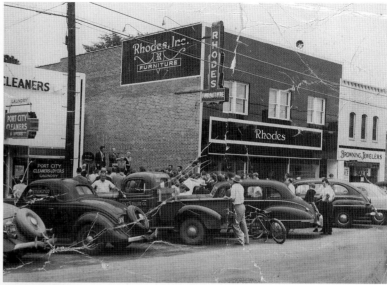

Azalea Festival Parade ▲

The Charleston Azalea Festival was a huge event in 1948, and being selected to represent your town was a high honor. Betty Ward (left) and Phyllis (Barrett) McGrew shared the privilege of representing McClellanville in Charleston's Azalea Festival Parade down King St. To the city of McClellanville, Charleston was simply The City: it was a big deal to go into The City and enjoy everything Charleston had to offer, including shopping, dining, socializing and riding atop a floating convertible garden.
Submitted by Phyllis B. McGrew

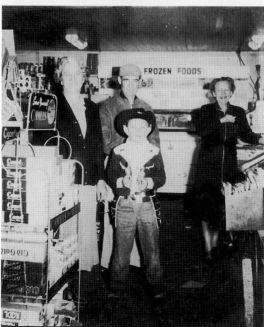

Cooper River Federal Dedication ▲

North Charleston's Montague Ave. was the scene for dedication ceremonies of Cooper River Federal's drive-up in the 1940s. The dedication was tucked in between Port City Cleaners and Rhodes Furniture. Joseph O'Hear Sanders, Jr. is pictured standing in front of the Sikes Radio Co. truck, facing the camera.
Submitted by Jo Gowdy

Perry's Grocery Store, Edisto Island ◄

Edisto Island has long been known as an uncommercialized, family-oriented beach, but life on the island today doesn't compare to how it was in the late '40s. Joe and Mae Perry ran the only full-service grocery store on Edisto at that time; Mr. Perry delivered groceries to the families who patronized his store. The store was bought by a grocery chain; the building is no longer there. Pictured left to right are: Marie Burbage, Mr. and Mrs. Stan Craven, and Roddy Perry who, according to his sister, played Cowboys and Indians all the time. Perry grew up to be Mt. Pleasant Chief of Police.
Submitted by Rhonda (Perry) Cummings

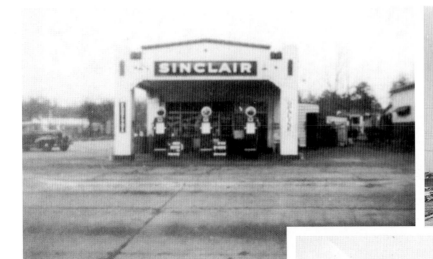

Full-Service "Filling" Station ▲

"Full-service" in 1946 meant someone pumped the gas for you, washed your windshield and checked your oil level. The Sinclair gasoline station in North Charleston, owned by Casper Padgett, was no different. But what Padgett's station offered that others did not was its location to Padgett's Drive-In, run by Mae Padgett, Casper's wife. Mrs. Padgett did the cooking, so while your car's tank was being filled, you could walk next door and get your own tank topped off as well. The business was in North Charleston's "Iron Dog" section, so named because there used to be two iron dogs on either side of the railroad tracks.
Submitted by Ron Padgett

Roper Hospital, 1946 ▲

With funds bequeathed by Col. Thomas Roper, Roper Hospital was built on Queen and Logan streets; the facility began admitting patients in 1856 "to treat all sick and injured people without regard to complexion, religion, or nation," according to the Medical Society of South Carolina website. From those beginnings a new facility was built on Barre and Calhoun streets in 1906 and expanded in 1946, pictured here.
Submitted by Margaret Mullins, Roper St. Francis Healthcare

Meeting Street Christmas ◄

Trolley tracks are visible and more traffic than one would expect on Christmas Eve, 1941. This view is on Meeting, looking east. An Esso service station is down the block on the left.
Submitted by Sally Fisher

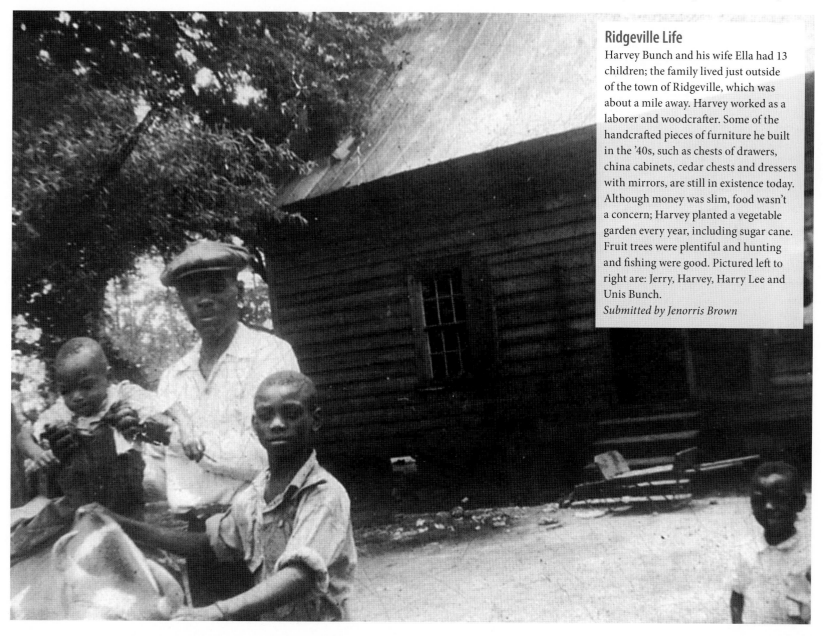

Ridgeville Life

Harvey Bunch and his wife Ella had 13 children; the family lived just outside of the town of Ridgeville, which was about a mile away. Harvey worked as a laborer and woodcrafter. Some of the handcrafted pieces of furniture he built in the '40s, such as chests of drawers, china cabinets, cedar chests and dressers with mirrors, are still in existence today. Although money was slim, food wasn't a concern; Harvey planted a vegetable garden every year, including sugar cane. Fruit trees were plentiful and hunting and fishing were good. Pictured left to right are: Jerry, Harvey, Harry Lee and Unis Bunch.

Submitted by Jenorris Brown

Logan-Robinson Fertilizer Plant ▶

At the foot of Charlotte St. the Logan-Robinson Fertilizer Plant took up the whole block from Washington to the waterfront where the cotton compress warehouse used to stand. Farmers would bring their trucks in and load up with potash, 5-10-10, all sorts of fertilizer for crop production. Edward W. Weekley was superintendent of the plant. This location was across the street from where the aquarium is now.
Submitted by Eddie Weekley, Jr.

Drive-Thru Gas Station, 1923 ▼

Federal Tires & Tubes sold gasoline on the corner of Sheppard and Meeting streets, but they also apparently gave away some stuff, according to the sign out front. Alonzo Anderson Burris, Sr., the station's owner, is pictured on the left of an unidentified man. Burris was president of Burris Chemical Company, Burris Products Company of Charleston, and the Atlantic X-Ray Corp. He was founder of Atlantic Pest Control and the Piedmont Chemical Corporation of Charlotte and Bluefield, W.V.
Submitted by Betty B. Cross

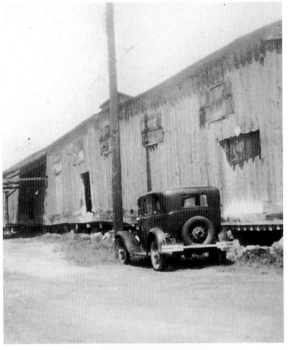

25th Wedding Anniversary ▼

Marcella and Joseph Davis renewed their wedding vows at their home in the Accabee section of North Charleston in 1948. The Rev. Cherry of Central Baptist Church officiated. The affair was attended by invited family, church members and friends. Pictured left to right are: Marcella Davis, Doris (Davis) Miller, Frances Robinson, Louis Davis, Gwendolyn Davis, Minnie Davis, Marcella Davis, Joseph B. Davis, Jr., Joseph Benjamin Davis, Archie Davis, Minnie Sword, Arnold Collins and his father, Hezekiah Collins.
Submitted by Arnold Collins

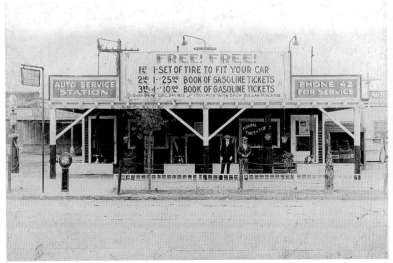

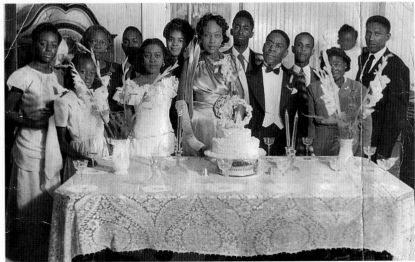

Fingerprint and Detective Department ▼

Due to a shortage of people during the war in 1942, John Seignious, Jr. (top left) was assigned to the fingerprint and detective department of the Charleston Police Force. Others who can be identified in the photo include Buster Rentiers (second row with glasses) and Detective Droze (first row, second from the left). The man in the center of the first row is George Warren. The building at St. Philip and Vanderhorst streets is now Charleston Water Works.

Submitted by the John R. Seignious Family

Beginnings of the Battling Bishops ▲

The Battling Bishops presented quite the line-up in 1944. Bishop England's first football team dressed out for photos in 1944 in Martin Park at the foot of the old Cooper River Bridge. Pictured on the back row, left to right: Coach Gerald McMahon, Fr. John L. McLaughlin, #29 Joe Thomas, #10 Larry Presta, #18 William Ryan, #14 Gene Kenney, #12 Emmett Santos, #30 John Rowland, #35 Mickey Tezza, Fr. Joseph L. O'Brien, #23 Charlie Smith, #33 Lloyd Clayton, #9 Charles Ted Delorme, #17 Leonard Duke, #11 Louis Cass, Coach L. D. Howell, Coach George Bullwinkel.

Middle row, left to right: #8 George Traynor, #31 Victor O'Driscoll, #16 Joe Griffith, #22 Claude Blanchard, #19 George Duffy, #5 Eddie Sturken, #34 Walter Murphy, #25 Dick Condon, #28 John Latorre, #27 Jake Leamond, #13 Jimmy Lloyd, #20 Francis Coleman.

Front row, left to right: #7 Bryant Johnson, #36 Philip Chevrier, #15 Harold Weaver, #6 Billy McPherson, #24 Dickie Lear, #3 Joe Bean, #4 Keith Salmonsen, #1 Robbie Cole, #32 Gordon Sturken, #26 Arthur Joseph, #2 Furman Wham, Manager Harry Patrick Santos.

Submitted by Gerald F. McMahon, Jr.

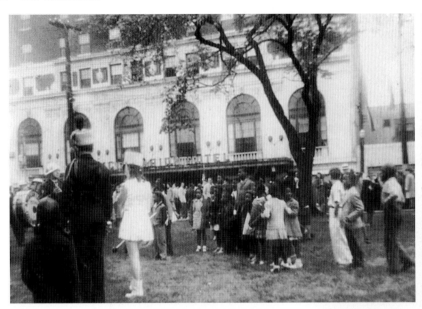

Not to Scale ◄

The Cooper River Bridge backdrop is dwarfed by Earl W. Hilton in this photo taken May 10, 1942. Belk used to offer portraits such as these in their store; it is believed Hilton had the photograph made there. The family lived on Grayson St. just outside the Navy Yard main gate at the foot of Reynolds Ave. Hilton worked as a leading man ship fitter; in the '40s he also served as a Red Cross warden, patrolling the North Charleston Navy Yard community to ensure lights were out as an air raid precaution.
Submitted by Diane Zielinski

Azalea Festival Reorganized After World War II ▲

Founded in 1934, the Azalea Festival in downtown Charleston was temporarily interrupted from 1941 until 1947, during World War II. But in 1948, the festival had plenty to celebrate. The Azalea Festival, which became a weeklong celebration, included a parade down King St., beauty pageants and a lancing tournament. Pictured is the American Legion Band from Columbia as they wind their way through the crowd in front of the Francis Marion Hotel. In the '40s the Francis Marion was one of two very nice hotels in Charleston; the Fort Sumter Hotel has since become condominiums but the Francis Marion still stands much as it once did when it was built in 1924: a 12-story tribute to southern hospitality and charm.
Submitted by Samuel Steinberg

Blue Star Mother ◄

A simple gesture in 1917 quickly became a nationwide effort in World War I and was continued during World War II when mothers began displaying a blue star for each son on active duty. When a son was killed, the blue star would be replaced with a gold star. The blue star flag became a symbol for communities, a reminder of things everyone could do to help bring these boys home safely: rationing, working in factories, and keeping critical information close to the vest. Agnes Veronee had seven sons serving in World War II. This photo appeared in The News & Courier at the end of the war with Germany.
Submitted by Robert C. Maguire

Hollywood, SC Head Start Center Director ▲

When Martha Miller Edwards, of Rantowles, graduated from Burke High School in 1948, she had been trained to become a cosmetologist. Burke High School offered technical and vocational training at that time; when the school opened in 1911 as the Charleston Colored Industrial School it was the first public high school for African Americans in Charleston. Her future led her down a different path however; She spent 45 years as the Head Start Center Director in Hollywood, at St. Luke A.M.E. Church. Her family's home, pictured in the background is gone now, but the property remains in the family.
Submitted by Gwendolyn Whitsell

Christmas Shopping on King ▼

Eddie and Anna Pauls had several wrapped items with them in 1940 as they tried to beat the Dec. 24 deadline. King St. was the place to go for shopping in the '40s. The couple is at the foot of Hasell St. on King. A roving photographer frequently caught shoppers on film while they strolled King; the photographs were available to his subjects for a small charge.
Submitted by Janna Peele

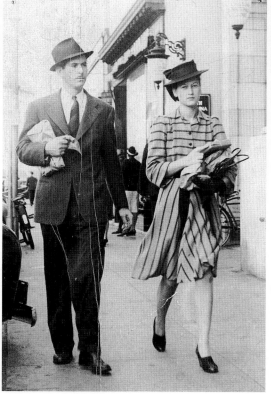

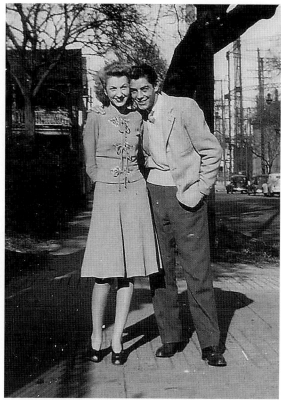

Happy Couple, Soon to be Wed ▲

Harry Miller and his bride-to-be Jennie are pictured here across the street from 7 Charlotte St. The couple enjoyed a Sunday stroll after church in 1942. Harry's family lived at 7 Charlotte St.; the home is still in existence today. The couple married at First Christian Church on Calhoun St.; those facilities are currently being used by the College of Charleston. Harry, who went to Charleston High, entered the Navy shortly after the couple wed. He graduated from The Citadel as an electrical engineer and retired from the Charleston Naval Shipyard.
Submitted by Jan Miller

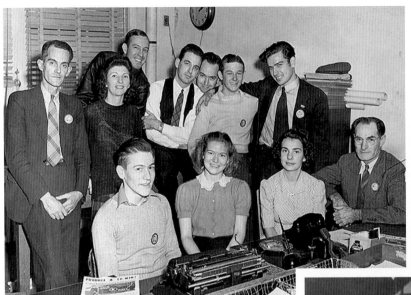

Navy Yard, circa WWII ▲

Ruth Ella Hogg worked at the Charleston Navy Yard in the early 1940s. She is pictured second from the left, standing. A few years later she would meet Lt. Robert Kight; the couple married in 1943 and lived on Walnut St., just blocks away from the Cooper River Bridge.
Submitted by Bob Kight, Jr.

She's a Shoe-In ▶

Sixteen-year-old Joan (Dixon) Wilcox made a lovely outdoor display in spectator pumps outside of Wilcox's Shoe Repair in 1948, located at 206 ½ Rutledge Ave. The building, which also housed Bullwinkel Bakery, no longer exists. Today the footprint of office buildings occupies the site where the family business once stood. Wilcox's son, Herbie, took over the family business for a while, and he married pretty Joan to boot.
Submitted by Herbie Wilcox

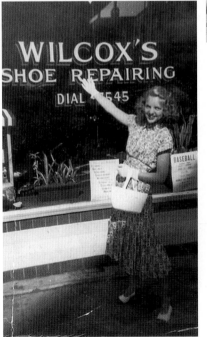

The Paper Boy, An American Icon ▲

Charleston's daily newspapers employed many newspaper boys over the years to get the product out to subscribing households. Bill Winter (second from left) delivered papers over the course of six years, building his business to five routes by the time he quit at age 18. The newspaper was located at 134 Meeting St. at that time; this 1947 photo shows the bays where trucks were loaded for distribution. Others who could be identified include: (right to left) Russell Huxford (far right), Buddy Miller, Donald Shaw, Julian Kornahens and Murray Miller. Julian Mappus is in the truck.
Submitted by Bill Winter

War Bond "Drive" ▶

The military showed up in force for a war bond "drive" at Marion Square around 1943-44. "Buy A Bond, Get A Ride" in a jeep, and Uncle Sam might even come along for the trip. The event in downtown Charleston included an appearance by John Scott Trotter. Trotter and his orchestra recorded "White Christmas" with Bing Crosby in 1945. Those who could be identified in the photo are: Henry Siegling (the child seated on a man's lap at the back of the jeep) and Albert Schraibman (in the front row) seated on his mother's lap, Syd (Mrs. Harry) Schraibman. The dark-haired girl in the back next to Uncle Sam is Faye Goldberg Miller. Citadel Square Baptist Church is visible in the background to the left.
Submitted by Albert Schraibman

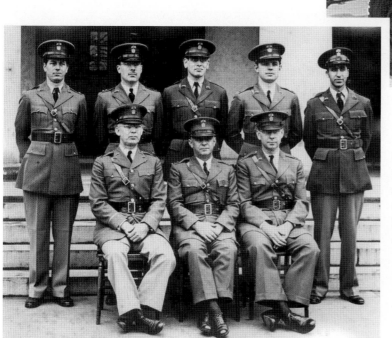

Citadel Math Department ◀

In the 1940s, these gentlemen constituted the faculty of The Citadel's Math Department. The only professor who could be identified is George E. Reves, standing on the left side.
Submitted by Jerry Reves

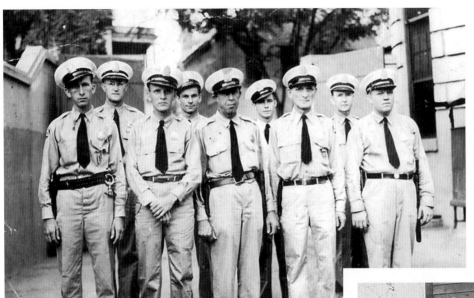

Charleston City Police Officers ◀

These gentlemen made up an auxiliary force around 1940. James J. Roberts, Jr. is on the front row, right side. The photo is believed to have been taken at the old city jail on the corner of St. Philip and Vanderhorst streets.
Submitted by Shirley D. Roberts

Shipyard Security Guards ▶

When World War II broke out, security became even more crucial at the Charleston Naval Shipyard. These men, as part of the security force, were responsible for checking identification on all personnel at the shipyard. Security was very tight; everyone had to have a high security clearance. Employees were fingerprinted and given a shipyard number. John M. Davis (right) worked as a security guard for a year or two, and then became a rigger, eventually retiring from the Shipyard.
Submitted by Marvaline Morris

Charleston High "Bantams" ▶

The Charleston High football team's wingback "Dutch" Buckheister looked to be well on his way to a touch down in 1943. Bill Wannamaker, Number 17, ran interference for him. The team played at the old Johnson Hagood Stadium before it was renovated. The Bantams took the name from the nomenclature used for various breeds of small domestic fowl characterized by combativeness—not unlike a college team down the street a ways.
Submitted by H. E. "Dutch" Buckheister

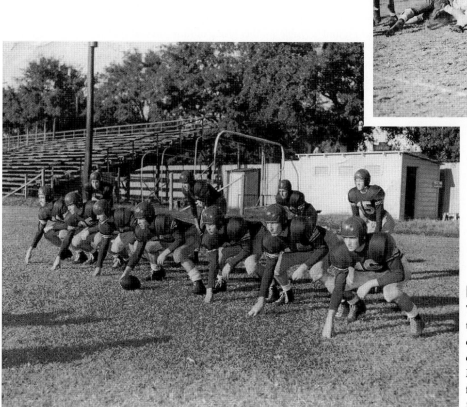

High School of Charleston Football Team ◀

The Bantams played at Johnson Hagood Stadium and all over the state in the '40s. The team is pictured here at College Park, corner of Rutledge and Grove. The last names of those who could be identified are, left to right: Taylor (second from left), Magoulas, McGlocken, Driggers, Esbee and Shaw. In the backfield from left to right: Morelli, Grayson, Cox and Fabian.
Submitted by Charles V. Driggers

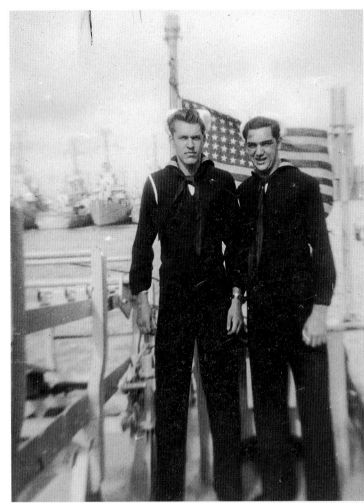

The Fantail of the U.S.S. Knapp ◄

Everett J. Alster (left) and Joseph Binaco of New York were hopeful that their enlistment in the Navy in 1945 would involve some action. The first atomic bomb was dropped on Japan Aug. 6, 1945; the boys were ordered to report to the Charleston Navy Base on Feb. 1, 1946. When they arrived they were told that instead of getting sea duty they were assigned to decommissioning duty. The Navy was already taking ships off the line to be decommissioned and since Charleston was a destroyer base there were a large number of destroyers returning to Charleston to be "mothballed." Alster assisted in mothballing four ships until his discharge in August of 1946. In the background is visible another group of ships "nested" in the Cooper River.

Submitted by Everett J. Alster

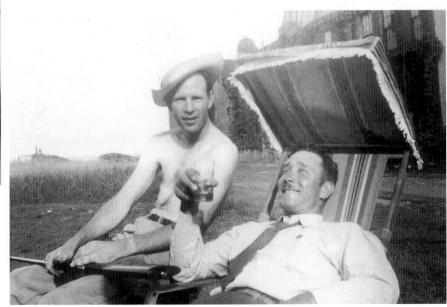

Boyce's Wharf ▶

Red Blanton (left) and Dewey Mose are pictured relaxing at Boyce's Wharf, which used to be on East Bay, in 1944.

Submitted by Camilla Blanton

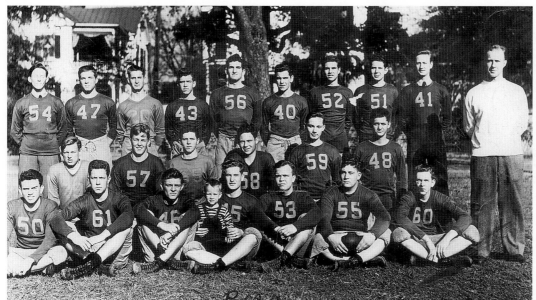

The 1942 North Charleston High School Blue Devils ▼

Photographed here on Garco Field, the Blue Devils may not have had a winning season in 1942, but it didn't stop them from meeting the competition head-on. They played Moultrie High, Summerville, Walterboro and Beaufort teams that year, among others. Pictured left to right, front row: Gene Rutherford, Edward Luschinsky, Ralph Harbeson, George Flynn (captain of the team and All Stars in North Carolina), F.B. Hawkins, Charles Smith, and James Wright. Back row, left to right: Ralph Hunter, Gene Rosenberg, Curly Coffman and Donald Maxwell.
Submitted by Diane Zielinski

Porter Military Academy Cyclones, 1945 ▲

When the old Federal Arsenal on Ashley Ave. came up for sale in 1879, Anthony Toomer Porter arranged to lease the property to the Holy Communion Church Institute for a dollar a year, according to the school's website. It was around that time that the school, which began in 1867 to educate children orphaned during the Civil War, became Porter Military Academy. All that remains from the Arsenal complex today are St. Luke's Chapel and Colcock Hall. The 1945 Cyclones, pictured here, are: R. J. Gould (#50), Charlie Taylor (#60), Wilbur E. Flowers (#57), Chandos L. Smith (#45), Frank H. Rodeniser, Jr. (#55), Johnny Adams (#59), William Strickland (#24), Lonnie Burris (#40), Wilson Leggett (#52), T. Benbury H. Wool (#41), James L. Palmer (#61), Tommy L. Jones (#53), Jim Coleman (#47), Jesse Richard Holland, Jr. (#58), Jim Haughton (#54), Pete Alexander (#48), Richard Hughes, Jr. (#46), Emmette Tomlinson (#51), J. L. Rhodes (#43) and Saul Krawcheck (#56). John F. Dunbar, Bill "Frog" King and Wallace Kelly were not present for the photo. The coach was Laurie Thompson; the young boy pictured was a coach's son.
Submitted by Bill Allen, PMA Alumni

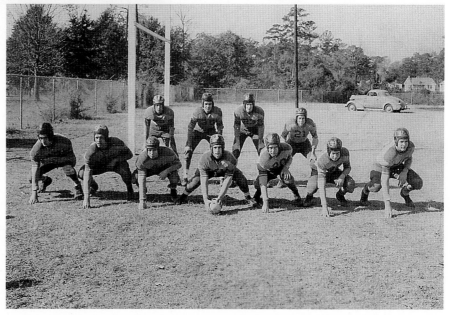

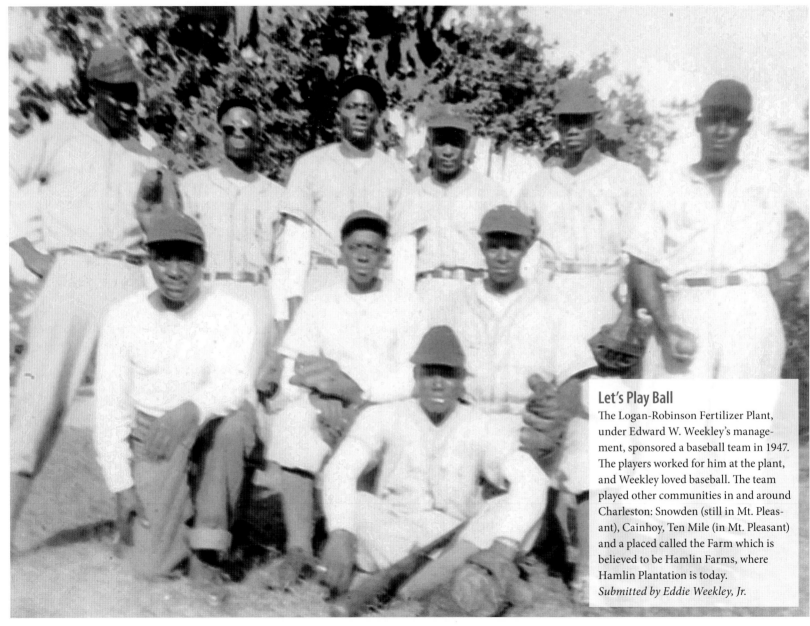

Let's Play Ball

The Logan-Robinson Fertilizer Plant, under Edward W. Weekley's manage-ment, sponsored a baseball team in 1947. The players worked for him at the plant, and Weekley loved baseball. The team played other communities in and around Charleston: Snowden (still in Mt. Pleas-ant), Cainhoy, Ten Mile (in Mt. Pleasant) and a placed called the Farm which is believed to be Hamlin Farms, where Hamlin Plantation is today.
Submitted by Eddie Weekley, Jr.

Softball Champions ▷

Although it looks like they were making a bat bonfire, these men were celebrating a victory. Burbage's Gas Station on Spruill Ave. in North Charleston sponsored the champion softball team in 1942. Pictured here at Harvey's Super Service Station is the Hewitt Oil Company team. Willard Gooding is fourth from the right; Roscoe Gooding is fourth from the left.
Submitted by Donna Hill

Charleston City Bus ◁

Old City bus #820 to Rutledge has been replaced by Charleston Area Rapid Transit Authority (CARTA) and Downtown Area Shuttle (DASH) today but the old buses were a part of the landscape in the 1940s.
Submitted by Sandy Gilchrist Kuntz

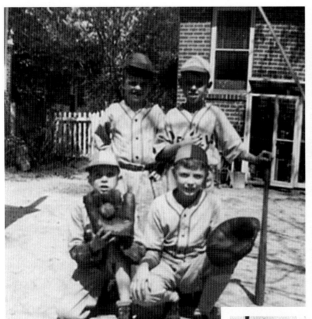

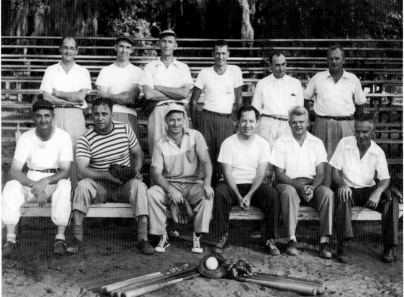

Mitchell Playground Chums ▲

The boys lived on Race St. and played base-ball at Mitchell Playground in 1948. Pictured left to right are: Tommy Lavelle, age 5, who handled the position of bat boy, Joe Lavelle, age 8, outfielder, John Lavelle, age 9, catcher, and Henry Marle, 10 years old, shortstop.
Submitted by Mary Ann (Marle) Camp

Park Circle Recreation ▲

Softball leagues were quite popular in the late 1940s; North Charleston businessmen grew up playing little league at the baseball field so it was not surprising that their love of the game continued into adulthood. Those who could be identi-fied include: Slim Henson (back row, third from the left) and Joseph Sanders (back row on the right). Doc Thornley is seated on the front row, right hand side; next to him is Jim Sollar, and a man identified as "Zipperer."
Submitted by Jo Gowdy

America's Favorite Pastime ◄

Larry Riggs played catcher's position while Harry Gambrell took a turn at bat on April 4, 1941. The photo was probably taken at Charleston High since Gambrell was a student there. Gambrell made All-State on the baseball team and because of this accomplishment, his photo was published in the newspaper.
Submitted by Pam Gambrell

Christmas Day, Battery Included ▼

The Rev. Wilbert T. Waters was a Methodist preacher in upstate South Carolina; his wife was a school-teacher. The only time the family could take vacations was Christmas and New Year's. So they spent it, every year until their son went to college in 1964, at the Fort Sumter Hotel in Charleston. The Rev. Waters and son W. T. "Butch" Waters are pictured at White Point Gardens near the Confederate monument in 1947.
Submitted by W. T. Waters

The Little Engine That Could ▲

Casey, Jr. was a favorite attraction at the Isle of Palms Amusement Park in the summer of 1949. The coal-burning locomotive was maintained and operated by James Gordon Burn (pictured) during the '40s and early '50s. Casey, Jr. pulled three open cars carrying four children in each car on a circular track that ran at the edge of the park. The park itself was located on the front beach where shops now stand. Mr. Burn was shop foreman for the South Carolina Port Utilities Railroad, the shortline railroad at the S.C. State Ports Authority. When he retired, he became the little locomotive's engineer.
Submitted by "Cookie" Hutchinson

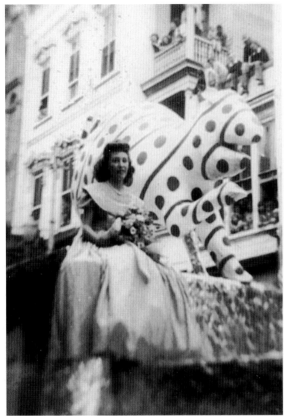

Handsome High School Graduate ▽

St. Julian O. Cox would have been about 18 or 19 in this photo dated 1940; he had just graduated from Colleton High School in Walterboro. He and his mother lived at 75 Spring St. Cox worked at Haberdasher Clothing Store on King St.
Submitted by Juliann C. Rattley

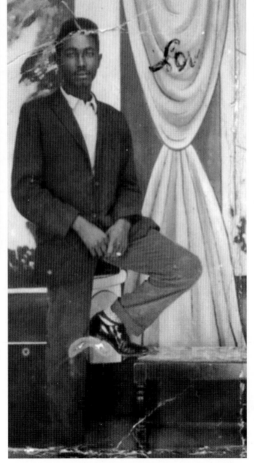

Floating Down King St. ▲

The Azalea Festival was a major event in Charleston in 1948. Float designs were closely guarded secrets, although this float still seems to be somewhat of a mystery. Perhaps it is a carousel animal or a mythical striped and polka-dotted beast. Decorations of all sorts were float fare during the festival—especially lovely ladies bearing bouquets. The appeal of the Azalea Parade is evident in the scores of onlookers pictured in the background. Second and third-story windows, porches and balconies are filled with parade revelers.
Submitted by Samuel Steinberg

Baby Needs a New Pair of Shoes ▲

Carlton Blair, in the arms of his mother's good friend Sara S. Powell, went shoe shopping with his mom Willa Mae Blair (left) on King St. in 1949. It is unclear whether Carlton is wearing old shoes in this photo, or his brand-new shoes, but without a doubt he enjoyed his trip into town. Stores such as Condon's, Kerrison's, Bandbox (a women's dress shop), Lerners and Edward's 5 & Dime were just a few of the retail choices. It is possible that the store at the upper left of the photo is Rexall Drugs. Carlton didn't care much about all that; he just liked to sit on the animals in Condon's shoe department.
Submitted by Sara S. Powell

Taking a Stroll Down Murray Boulevard ▽

One-year-old Guy Cheves Tarrant and his nanny, Maree, enjoyed an outing in 1943. Guy's great-grandfather built their home, pictured at the left, along with the two houses next door. PaPa, as he was affectionately known, built the houses for his two children. The family owned the house next to the Fort Sumter house until the mid 1980s when it was sold. The lady wearing a stole wrap in the background is Guy's mother, Leonora "Sister" Cheves Brockinton. She was with her sister-in-law, Chilton Cheves, who was known as "Hunkey." Guy grew up to become president of The Tarrant Company, Inc., an investment real estate firm.

Submitted by Teresa Tarrant

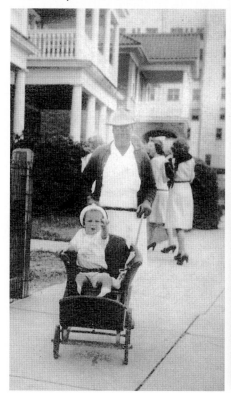

Christening, in the Greek Orthodox Tradition ▲

Christenings are occasions for family and friends to gather, and when Nicky Telegas was christened at Holy Trinity Greek Orthodox Church Hellenic Center in 1947, he had a large turnout of family and friends. Pictured standing at the back, from left to right, are: Mary Gianaris, Mr. And Mrs. George Carabatis, George and Toula Telegas (Nicky's parents) and Olympia Philipps. Others in the group include: William and Anastasia Anagnos and their daughter Lily, Pete Philipps, Mina Philipps, Harry Ginaris, Sr. and Angelo Anastopoulo.

Submitted by Toula P. Williams

Parading by Palmetto Grill ◁

Two things could be counted on in any Charleston parade: pretty girls and large crowds. The Nowak family lived in Riverland Terrace and came into town at least once a week on the bus. On this particular trip to Charleston in 1949 or 1950 they were treated to one of Charleston's classic parades. Palmetto Grill, serving "seafood and western steaks," is in the background. Best recollections are that the restaurant was located on the west side of King, between the Garden and Majestic Theaters.

Submitted by Chet Nowak

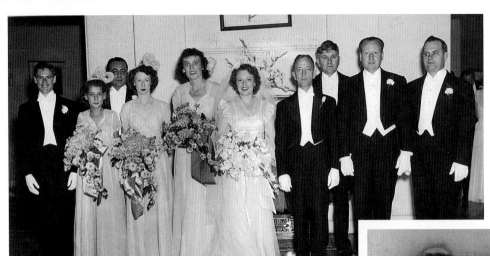

Wedding Reception at the Country Club of Charleston ▲

When Frank James Taylor married Helen Freda Hockemeyer in
1945, it was a formal affair, complete with gloves and tuxes. The
service took place at 8 p.m. at St. Matthew's Lutheran Church on
King St., followed by a reception at the Country Club of Charles-
ton. Hugo destroyed the original clubhouse in 1989 but a new
clubhouse has replaced it. The couple honeymooned in Havana,
Cuba, a popular destination in the '40s because of its nightclubs,
gambling and fabulous hotels. Mr. and Mrs. Taylor owned and
lived in the Nicholas Trott House on Cumberland St. They also
owned and ran Franklin Apartments next door, which are being
converted into condominiums, and Taylor's Men's Wear, 301
King St. Pictured in the wedding party (left to right) are: Henry
D. (Dick) Schweers, Ruby Hockemeyer, Frank Sottile, Katherine
Shelby, Ethel Hockemeyer, Helen Hockemeyer, Frank Taylor, J. C.
Long, John Schweers and Erwin Bohlen.
Submitted by Becky Greene

Davis "Re-Wedding" Portrait ◀

Marcella and Joseph B. Davis renewed their
wedding vows on their 25th anniversary
Sept. 19, 1948. The couple celebrated on the
front lawn of their home of 2147 Becker St.
in the Accabee section of North Charles-
ton with family and friends. Long before
integration in the South, Mr. and Mrs. Davis
were entrepreneurs who worked for them-
selves. Both were well-educated, aspiring in-
dividuals: Marcella was a speech writer and
orator and Joseph was the second 33-degree
Mason of his time in this area. They insisted
that the children attend college. Because of
their influence, their grandson Arnold be-
came the first African American vice-presi-
dent at a major bank in South Carolina.
Submitted by Arnold Collins

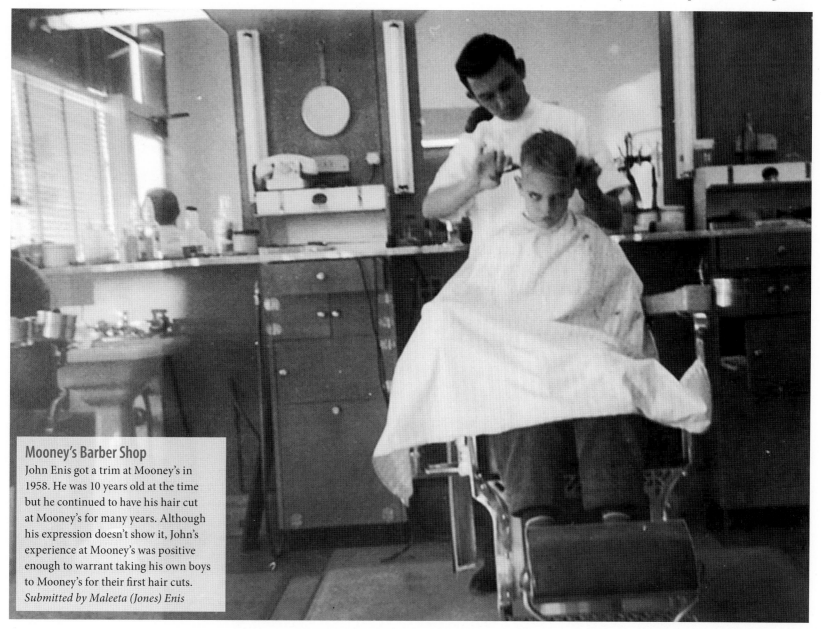

Mooney's Barber Shop

John Enis got a trim at Mooney's in 1958. He was 10 years old at the time but he continued to have his hair cut at Mooney's for many years. Although his expression doesn't show it, John's experience at Mooney's was positive enough to warrant taking his own boys to Mooney's for their first hair cuts.
Submitted by Maleeta (Jones) Enis

The VW Bug ▲

The Flints were pleased to show off their new Volkswagen convertible bug in October 1957 in the driveway of their James Island home. Vicki Anne, age 6, and her sister Ivy Elizabeth Flint, age 5, were the oldest of Joseph and Elizabeth Flint's five children. Mr. Flint, who worked at the Retail Credit Company, founded the James Island Journal as an Exchange Club project.
Submitted by Ivy Elizabeth (Flint) Stanger

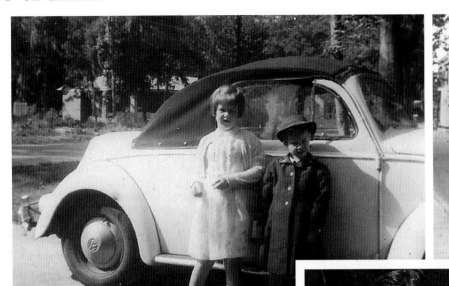

A Beauty of a Buick ▲

In 1950 Orrin Patrick Ryan was stationed in Norfolk, Va. on the U.S.S. Coral Sea. The Coral Sea was the largest aircraft carrier in the world at that time. Second Class Petty Officer Ryan was home on leave visiting family on North Tracy St. His car, a 1948 convertible Buick Roadmaster, must have been a beautiful sight rolling down the streets of the old neighborhood.
Submitted by Michael Young

Prisoner of War Reunited with Mother ◄

Eugene Tumbleston (right) spent close to three years in a North Korean POW camp. When he returned to Charleston he was greeted with parties, gifts and recognition for his service in the war. His mother, Frances, was among those most happy to see her son return home in 1951.
Submitted by Barbara C. Inglett

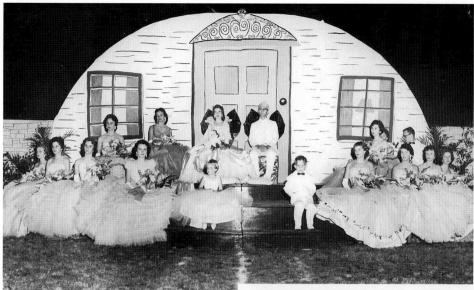

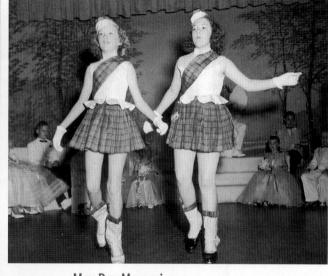

May Day Memories ▲

Sandra Burn (left) and Mary (Breuer) Riddle performed at North Charleston Elementary School's May Day celebration in 1955. Sandra and Mary were next-door neighbors and had learned the "Highland Fling," a Scottish dance, for their recital at Cecilia Vaughn's Dance Studio. The girls were about 12 years old at the time, and in the 6th grade.
Submitted by Mary B. Riddle

North Charleston High's Activity Festival ▲

The Activity Festival was North Charleston High's opportunity to hand out club and library awards and crown the May Day King and Queen in 1959. The former queen, Judy Eaton, is barely visible to the right of the stage. Seated next to her is the former king, Bobby Arant. Reigning Queen was Alice (Graham) King, center stage; Ben Killian, the 1959 May Day King, is sitting on the right. Others who could be identified include: Nancy Edge (back row, left) and Jo Sanders (back row, second from left). Beth Drews is sitting just below the Queen. Bobby Jordan is seated to the right of the stage, in front of the previous year's queen.
Submitted by Jo Gowdy

Celebrating Graduation ◄

It was the week before graduation May 15, 1958 but that was close enough to begin celebrating at the Isle of Palms for these Moultrie High Seniors. Left to right are: Janet Poole, Helen Foxworth, Margaret McCue, Frelia Litton, Helen Tapio, Patricia Filliberti, Jackie Hiers and Mary Jane Craven.
Submitted by Mrs. Joe E. Still

A Christmas Performance ▶

Six-year-old Judy (Walker) Hiers performed "Silent Night" for her parents and extended family while 9-year-old sister Katie (Walker) Windmueller accompanied on the piano. The special performance was held at the home of Ned and Evelyn Walker, 390 Ashley Ave. across from Hampton Park, in 1951.

Submitted by Katie (Walker) Windmueller

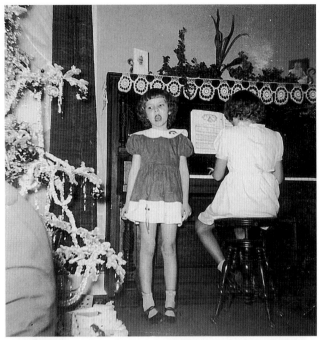

Next Stop, Isle of Palms ▼

The front seat of the IOP kiddie train ride, occupied by Russell Muschick, was a coveted position; whoever sat there was the "engineer" and got to ring the bell. Diane (left) and younger sister Kay Muschick are relegated to the bench seats at the back in 1954. The wooden barrel behind Diane probably was a pretend water tower which might have been used to load water into a real steam engine.

Submitted by Kay (Muschick) Schneider

Amusing Times at Isle of Palms ▼

Barbara Diane (Muschick) Brandes (left) and Katherine (Muschick) Schneider were full-time Isle of Palms residents in 1954; their family lived just a few blocks down from the pavilions where the Ferris wheel stood scraping the clouds and the kiddie train ran endless circles around its track to the squeals of delighted youngsters. The pavilions offered chili, hot dogs, ice cream and sodas in addition to a bit of respite from the heat.

Submitted by Kay (Muschick) Schneider

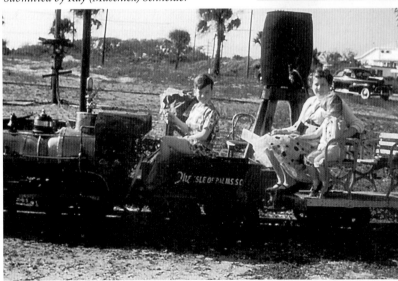

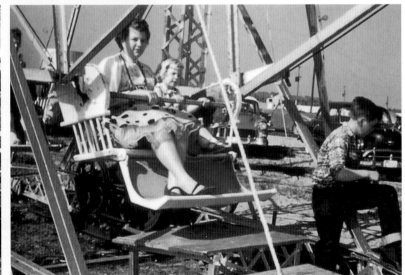

Kiddie Cars ◄

The Isle of Palms amusement park included a kiddie ride, candy concessions and games of chance, such as the basketball hoop game in the background, in 1953. Cecelia Livingston is shown here with little Sonya Livingston, who is taking a turn behind the wheel.

Submitted by Sonya Livingston

Hoopla ▶▼

Katherine Carlton (Hunt) Simons must have wondered what all the hoopla was about, so she took a turn at the Hula Hoop® herself. She and her husband Andrew lived here at Lamboll St., with their children. Hula Hoops® were manufactured by Wham-O® beginning in 1958; within six months the toy had rolled across America, with 20 million sold at $1.98 each.

Submitted by Carlton Simons

Brownies in the Kitchen ▶

Barbara Jean (Cope) Inglett (left) and Mary Ann DuTart prepared some sort of egg dish in the kitchen of Mt. Pleasant Academy while the head of the kitchen, Mrs. Newton, made sure everything goes according to recipe. The girls, under the direction of Mrs. Bissell, their troop leader (not pictured), were working toward a cooking badge. The girls were probably in the second or third grade at the time. Brownie Scouts, as they became known in 1938 in order to identify Brownies with the whole Girl Scout movement, focused on the needs and interests of girls aged 7 to 10. The Brownie Promise was: I promise to do my best to love God and my country, to help other people every day, especially those at home. A good cook certainly fits that bill.

Submitted by Barbara C. Inglett

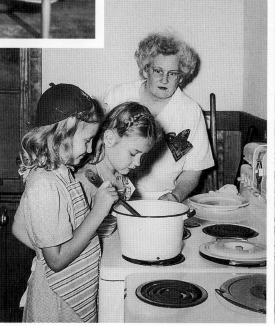

Let's Go Fishing ▲

Giulio Ferri, seated on the car in the background, was put in charge of his grandchildren and a few other neighborhood kids in the early '50s. To keep them occupied he suggested that they "go fishing" in the gully in front of the house. The house at 524 Canterbury Drive in West Parkwood Estates was under construction at the time. It would become the residence of the Frizelle family, next door to the Sofferas. Pictured left to right are: Tommy Soffera, Ann (Frizelle) Coleman, Tim Frizelle, Eddie Ferri, Mamie (Frizelle) Stoughton, Joe Soffera and Michael Ferri. None of the children caught a single fish that day.
Submitted by Johanna Miller

Target Practice ◄

Here's one Christmas gift where Mother would have been right; you could put your eye out with the bow and arrows Russell Muschick (right) and his friend are using. The burlap target bag did its best to handle the metal-tipped arrows pointed at it; the boys were expressly forbidden from pointing the arrows at any two-legged target. It's possible, however, that more than one crab or horned toad on the Isle of Palms fell victim to the boys' marksmanship over the course of the growing-up years.
Submitted by Kay (Muschick)
Schneider

A Good Day Fishing . . . ◄

is just a good day fishing, especially when you catch spot tail the size of some of these beauties. Walter Woods, an SCE&G bus driver for 35 years (left) and his son Theodore Anthony Rowland, Sr. were using the right bait in 1954. The two men had gone fishing at Chaplin's Landing, a popular place for picnicking, bank fishing, and launching a boat a few miles outside of Charleston on the Ashley River. They brought the catch back to their Meeting St. home, across the street from the old Sires Lumber Company, to clean and cook.
Submitted by David Rowland

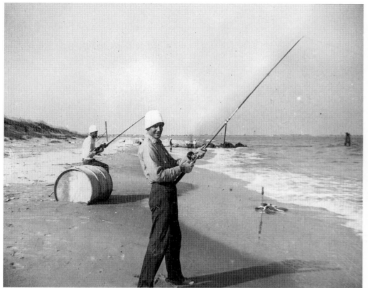

Catchin' Anything, Charlie? ▲

Well-known television personality Charlie Hall did a little surf-casting in 1957. The photo was taken at the north end of Folly, near the Coast Guard station. The Halls and the Thomas Hamlin family were neighbors in Parkwood Estates; they often spent time together at a beach house the Hamlins owned. To Hamlin's son, Terry, and to many other local boys and girls who watched WCSC's children's program, Charlie Hall was always just "Uncle Charlie." Charlie Hall spent a total of 51 years in radio and television broadcasting before his death at the age of 72 in February 1997.
Submitted by Terry Hamlin

Army Jeep Gets A New Hood Ornament ▲

Lib Wright made a lovely addition to this old Army jeep in 1957 on Folly Beach. She and her husband, Monroe, bought an old, scrap metal jeep every year. Monroe fixed it up and used it to drive on the beach (and into the ocean!) while the couple worked on building their summerhouse. After a year's worth of that kind of abuse, there was a fair amount of rust, so they'd go buy another one. Wright owned a scrap iron and metal company in North Charleston so he had connections as a "junk man." Getting old fix'er upper jeeps each year wasn't much of a problem.
Submitted by Charlotte (Wright) Capo

Enter Inn ◄

This group of beachgoers was photographed at the entrance to the "Enter Inn" at the Sorenson's on Folly Beach, 1951.
Submitted by Chet Nowak

Paul E. Jantzen, Sr.

JANTZEN LOCK & SAFE CO.

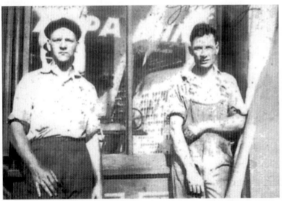

Bernhard K. Jantzen, Sr. and Johnny Roessler

Recent Photos courtesy of Sara Ann Jantzen

Locksmithing has played an important role in every city and town as far back as the Egyptian times. Jantzen Lock and Safe Company has been a part of the Charleston community since 1864, when it was founded by Adam Roessler at 250 Meeting Street. His son Johnny went into the locksmith business with his father. After his father's death, Johnny was soon joined by his brother-in-law, Bernhard K. Jantzen, Sr. After Mr. Roessler retired, Bernhard continued the locksmith business and moved it down about one block to its current location at 276 Meeting Street in the late 1940's.

Today, Paul E. Jantzen, Sr. is the sole proprietor of the business that has been in operation for three generations of the Jantzen family. Being a skilled craftsman for 38 years, Paul meets daily challenges and problems with swift precision as he repairs, reassembles, and repins locks. There are very few homes and businesses that have not benefitted from Paul's unique style and finesse of providing top security for the future. Safe and vault work is also a top priority for Paul.

Paul E. Jantzen, Sr. is proud to be able to continue his grandfather's legacy of locksmithing services to the Charleston community.

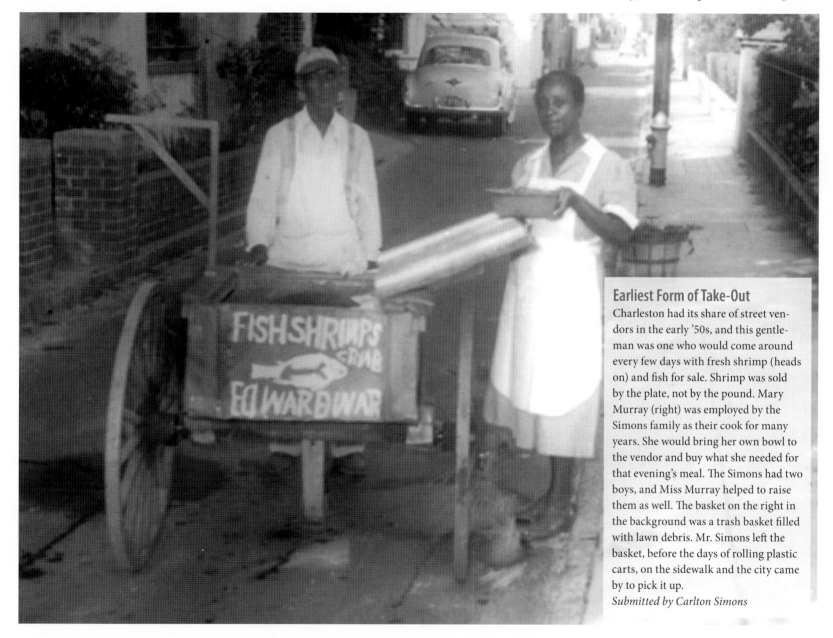

FISH SHRIMPS
CRAB
EDWARD DUNAR

Earliest Form of Take-Out

Charleston had its share of street vendors in the early '50s, and this gentleman was one who would come around every few days with fresh shrimp (heads on) and fish for sale. Shrimp was sold by the plate, not by the pound. Mary Murray (right) was employed by the Simons family as their cook for many years. She would bring her own bowl to the vendor and buy what she needed for that evening's meal. The Simons had two boys, and Miss Murray helped to raise them as well. The basket on the right in the background was a trash basket filled with lawn debris. Mr. Simons left the basket, before the days of rolling plastic carts, on the sidewalk and the city came by to pick it up.

Submitted by Carlton Simons

A Fine Kettle of Fish ▷

Tex Cammer and his son Jerome (right) enjoyed numerous fishing trips in the Charleston harbor; this photo taken in April of 1950 is representative of the spot tail and striped bass the men caught at the jetties on any given trip. Tex worked at the Charleston Naval Shipyard and Jerome was fresh out of the Navy and working at the shipyard. Their home on Spruill Ave. is pictured in the background; the drum contained heating oil used to heat the house.

Submitted by Dorie Timmons and Winkie Chaplin

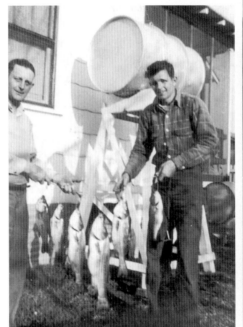

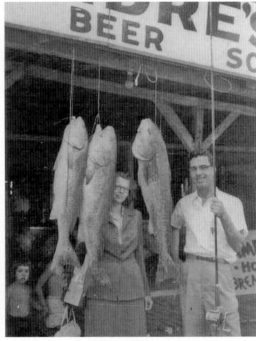

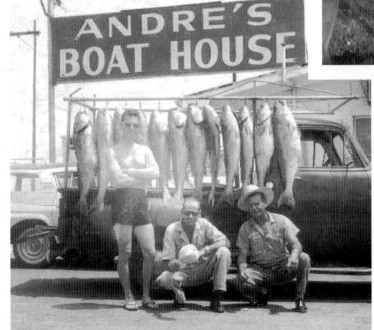

Andre's Boat House ◁

Andre's Tackle Shop and Boat House was a combination bait and tackle store and short-order restaurant just this side of the Folly bridge. The business featured big garage doors that opened out and slid overhead; children would wait for the school bus there. The restaurant served breakfast and reportedly had the best hamburgers around. Ed Stringer (left), Herman Hagen and Mr. Hiott stand in front of the Channel Bass they caught off Morris Island in the 1950s.

Submitted by Sandra Stringer

Andre's Tackle Shop ▷ △

Andre's was a local hangout in the '50s, '60s and '70s. The business was torn down to make room for Mariner's Cay parking spaces, but in its time, it was the place to show off a big catch. Joy and Ed Stringer are pictured with three good-sized fish. Children, such as Jackie and Karen Stringer (in the background), made Andre's an Allowance Day destination for candy-shopping.

Submitted by Sandra Stringer

Children Invited to Lucky 2 Ranch Were Lucky 2 Go ▲

Tony Glenn and Suzi Q the elephant were big draws in 1957 when WUSN-TV Channel 2, the NBC affiliate in Charleston, broadcast a live children's program celebrating birthdays. Parents who wanted their children to be on the show would call the station and make a reservation; the station would send a reply card confirming the date and time for the child's appearance. Each family brought a cake and candles to celebrate; sometimes the youngest children would begin to eat the cake prematurely on live television. Suzi Q lived in front of the station for a long time.
Submitted by Elizabeth Abbey

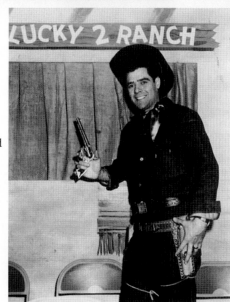

High School Musical, the Prequel ▲

In the early '50s the old St. Andrews High School performed its own version of "High School Musical," complete with a band and 18-girl chorus. Drummer Jerry Johnson (right) wasn't a student at St. Andrews but Bernard "Fess" Hester, principal and revue director, heard him play in the city and invited him to participate in the production. Johnson met one of the chorus girls the night of the performance May 15, 1950; they eventually married. The old St. Andrews High School burned many years ago; St. Andrews Middle School occupies the same location today.
Submitted by Ann P. Johnson

Tony Glenn, Live at Berkeley Drug ◄

Tony Glenn, a local celebrity to children, attracted a big crowd when he made a personal appearance at Berkeley Drug in 1958. It was an opportunity for many children to meet and talk with him personally. Berkeley Drug was located in North Charleston at Yeamans Hall and Loftis roads. The location is now Yeamans Hall Plaza Piggly Wiggly today.
Submitted by Elizabeth Abbey

Stay Tuned for "The Old Country Church" ▼

On Sunday afternoons between 1956 and 1958 Channel 2 aired a program called "The Old Country Church." The shows host, Gordon Hamrick (fourth from left) played the mandolin. His wife Billie (fifth from the right) played guitar. The show began as a half-hour broadcast but became a 90-minute show over the life of the program. The Johnston Sisters, three girls who began singing in churches and on a weekly radio broadcast, were invited to be guests on "The Old Country Church." It wasn't long before the trio became regulars on the show. Other members of the group who could be identified are: Smokey Joe Ellis (violin player, second from the left), Little Ginger Haselton (child standing on platform), Clarence Jackson (steel guitar player standing next to Billie) and the Johnston Sisters, Ruth (accordion player), Louise (on the left of Ruth) and Lois (far right). Red Ferrell also sang and played guitar.
Submitted by Lois Johnston Chears

Playing "Camera Man" ◀

Fifteen-year-old Bishop England High School student Bernie Oliver pretended to be the camera man at the WCSC-TV Channel 5 station located, at that time, on East Bay St., between Charlotte and Calhoun. The station had one studio, and each wall depicted a different scene: a news desk and weather on one wall, a kitchen on another, a living room with fireplace on another wall.
Submitted by Bernie Oliver

Carolina Yacht Club Orchestra ▼

The Carolina Club Orchestra, performing in the 1950s, included: Whatley Lewis on bass cello, Leo Tomaszewski on trumpet, Ray Edwards, saxophone player, Kenneth Bates, on guitar, and Mr. Jones on drums.
Submitted by Grace Bates

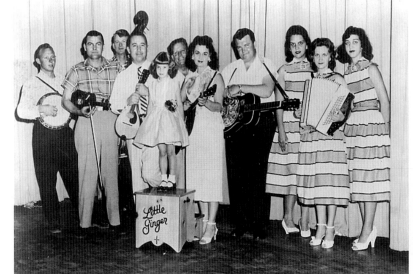

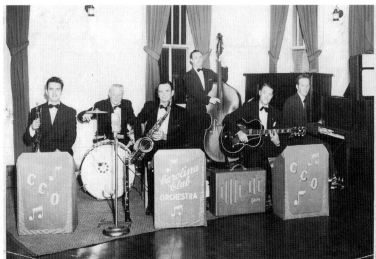

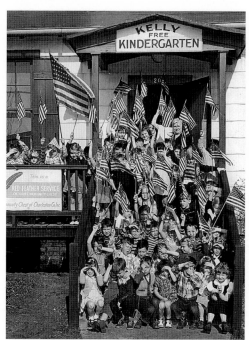

It's a Bright Sunshiny Day at Kelly Free Kindergarten ◄

Apparently the sun shone directly in the eyes of these kindergarteners in 1950, since most of them are peeking out from behind fingers and flags. Mrs. Bell, the kindergarten teacher, and her entire class of close to 50 students were celebrating Washington's birthday. The school, located between Meeting and King streets on Huger, was a "Red Feather Service" of Charleston County's Community Chest. Community Chest was a charitable organization that allowed children to attend at no charge. On the fourth row up, second from the right is Mike Young, in his Hopalong Cassidy shirt. Others who could be identified in the photograph are Leslie and Jerry Golubow, Marc Ackerman, Nicky Lempesis, Tommy and Bobby Riggs, and Jim Corbett.
Submitted by Michael Young

Mom's Homemade Divinity ◄

Four-year-old Ronnie Ott had permission to climb on the counter and eat some of his mother's divinity in 1959. Ronnie had four mothers: one real one, Louise Ott, and three older sisters. He was always getting into something, as his socks indicate. Behind Ronnie is a Cracker Jack box and flour canister. To the left of the photo is a waffle iron. The family lived in the Park Circle area of North Charleston. Ronnie grew up to work for the Justice Department.
Submitted by Frances Via

Moultrie High's Head Majorette ▲

Barbara Cope, on her way to march in the Azalea Parade in 1953, is dressed for twirling. Schools in Mt. Pleasant and Charleston closed when Charleston had a parade because everybody went. Barbara, who was in the eighth or ninth grade at the time, took private twirling lessons which earned her the Head Majorette position at Moultrie High. This photo was taken in Barbara's back yard in Mt. Pleasant.
Submitted by Barbara C. Inglett

Weather Forecast: Cold ▼

Arnic Washington found the weather at Goose Bay Air Force Base to be a little cooler than the temperatures in South Carolina. Washington served in Canada's far north, in the province of Newfoundland, in 1956. As staff sergeant, his duties focused on supplies.
Submitted by Christine W. Hampton

Celebrity Sighting ▶

Tony Glenn, host of the Lucky 2 Ranch Show, was a local celebrity to children in 1956. Twins Lydia (left) and Lynda Glover and their sister Ruth-Ann (right) were big fans; when he was sighted walking around the Battery one afternoon, the girls had their picture made with him.
Submitted by Ruth Glover and Ranne Hammes

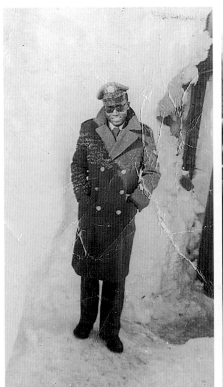

Home on Leave at Garco Village ◀

Ralph Harbeson was on leave from the U. S. Navy in 1951 when this photo was taken. The car, a 1946 Dodge, belonged to Ralph's father-in-law, Earl Hilton. Pictured in the background is the home of his parents, Harry and Anna Harbeson. The family lived in a mill village known as Garco Village, at 106 Gaffney Place. The neighborhood was close to North Charleston High School and not far from Park Circle. Garco Village was a family-oriented, close knit neighborhood with housing provided by General Asbestos and Rubber Company. All the homes had front porches and people spent a lot of time on them in rocking chairs or porch swings, chatting with friends about community life and world news as it came to them on the radio.
Submitted by Diane Zielinski

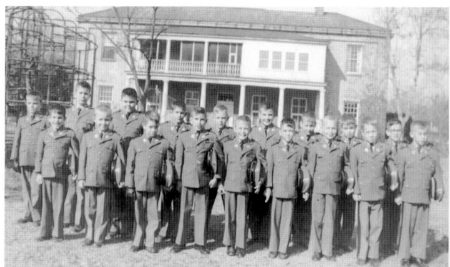

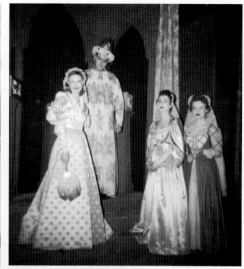

Third Graders At Attention ▲

Caps on the left, hands by their sides, these young men are pressed and dressed and ready for action in the early '60s. This photo of Porter Military Academy's circle drive, known as the Bull Ring, was at the rear of the campus on the President St. side of the block once bound by Ashley, Bee and Doughty. The "officers' quarters" in the background was one of the original U.S. Arsenal buildings built in the 1840s. Major Singleton and family, the last commandant of Porter, were the last occupants before the school merged with Gaud and Watt Schools. The boys in Ms. Tingley's third grade class are, front row, left to right: John Copeland, Peter Daspit, Lane Ector, Al Catlett, Eddie Carnes, Tommy Brooks, Lloyd Lent, Lee Glover and Eddie Meree. Back row, left to right: Stuart Langston, Danny Jones, Frank Strange, Andy McIver, Rusty Stelling, Roy Hawkins, Mortomer Sassard, Henry Copeland and Scott Sosebee.
Submitted by Mary L. McQueen and Henry deS. Copeland

"The Merchant of Venice" Performed at Footlight Players ▲

This scene from the play at Portia's estate pictures a few of the volunteer actors who played roles in the 1956 performance. Left to right: Peggy Simons, who played Portia, Gene Corrigan, the Prince of Aragon, Evelyn Woolston, who played Nerissa, and Carolyn Winters, who is listed as Portia's servant.
Submitted by Edith T. Dixon

Citadel Ring Ceremony ◄

Edward W. Weekley, Jr. and Sybil Johnson are pictured at the 1960 Ring Ceremony and Dance at The Citadel Armory, now McAlister Field House. The Ring Ceremony was, and is, a much-anticipated formal event for the First Class.
Submitted by Eddie Weekley, Jr.

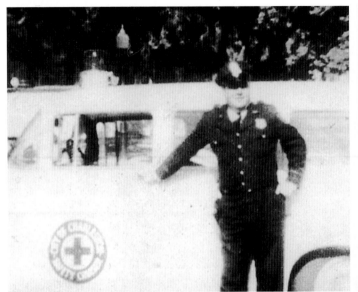

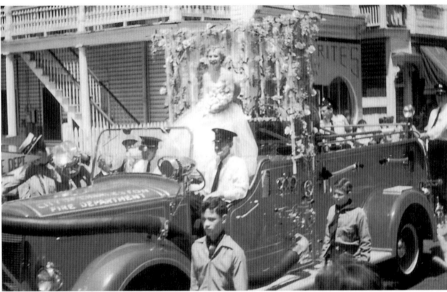

City of Charleston Safety Cruiser ▲

Traffic Officer Samuel David Ott was a private with the City of Charleston Police Department in 1958. This photo, taken in front of the old bandstand at the Battery, shows the 1957 Chevy that functioned as the city's "crash wagon" before EMS. Patrolman Ott responded to an accident in which a little girl was struck by a car. The girl died in his arms and later Ott discovered she was the child of a fellow policeman and friend. It was an event he never really got over.
Submitted by V.E. Ott

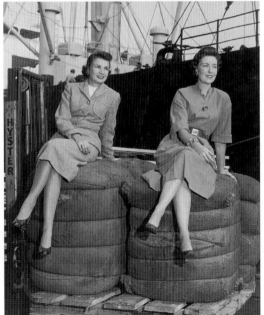

Miss Charleston Fire Department ▲

The City of Charleston Fire Department participated in the 1952 Azalea Festival Parade with several firemen in and around the decorated truck and "Miss Charleston Fire Department" seated in front of a cascade of flowers.
Submitted by Arla S. Holroyd

Bales of Australian Wool ◀

Fran Webb and Murial Clarkin sat atop bales of wool freshly imported from Australia at the North Charleston Terminal in 1955. During "Wool Week," thousands of people attended various festivities, assemblies, fashion shows and displays, including the crowning of a Princess of Wool and a dance known as the Wool Ball.
Submitted by Allison Skipper, SC State Ports Authority

Inspecting the Barracks ▲

Gov. Fritz Hollings, Dr. George H. Orvin, Gen. Mark W. Clark, Jud Spence, Ralph Bagnal and Col. Roy Harrelson (left to right) inspected the rooms inside the old Padgett-Thomas Barracks in 1959. The P. T. Barracks was the first building on campus after The Citadel relocated from Marion Square. They were torn down in 2001. Dr. Orvin was President of the Association of Citadel Men; Gov. Hollings, class of 1942, had come to speak on campus.
Submitted by Mrs. Rosalie S. Orvin

Cattlemen's Association Centennial Meeting ▶ ▲

Of those attending at the 100th anniversary meeting of the Cattlemen's Association, the following men can be identified: Julian Limehouse, John P. Limehouse, Arthur Ravenel, Louie Baker, C. W. Caraway, County Agent, G. Philip Higdon, William Kennerty, J. Ray Waites, B. M. Edmonson, Newman Buck, Arthur Liebenrood, Assistant County Agent, and Mr. "Gunny" Wallen.
Submitted by Gene Limehouse

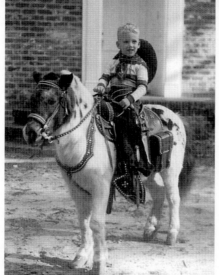

A Birthday Pony Ride ◀

When the traveling photographer came through The Crescent in 1951, it just happened to be little Tommy McGee's fourth birthday. His parents treated him to a ride on the photographer's pony. The Crescent, off Folly Road and across from the South Windemere Shopping Center, was the first subdivision in that part of town in the early '50s. Tommy grew up to be a third generation employee of Evening Post Publishing. He currently serves on the Board of Directors of White Oak Forestry, an environmental arm of the company that is one of several plantations re-foresting to save the coastal longleaf pine. Coastal longleaf pine is used in flooring, phone poles, and pilings. It was also used in the construction of the tall ship, the *Spirit of South Carolina*.
Submitted by Tommy McGee

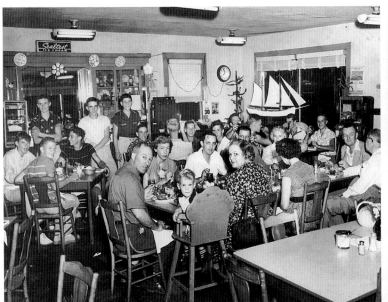

Team Party at The Tower Restaurant ▲

West Ashley's first American Legion baseball team got together at the Tower Restaurant in 1952 to celebrate a winning season for Post 10. The Tower isn't around any longer but in those days it was a block from College Park across from Rivers High School at the corner of Grove and King streets. The boys standing up in the back, from left to right, are: Eddie Weekley, Jack Destefano and Petey Peters. The boys seated at the table on the left are: Billy Lee (turning around to look at the camera), Bevo Clair and Walter LaTorre (closest to the boys standing). *Submitted by Eddie Weekley, Jr.*

When Political Stumping Meant Barbecue ... ▲

Ernest F. "Fritz" Hollings (far left) enjoyed a plateful of Limehouse barbecue with Loyless (center) and Loyless' brother John F. Limehouse (right). The then governor-nominee Hollings was an honorary pallbearer at Limehouse's funeral in 1958. *Submitted by Lynn Limehouse-Priester*

Modern Conveniences ◄

Nathan Lee displayed a large-capacity refrigerator at Vane's Appliance Store, where he worked part time in 1957. Lee retired from the Charleston Shipyard after 38 years of service as a rigger—a person who transports heavy equipment on and off the ships. As an appliance salesman, Lee made it a point to help people who lived in rural areas or who did not have transportation. Vane's Appliance Store was located on Montague Ave. in North Charleston; it does not exist anymore. *Submitted by Montina V'Nor Lee*

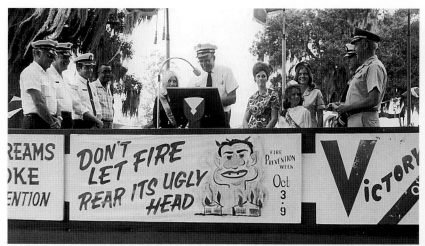

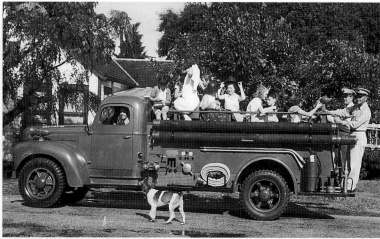

Fire Prevention Week at the Army Depot ▲

Oct. 3-9, 1956 was designated as Fire Prevention Week at the Army Depot, with cookouts and speakers and visiting dignitaries and a parade. Woodrow C. Suit, Fire Chief at the Army Depot in North Charleston, is pictured addressing the crowd. Chief Suit served 25 years as Fire Chief, and a total of 34 years in federal service. To the left of him is "Miss Flame," and her younger counterpart, "Miss Spark" on the right of the photo, wearing a fireman's hat.
Submitted by Irene Suit

Palmer's Inauguration ▶

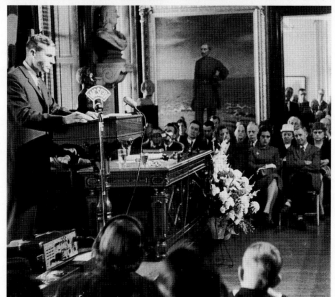

Palmer Gaillard, at the podium, accepted the duties of his elected position in City Hall Gallery among a large crowd of supporters. Gaillard became the mayor of Charleston in 1959; he would serve the city for 16 years in that capacity. He succeeded William McG. Morrison. This photo published in The News and Courier highlights the inauguration.
Submitted by Jane L. Thornhill

Fire Fighters Treat Children to a Ride ▲

Fire Chief Woodrow Suit took officers' children on a fire truck ride at the Army Depot in 1956. Several of the children seemed to have found firemen's hats to wear while "on patrol." Apparently there was no room for the firehouse mascot, Robert the Dog (although everyone referred to him as "Bob") but he made sure his owner, Chief Suit, knew how he felt about the situation. "Bob" was a bone-afide fire fighter with his own badge number and everything.
Submitted by Irene Suit

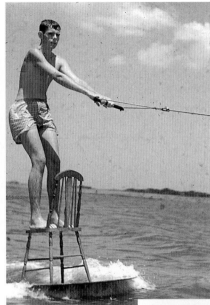

Who Says Chair Lifts Are Just For Snow Skiing? ◄

Certainly not Carlton Simons, who enjoyed trying different types of trick-skiing as a teenager. He also attempted shoulder-skiing at one time, and always without a life jacket. Simons' family owned a summer home at Isle of Palms, near the old wooden bridge that existed at that time. Simons is pictured here in Breach Inlet in the early '50s, skiing on top of a chair which is on top of a circular piece of plywood.
Submitted by Carlton Simons

Family and Friends ▼

Kerzell "Sue" (Drayton) Fleming was employed by Ruth and Francis St. Clair Glover on James Island. She assisted in raising their children and although the girls are long grown and out of the house, Sue and the entire Glover family continue to be friends some 50 years later. Little Ruth-Ann is in Sue's arms, with Ruth-Ann's sister Lynda on the left and Lydia on the right. Lynda and Lydia are twins; at the time they were almost 2 years old. The house at the end of Harborview still exists and has been restored. The family still lives there.
Submitted by Ruth Glover and Ranne (Glover) Hammes

Fourteen-Year-Old Joins Marine Reserves ▲

In 1954 Paul Sports was 14 years old, and had already spent six years of his life in the Charleston Orphan House. After the death of his father, Sports' mother could not care for the family of eight children. She put five of the children in the Orphan House. Paul was 3 years old when he went in. Charleston Orphan House, on the corner of Calhoun and St. Philip streets, was a huge facility that accepted orphans and children of poor, distressed or disabled parents from 1790 until 1951, when the building was demolished. Paul's mother was able to get him out in 1949, a day he described as the happiest day of his life. But Paul had wanted to be in the service for as long as he could remember; when he found out he could enlist if his mother would sign stating he was 17 years old, he badgered her until she relented. Sports became one of Charleston's own 53rd Special Infantry Company, U.S.M.C.R., based at the Navy Yard in North Charleston.
Submitted by Paul Sports

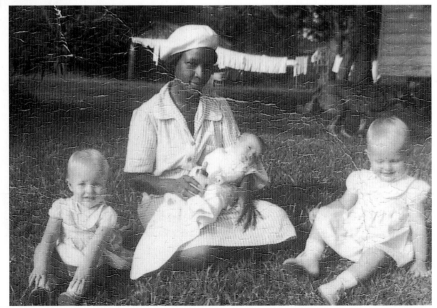

Charleston's Town & Country Clothier Since 1917

Family owned and operated for three generations, M. Dumas & Sons has been outfitting customers on historic King Street in the heart of Charleston's shopping district since the early twentieth century. Established by Mendel Dumas in 1917, the store specialized in riding apparel, luggage and hunting gear.

In the 1940's, brothers Abe and Joe Dumas joined their father in the family business. It was thirty years later, on their birthday, that the store moved to its present location at 294 King Street. The store has diversified to offer shoppers options from outdoor to traditional to updated styles, with an impressive array of sportswear, apparel, shoes and accessories.

After the death of Joe Dumas in 1990, his wife Claire and sons Larry and David ran the store until 2003, when David became sole owner after his mother's death. David Dumas continues to serve the Charleston community through the family business today, offering quality merchandise and unparalleled service to fourth-generation Charlestonians, newcomers and tourists alike.

M. DUMAS & SONS
294 King Street / Corner of King & Society

Joe & Abe Dumas

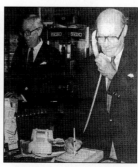
Joe & Abe Dumas

Claire & Joe Dumas

It's Business as Usual After an Attempted Robbery ▷

Billie (Hill) Rodgers is pictured here in 1955 after the bank at which she was employed, Citizens and Southern National Bank on King St., was robbed. A man at Miss Hill's teller window handed her a note demanding money. The theft was unsuccessful, due in large part to Miss Hill's calm reaction to a dangerous situation.

Submitted by Billie (Hill) Rodgers

Typesetting Demonstration ▽

Whenever a new business held an open house, or a public demonstration of new technology, it usually drew a crowd. When The News and Courier and The Evening Post held a typesetting demonstration in the early '50s, people came to watch the "cutting edge" of newspaper production. Those who can be identified in the photo include Mimi Fox (left), Hank Gissell (third from left) and Ellen Fox, just behind the typesetter.

Submitted by LeRoy T. Fox

Administration Building, Charleston Naval Shipyard ▽

Building 8, located in the center of the shipyard on North Hobson Ave., was the administrative building. Commanding officers had offices upstairs; the flag of the commanding officer for the day was flown on top of the building. The women pictured here in 1958 were civilian employees who handled officer records. June (Reeves) Wireman is seated at the desk in the foreground; Virginia Shaw is seated behind her in the foreground. At the far left of the photo is Ann Mitchum; behind her is Louise Nettles.

Submitted by Anna (Wireman) McAllister

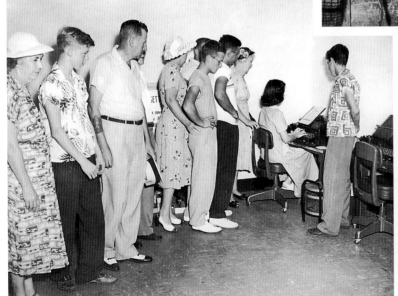

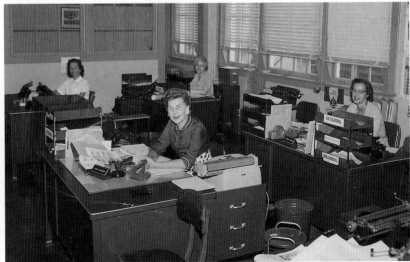

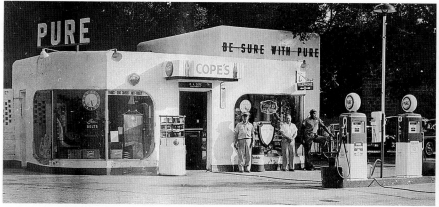

Be Sure With Pure

Rodney Cope's place was a popular meeting spot with the children who attended Mt. Pleasant Academy and Moultrie High School in the '50s. The service station serviced automobiles and sold gasoline but they also sold milk, eggs and snacks and Cokes. It was the snacks and Cokes that intrigued the children. The business was on the corner of Coleman and Boundary, which was the "boundary" of Mt. Pleasant at that time. Boundary St. is now Simmons. Standing next to Rodney Cope (left) is Gene Cope and Elijah Edwards. Randy's Hobby Shop occupies the location today.

Submitted by Barbara Inglett

Cypress Gardens, 1954 ▷

The Muschick family visited Cypress Gardens in Moncks Corner every spring. Bulbs were blooming, and the azalea bushes towered over grown men, replete with color. Black swamp water mirrored ancient cypress trees thick with Spanish moss. Each flat-bottom boat had a tour guide; as he poled the boat along the water, the ripples made the reflection of colorful blooms appear to be alive and fluid. The air was filled with the sound of boats full of local black spiritual singers whose voices floated across the silent water. It was a truly magical experience.

Submitted by Kay (Muschick) Schneider

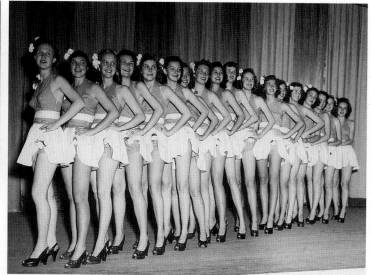

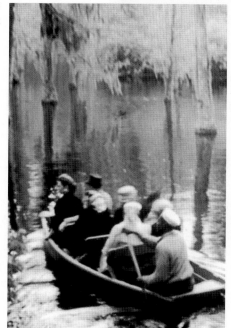

St. Andrews High School Musical Revue ▲

The musical entitled, "Get Happy" began in the early '40s as a one-night event but over the years it grew in popularity. By the late 1940s it was running three nights during the month of May to an audience of 2,500. The caliber of the production by the St. Andrews High School Drama Club was due, in large part, to Principal Bernard Hester, or "Fess," as he was called. "Fess" was involved in Broadway shows and brought much of what he learned back to the school. When Old St. Andrews High School burned, the performances ended as well.

Submitted by Ann P. Johnson

Tom Thumb Wedding ▶

Randy Scott and his sister Betty pretended to be bride and groom for a charitable event at Summerville High School's auditorium in the early 1950s. The children represented S.C. Gov. and Mrs. James Byrnes for the fundraiser, which included a full-blown wedding with tuxedos and long gowns and music. Randy Scott grew up to become a S.C. state senator.
Submitted by Betty S. Abdon

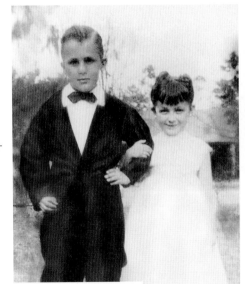

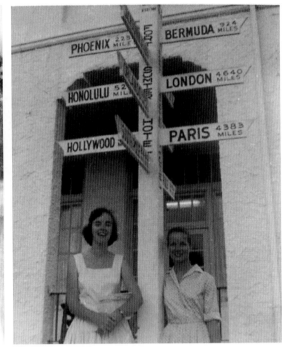

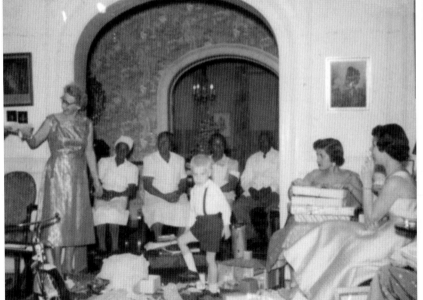

Driving Miss Daisy ▶ ▲

Anne (Ferguson) Caughman (right) probably would drive Miss Daisy (Barron) Leland to any one of the 12 destinations itemized on the Fort Sumter Hotel street sign. The two girls met at Converse College and continue to be the best of friends, 52 years later. Both grew up to be school teachers; Miss Daisy taught at Ashley Hall for 22 of her 27 years in education; the last 18 years of those 22, she served as head of the middle school.
Submitted by Daisy (Barron) Leland

Family Christmas Party ◀

The Thornhill family always held a formal gathering that included dinner and gift giving on Christmas Eve at the home of T. W. Thornhill, 26 Legare St. Shown here in 1955, presents are being distributed and opened but the wrappings and boxes seem to be just as much fun to play with as the toys. Looks like a bicycle and miniature dollhouse were among the children's gifts that year.
Submitted by Jane L. Thornhill

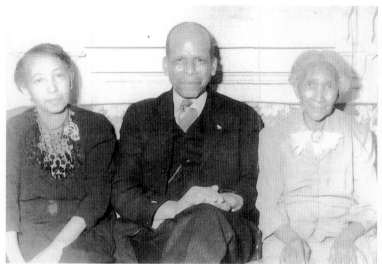

Pullman Porter ▲

Andy McCottry was a Pullman porter employed out of Charleston with the Southern Railroad. His work kept him on the road, or on the rail, most of the time. When the station burned on Columbus St. in the late '40s, Southern came in at the station on Line between King and Meeting streets. Pictured on the left is Lucille McCottry; on the right is Mary Turner.

Submitted by Cynthia (McCottry) Smith

The Rocks, 1954 ▶

St. Andrews High School back field, left to right: Herb Antley, Wesley Weeks, Ray Wright and Frank Drew (kneeling in front). The team was photographed for the newspaper's sports section; they lost to Walterboro High School in district 8 playoffs.

Submitted by Herb Antley

Watt School Student Body, 1955 ▲

The Watt School was founded in 1931 by Mrs. Ann Carson Elliott, the mother of Berkeley Grimball, longtime headmaster of the Gaud School and later, of Porter-Gaud. Mrs. Elliott and Miss Mary Lee Haig taught first- through third-grade students in Mrs. Elliott's home on Broad St., just west of Franklin St. Pictured first row, left to right: Boopsie Gibbs, Nancy Thompson, Becky Saltonstall, Caroline Huggins, Susanne Deas, Ann Deas, Eunice Smith and Laura Snowden. Second row: John Luke, Tom Stoney Tommy Lee Peeples, Mark Benton, David Aiken, Scotty Hood, Phillips McDowell, Warren Roberts, Louis Middleton and deRosset Myers. Third row: Elliott Barnwell, Bill Grimball, Stephen Middlebrook, Steve Barker, (unidentified), Tim Simmons, Scott Cogswell, Don Thompson, Jack Bryan, Chisolm Coleman and Gerard Stelling. Fourth row: Batson Hewitt, Jules Deas, John Metcalf, George Boggs, Henry Deas, Lowndes Sinkler, Chip Russell, Frank Barnwell, Henry Fishburne, Will Hope and Henry Grimball.

Submitted by Thomas P. Stoney, II

A Sullivan's Summer Celebration ▶

Dressed in their Sunday best for cousin Sara Ostendorff's fourth birthday party in July of 1958, these children appear to be having a grand time at the Sullivan's Island beach house her grandparents rented. Sara received a small toy piano at her birthday party, which included cake and ice cream, party hats and tasseled horn blowers, along with a rousing game of Pin the Tail on the Donkey and, most certainly, a trip to the beach. Pictured on the top row, left to right: Vernon Olsen, Linda Olsen, Betsy Olsen, Diane Ostendorff. (Mrs. John O'Hagan is pictured in the background). Bottom row, left to right: John O'Hagan, David O'Hagan, Sara Ostendorff and James Rickman.
Submitted by Diane Ostendorff De Angelis

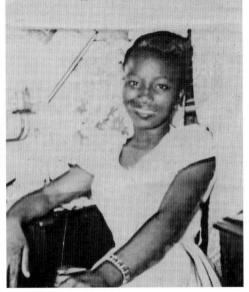

Pretty as a Picture ▲

Eighteen-year-old Charlotte Godfrey poses for a picture at her parents' home, 57 Spring St., in 1953. Miss Godfrey married William H. Scott that same year; Scott proposed to her before he entered the army. For entertainment Miss Godfrey and her friends, Gloria Jenkins and Margaret Frasier, liked to go dancing at the Old County Hall on King St. on the weekends, or at a little "juke joint" called the Moulin Rouge on Rutledge Ave. They often took in a movie at the Lincoln Theatre or the Riviera on King St. Sometimes they took a bus to Mount Pleasant and spent the day at Riverside Beach, which is no longer there.
Submitted by Joanne Chisolm

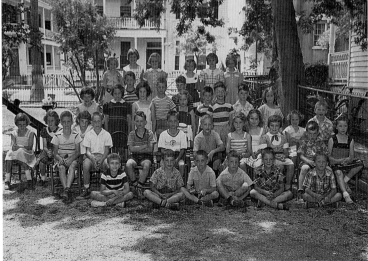

The Watt School ◀

Ann Carson Elliott began her school in 1931, but her first informal pupil was her son, who bought the Gaud School for Boys when Mr. Gaud retired in 1948. She began holding classes in her dining room but later built a small classroom in her back yard on Broad St. Most boys, upon completion of the third grade at the Watt School, would transition to the Gaud School. The student body of Watt School is pictured here in 1951; Jerry Reves is the boy in a striped shirt standing behind a boy with glasses in an identically striped shirt.
Submitted by Jerry Reves

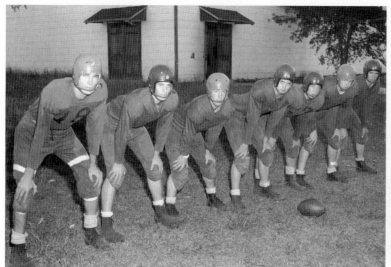

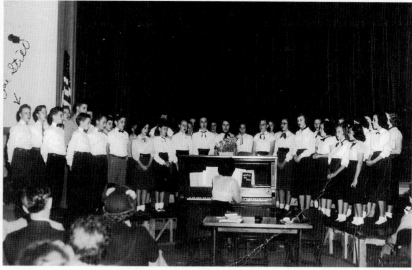

1950 Moultrie High School Generals ▲

These young men ended the year with an undefeated season, winning the Class B South Carolina State Championship in 1950. Home games were played on Jasper Green, named in honor of Sgt. William Jasper who saved the state flag during fierce fighting at Fort Sullivan, later named Fort Moultrie, on Sullivan's Island, June 28, 1776. The building in the background is the Gen. William Moultrie High School gym. All the school's buildings are gone now; a new Moultrie Middle School will open on the site. Linemen pictured left to right are: George Sander, Ned Montgomery, Koga Porcher, Jimmy Smith, Al Hutchinson, Charlie Darby and Earl Litchfield.
Submitted by Ned Montgomery

"Merrily We Sing" ▲

At least that's what the songbook said at Mrs. McDonald's piano. Mrs. McDonald was the music teacher and assistant principal at Liberty Homes Elementary School in North Charleston. The 7th grade chorus performed in 1951 in the school's auditorium. Joe Still, Sr. is pictured on the far left. The neighborhood of Liberty Homes, which was built for families at the shipyard during the war, has been torn down along with the school.
Submitted by Mrs. Joe E. Still, Sr.

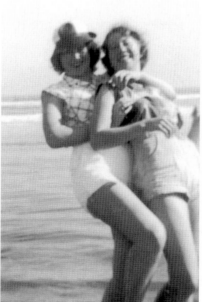

Folly Friends ◄

Catherine Vereen had just moved to Charleston in 1952 to attend Palmer College when she met Edith Quarterman at Citadel Square Baptist Church. The two struck up an immediate friendship and enjoyed going to Folly Beach for fun.
Submitted by Candy Nevils

Searching for a Drowning Victim ▲

The rip currents were bad that day; Ronnie Norris (third from left) remembers when someone went under the water about 100 yards from the old pier in the early '60s. He and five others dragged the surf looking for the drowning victim while Jack Nathan, a volunteer lifeguard, searched by boat. The search continued for about an hour; the body of the victim washed up later, down the beach.
Submitted by Ronnie Norris

At the Wash Out ▶

Lib and Monroe Wright took a break from construction on their summer home in 1957 to relax at the Wash Out on Folly Beach. The couple, married in 1945, purchased a lot on the riverside for $1,000 and built their own retreat over a two-year period. The little white house with hot pink shutters is still in the family. "Charlotte's Web," as the beach house is called, is located at 1418 E. Ashley.
Submitted by Charlotte Wright Capo

Cause for Celebration ▲

The admission of Alaska and then Hawaii into the union created quite the nationwide discussion about how the new flag's stars should be configured. Suggestions poured in from almost every state, and even some foreign countries. President Eisenhower's Executive Order settled the matter, however, with the unfurling of our official flag on July 4, 1960. Family and friends shown here celebrating the new design on the Isle of Palms are, front row: Grace Bates, Eunice Brewer, Teresa Zwingmann, Susan Wilson, Mary Lou Blanton and Linda Wilson. Second row: Grace Geiger, Gerry Blanton, Margie Blanton, Ed Blanton, Burt Blanton and Joe Bartee. Third row: Dot Bates, Elizabeth Blanton, Hazel Cheek, Amos Cheek, Helen Blanton and Ed Blanton. Fourth row: Eddie Blanton.
Submitted by Grace Bates

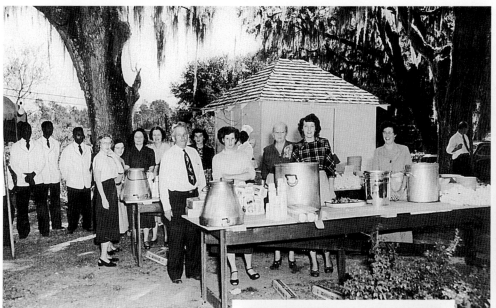

Another Limehouse-Catered Barbecue ▲

Amid moss-strewn oak trees and the company of friends and relatives, Loyless Limehouse served up big buckets of barbecue. Well-known in Ladson for his cooking skills, Loyless was often called upon to cater all sorts of events. A blurb in The News and Courier said Limehouse held a barbecue for Charleston County candidates for political office and approximately 700 people showed up. Limehouse is pictured on the front row, far left. His wife Bertie Limehouse (wearing glasses) is in the center front row.
Submitted by Lynn Limehouse-Priester

It's a Long Way to Miami But Just Steps to a Great Vacation ▲

Selina L. Rosen (left) and a childhood friend she had not seen in years, Retta Bowman Damenstein, reunited at the Fort Sumter Hotel in 1955. This amusing old sign was a much-photographed "destination calibration" for many Charleston visitors and residents alike. The sign is gone now, along with the Fort Sumter Hotel and its Rampart Room Restaurant, which offered fine dining and a beautiful view of the harbor.
Submitted by Carolee R. Fox

Reeves & Son Shoe Repair, 1958 ◄

Hoap C. Reeves continued the business his father, W. D. B. Reeves, owned at 442 ½ King St. The business claimed to be the oldest shoe repair shop in South Carolina, established in 1860. During the war several competing shoe repair shops sprung up downtown due, in large part, to the rationing of shoes. People had no other choice but to fix what they had and make do. The business address is now occupied by FISH Restaurant.
Submitted by Mrs. Ruth (Reeves) Clark

Coleman Boulevard Prior to Widening ▽

In 1956 Coleman was a two-lane road, but home-owners along the street were told they needed to "make room for progress." The house on the left of the photo was instructed to give some of their land, 176 feet long and 15 feet wide, to the project. The homeowners fought, but progress prevailed. The house was moved across the field to Toler Drive. The remainder of the acre of land was sold to First Federal Bank.
Submitted by Carol Way

Lapin Dry Goods For Sale ◀

Israel and Dora Lapin owned the Lapin Dry Goods Store at 131 King St. for many years until the business was sold, upon their retirement, in the '60s or early '70s. The family kept chickens in the back and lived upstairs, which was accessible via a separate back entrance. The store was a department store, of sorts, selling belts, clothing and pocket watches among other items.
Submitted by Terrill Leff

Future Site of Cooper River Federal ▽

Founder of Cooper River Federal Savings & Loan Association H. E. Ashby is pictured talking with a man who is believed to be then-Senator Strom Thurmond, a friend of Ashby. A branch of the bank was planned for construction on Rivers Ave. across from the Naval Hospital in 1954. The building is still there but another business occupies the space.
Submitted by Robert W. Ashby

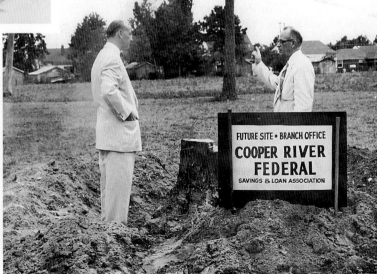

Barbecue, Loyless Limehouse-style ▲

In Ladson back in the 1950s, Loyless Limehouse was Mr. Barbecue. Limehouse became known as Ladson's Chief Cook, a moniker he earned through his culinary talents in the barbecue pit and his willingness to cater any affair. Loyless, on the left, is shown at a Limehouse-catered event. The gentleman on the right is John F. Limehouse, Loyless's brother. "Cool" Brooks, a foster son of Loyless and his wife Bertie, is pictured third person from the right; next to him is one of the Limehouse's three sons, Vinnie.
Submitted by Lynn Limehouse-Priester

Let Me Try ▶

The details are a little sketchy about how Cecilia Livingston came to be wearing roller skates in 1953; perhaps it was the result of a dare, or perhaps she saw a child roller skating and thought it looked like fun. The outcome is equally uncertain, but assumptions are that everyone survived the experience, that no one rolled head first down the stairs, and the roller skates lived to roll another day.
Submitted by Sonya Livingston

Lincolnville Elementary Graduation ▲

Anna Ruth Williams is dressed for her graduation ceremony in 1960 at her parents' home on Lincolnville Circle. Lincolnville Elementary School was one of the Rosenwald schools established in rural Southern states for African American children. Julius Rosenwald, founder of Sears & Roebuck, contributed significant amounts of money to build schools that educated black students. The school closed due to integration and was converted to the town's municipal complex. Anna Ruth grew up to serve as a Lincolnville town councilwoman.
Submitted by Christine W. Hampton

Dressed to the Nines ▶

Ruth Odessa Washington enjoyed looking her best. This photo, taken at a professional studio, proves it. She was born and reared on 63 Lee St.; she died in her 30s from an apparent heart attack in her sleep.
Submitted by Tara Reynolds

Catching a Battery Breeze ▼

The girls' father, Dunny Zalkin, had one of those early Polaroids that developed right before your eyes. The girls thought it was so magical! The Battery was the girls' stomping grounds; they grew up on Radcliffe St. across from Ashley Hall, attended Julian Mitchell Elementary School and graduated from the High School of Charleston. Pictured left to right are: Jane Zalkin, age 7, Susan (Zalkin) Hitt, age 9, and Sally (Zalkin) Hare, age 12.
Submitted by Susan Z. Hitt

The Modern "Covered Wagon" ▼

Ike Young, a Citadel business professor in 1955, is pictured holding baby Jan in the driveway of their Dunnemann Ave. home. The Youngs moved from The Old Citadel at Marion Square to the four-story apartment building for faculty members before Jan was born. The Chevrolet station wagon in the background was another one of Ike's "babies." Young attended The Citadel as a student before leaving to fight in World War II. When he returned, he finished his studies as a veteran at The Citadel, and was hired to teach various accounting courses in Bond Hall until he retired in 1980.
Submitted by Jan Easterby

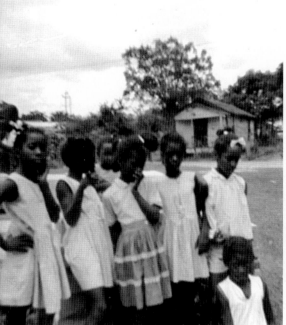

Neighborhood Friends ◄

Elizabeth June, Jeraldine Shivers Jenkins, Priscilla Smith, Marcella Smith Redding, Alethia Shivers Coaxum, Linda Smith and Rebecca Limehouse gathered in Elizabeth's mother's yard in North Charleston in 1960.
Submitted by Elizabeth June

Gaud School for Boys, 1960-61 ▼

This school picture, taken on the East Bay Playground, shows students at the Gaud School during the 1960-61 school year. Gaud School was located on the corner of East Bay and S. Adger's Wharf until the school merged with the Watt School and Porter Military Academy in 1964 to form Porter-Gaud. The crane in the background was part of the construction effort at the Naval Degaussing Station. The boats on the left were for the Charleston Branch Pilot's Association at the end of S. Adger's Wharf.
Submitted by Thomas P. Stoney, II

Dedicated Employee and Mother ▲

Janie Green Smith worked more than 30 years in the Charleston County School District as Assistant Manager in the Sanders-Clyde Elementary School cafeteria. She grew up in downtown Charleston; this photo was found after her death last year.
Submitted by Burnetta Smith

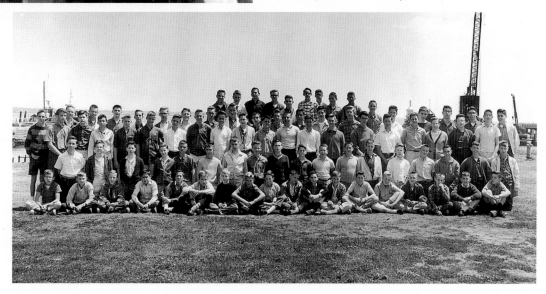

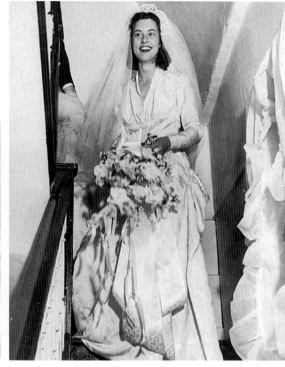

Shoe-Shopping at Condon's ▷

Children like Carol Ann Main looked forward to shoe-shopping at Condon's. The shoe department had a machine that X-rayed children's feet through the shoes to determine a proper fit. Carol Ann is sitting on a pedestal that featured animal chairs, where children tried on shoes.
Submitted by Carol Eustace

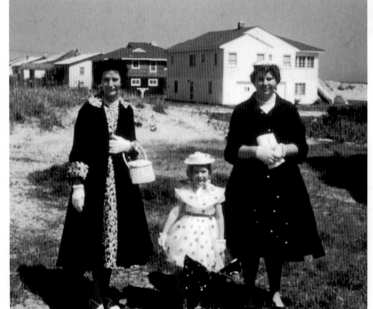

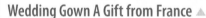

Wedding Gown A Gift from France ▲

Mrs. Esther Dupre (Gregorie) Gray is pictured on her wedding day wearing the gown and veil sent as a gift of gratitude from France. Mrs. Gray is of French ancestry on both sides of her family: the DuPres on her mother's side and the Porchers on her father's. The gown was among many articles sent to this country aboard the "Gratitude Train" which was France's response to our "Friendship Train" for help during the war. Miss Gregorie, of Oakland plantation in Mt. Pleasant, married John Judson Gray in Christ Protestant Episcopal Church on April 20, 1950.
Submitted by Julia Bailey

Easter Finery ◁

Rose Muschick (left) with daughters Kay and Diane Muschick were all dressed up with some place to go: the family was headed to Easter services at St. Andrew's Episcopal Church in Mt. Pleasant in 1953. The photo was taken in the family's front yard near the corner of 7th Ave. and Ocean Blvd.
Submitted by Kay (Muschick) Schneider

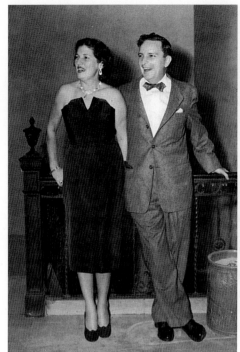

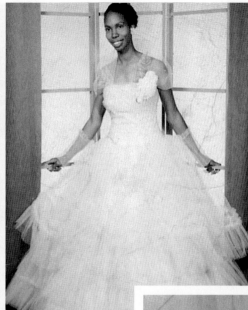

Senior Prom ◄

Ruth Bell Murray is pictured here in all her prom finery. She attended Burke High School Senior Prom in 1957.
Submitted by Tamara Murray-Wright

Junior League Follies ▼

Henry Saltonstall, Alta Brockington and Jane Thornhill entertained the crowd at the Junior League Follies in 1954. The ladies performed a lively dance number as part of a fundraiser to support the League's Speech School.
Submitted by Jane L. Thornhill

Enjoying a Special Evening ▲

The National Council of Jewish Women Gala in the spring of 1952 was a huge, formal affair held in the Francis Marion Hotel's Gold Room. Well over 100 people attended to socialize and dance to live music. Florence and her husband Joe Read are pictured at the Gala.
Submitted by Rosemary Cohen

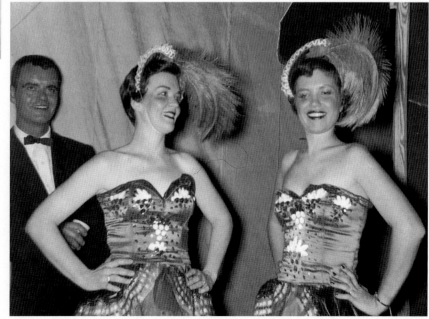

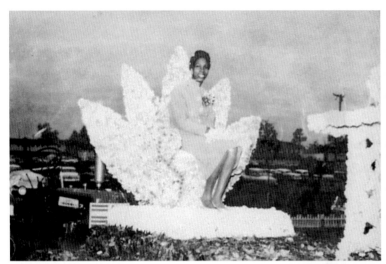

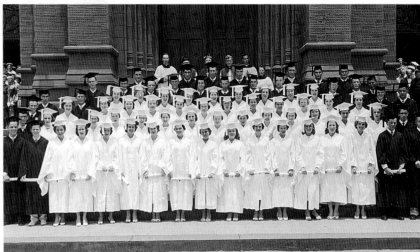

Trade School Parade ▲

Ruth Bell Murray represented the tailoring class in the 1959 Annual Area Trade School Parade. Burke High School, originally called the Charleston Colored Industrial School, was known for its vocational training. Burke is the only public high school in Charleston that continues to educate students who live on the peninsula.
Submitted by Tamara Murray-Wright

Old Charleston Museum ▶

The original Charleston Museum between Rutledge and Ashley avenues, near Calhoun Street, burned around 1980 and the ruins were demolished. All that remains of the old structure are the portico columns in Cannon Park, and photographs of the building in pictures. According to the couple in the foreground, Bob and Millie Fesler, they were photographed at the museum in January 1953, prior to their wedding.
Submitted by Millie Fesler

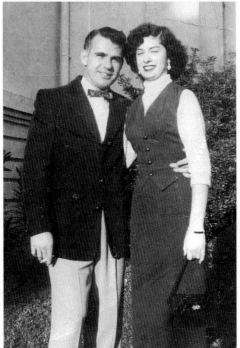

Class of 1956, Bishop England High School ▲

Just under 80 smiling faces clutched their diplomas after graduation of Bishop England's class of 1956. The school, located on Calhoun St. at that time, held graduation at Cathedral of St. John the Baptist on Broad St. The students did not wear uniforms then, but proper attire was strictly enforced; for young men, that meant slacks and a shirt, tucked in with a T-shirt underneath, and a belt. For girls, dresses or skirts only, and only with an appropriate hem line. All the teachers in 1956 were either priests or nuns. Of the priests who could be identified on the back row, second from the left is Father Jerome C. Powers, the Most Reverend John J. Russell beside him, and Father John L. Manning second from the right, the rector of Bishop England High School.
Submitted by Gene T. Janikowski

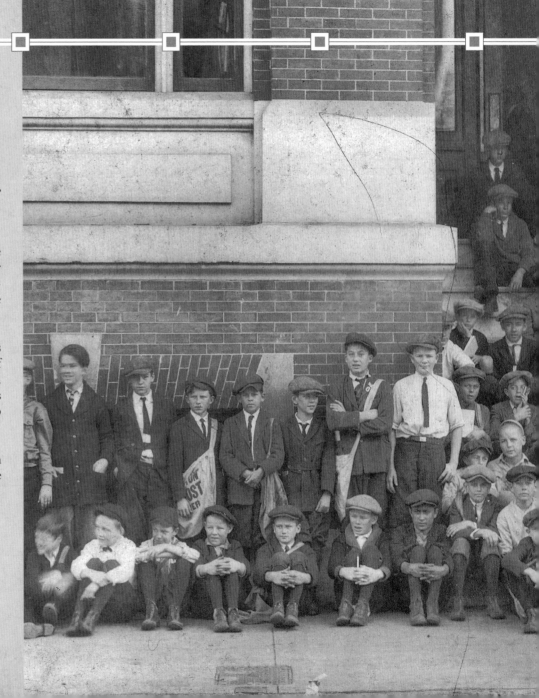

The South's Oldest Daily Newspaper

In a city which values ancestry and tradition, The Post and Courier is the proud descendant of four newspapers: The Charleston Courier, The Charleston Daily News, The News and Courier and The Evening Post.

For the past 204 years, The Post and Courier and its predecessors have provided an unbroken record of service and history to its readers and the community. Through war, siege, fire, financial ruin, earthquakes and hurricane disaster, The Post and Courier's deep roots held strong.

Today, The Post and Courier's roots have grown even deeper into your community offering the coverage most convenient to you and your family.

The Post and Courier

BECAUSE KNOWING MAKES A DIFFERENCE.

For Subscription Information Call 853.POST